KAFFE FASSETT'S
Quilts by the Sea

Celebrating 25 years of our Patchwork and Quilting series

featuring
Liza Prior Lucy

location photography
Debbie Patterson

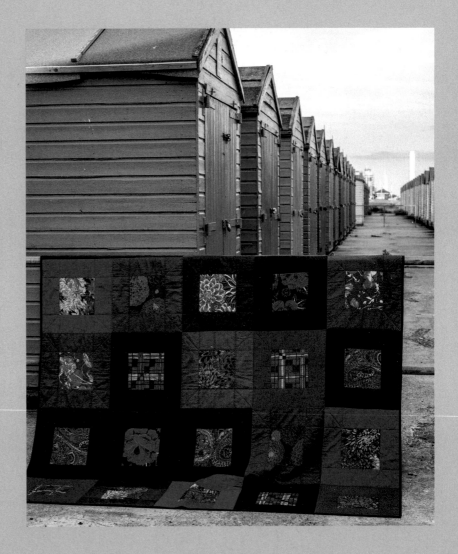

The Taunton Press

First published in the USA in 2023 by

The Taunton Press
Inspiration for hands-on living®

The Taunton Press, Inc.
63 South Main Street
Newtown, CT 06470
email: tp@taunton.com

Patchwork designs	Kaffe Fassett
	Liza Prior Lucy
Quilt making coordination	Heart Space Studios (UK)
	Liza Prior Lucy (US)
Technical editor	Bundle Backhouse
Designer	Anne Wilson
Art direction/styling	Kaffe Fassett
Location photography	Debbie Patterson
Additional photography	Brendon Mably (pp 4, 5, 7BR, 9BL, 10T)
Stills photography	Steven Wooster
Quilt illustrations	Heart Space Studios
Publishing consultant	Susan Berry (Berry & Co)

Library of Congress Cataloging-in-Publication Data
in progress

ISBN 978-1-64155-194-6

Colour reproduction	Pixywalls Ltd, London

Printed in China

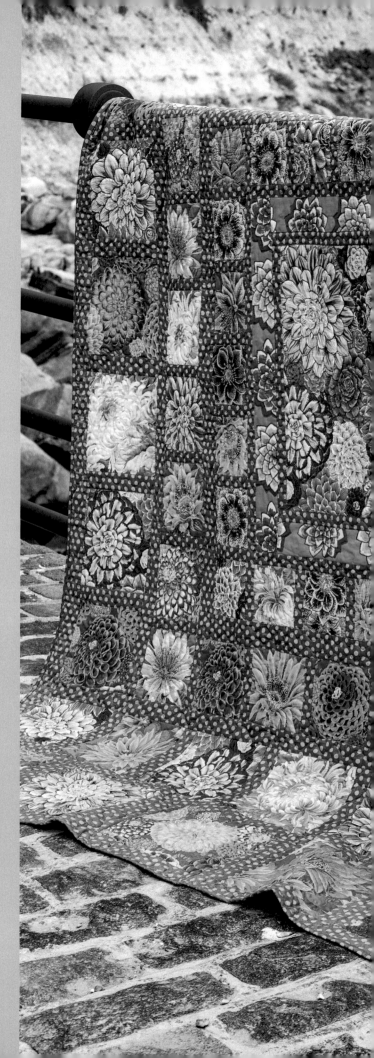

Page 1: My *Maroon Frames* quilt is set off perfectly by these painted beach huts in Hastings.
Right: My *Green Squares* quilt catches the eye on the beach.

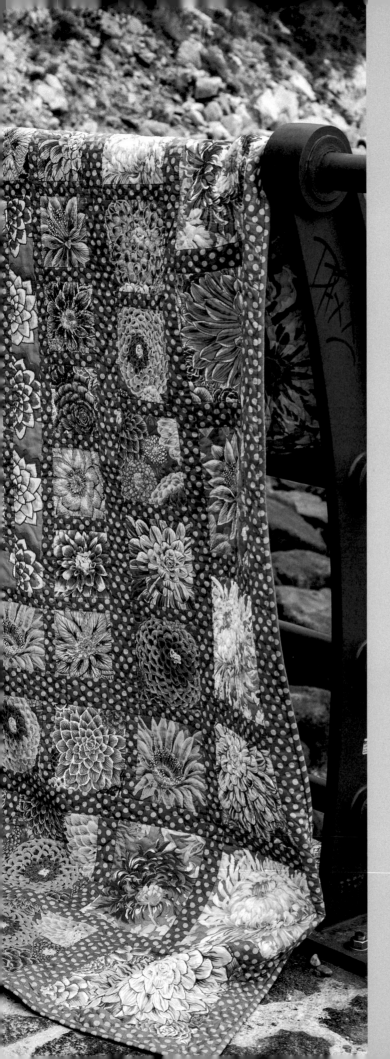

Contents

introduction

What is it about the seaside that brings back the child in us? Possibly it is the sense of freedom from restrictive clothes and shoes, the healthy feeling of tanned and salty skin, and the joy of collecting seashells and building sandcastles. For a budding artist like me, the sights get increasingly delicious through the years of visits to beachside towns all over the world. There is always the garish funfair atmosphere of bright parasols, beach balls and buckets, and colourful towels and swimwear. And, in contrast, there are the sun-bleached, faded colours of the peeling paint and neglected surfaces that I've grown to love, all surrounded by sand and pebbles.

Britain has wonderfully atmospheric seaside towns with just that nostalgic mix of heightened, vulgar colour and pastel tones. Hastings, our location for this book, has a particularly good mix of the fun and the faded that makes it the perfect setting for our quilts. Rows of jauntily painted beach huts are just the right dolls-house size to suit our quilts, along with the old boats on the beach with their

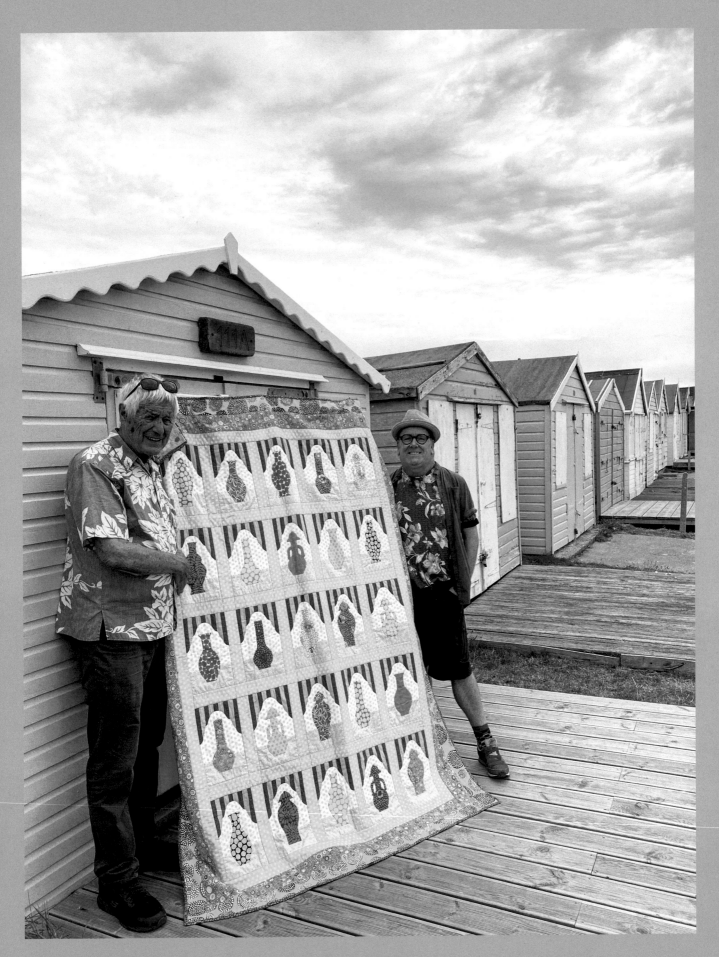

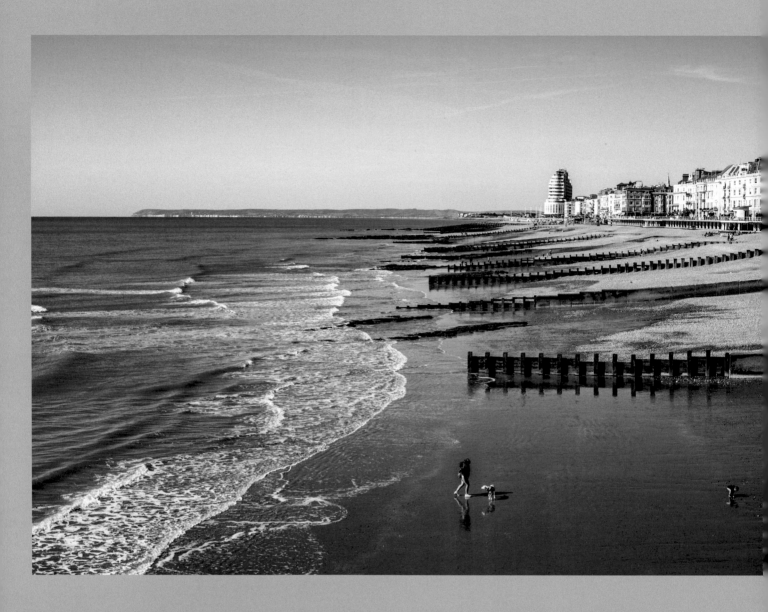

distressed, rusty charm, and the splendid pier with its funfair and its silvered wood.

Hastings is a once-prosperous town that has great terraces of colourful houses but, because it had an unfashionable era, it then became affordable for a great tribe of artists, musicians and bohemians who have given it a rich culture of festivals, live music and art shows plus many delectable cafés and restaurants. But special for me are the plethora of antique and second-hand shops that supplied Brandon and me with a great selection of colourful furnishings for the house we bought there many years ago. Pebbled houses, mosaics and creative paintwork catch

your eye all over this lively town, while the sea, even on a cold day, can be invigorating.

As a native of the New World, I'm endlessly fascinated by the old parts of British towns and cities. Hastings has a wonderfully quirky, atmospheric old town that I never tire of exploring. The fishing boats, pulled up onto the beach, and the huge black timber towers that were used to dry fishing nets give it a very particular flavour and provide a theatrical setting for some of our quilts.

A wonderful time can always be had sitting in one of Hastings' many cafés, watching the tattooed and colourful characters that make it

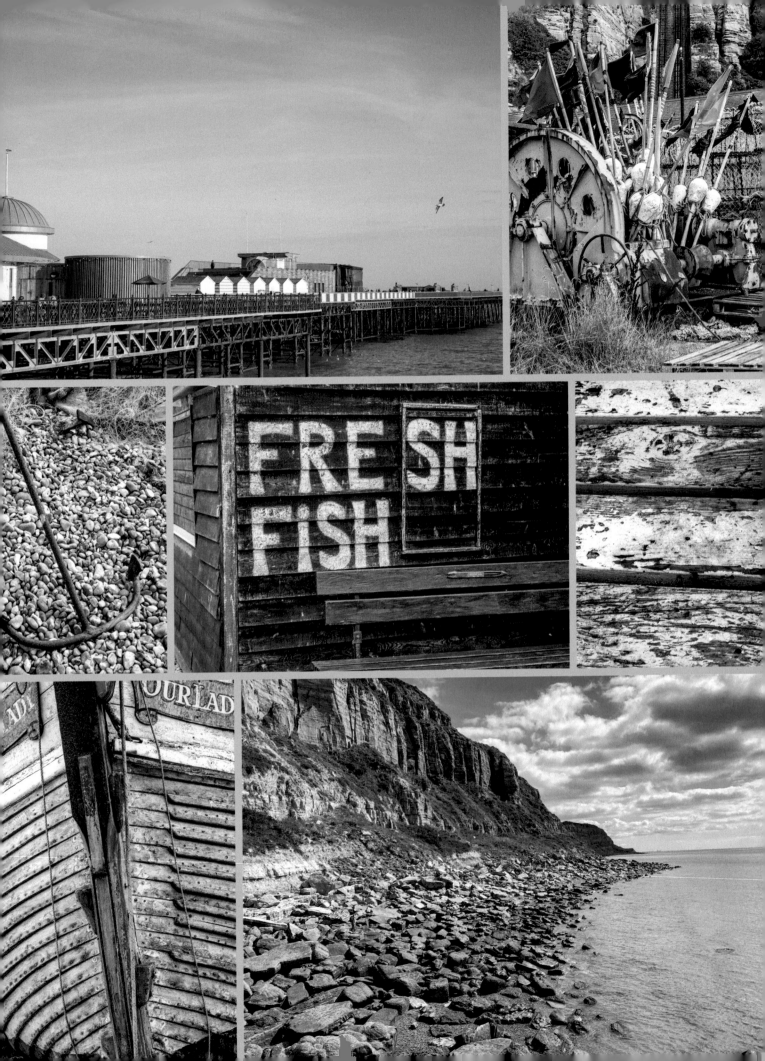

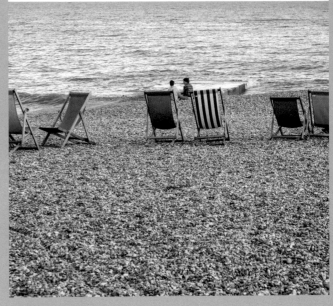
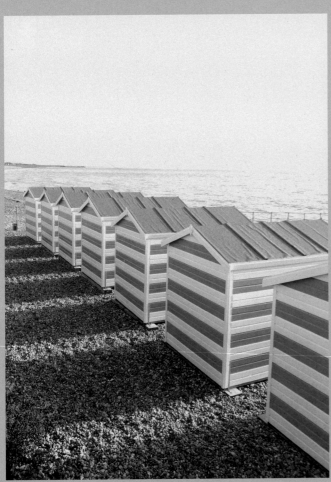
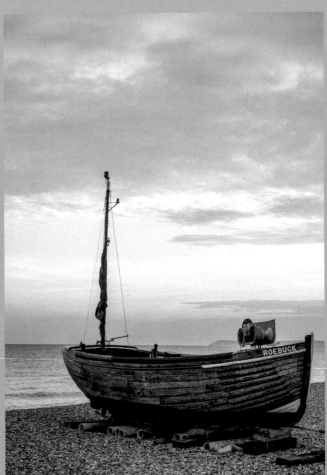

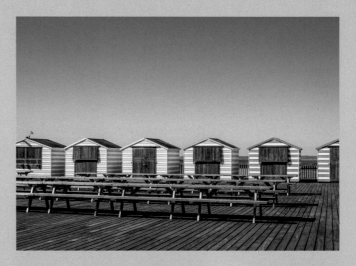

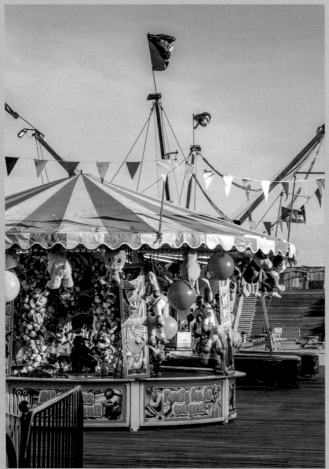

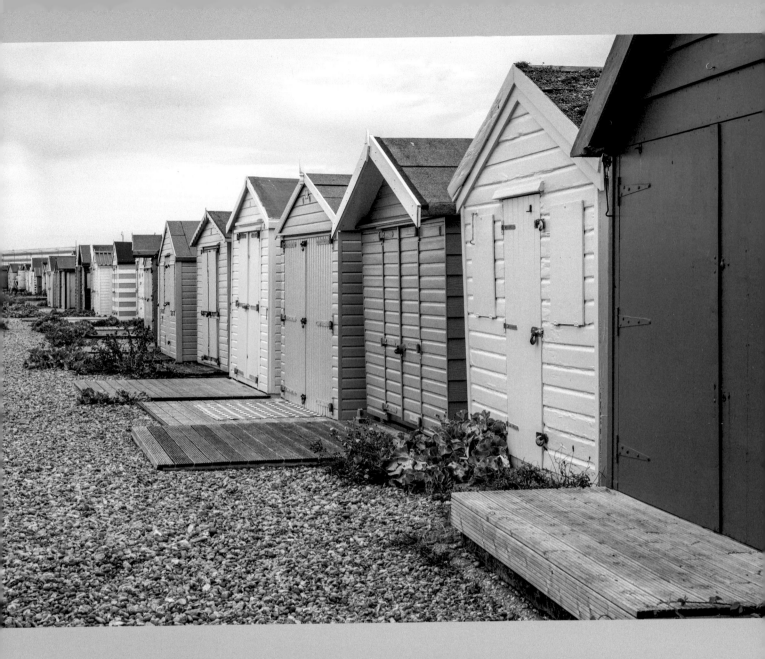

such a lively place to live. The particular light that seems unique to this seaside town always lifts my spirits as I stroll through the old town or along the shore or take a dip in the sea. Many of our quilts reflect the dark, rich colours of Hastings but we had just as much fun with the high pastel tones of the lighter seaside palette. I hope you, too, find just the right mood for your own personal setting or take our layouts to create your own colour combinations.

This is our 25th book in this series, so to celebrate that we have taken a quilt design from each book (apart from *Kaffe Quilts Again*, itself a collection of re-imagined quilts) and

revived or re-invented it with up-to-date fabrics. I've always been fascinated how colour can transform a print or quilt layout so it becomes quite unrecognizable. Sometimes we chose favourites from a particular book, but at other times it was exciting to rejig a quilt that hadn't been such a success to see if different colours and fabrics would breathe new life into the design. On a few occasions, we chose a single block from a quilt to make a special cushion.

This book has been a joy to create for and I was delighted to shoot it in the wonderfully British seaside town of Hastings, where I am so happy to be a resident.

Dusky Ribbons
by Kaffe Fassett

Liza spotted a drawing of this concept in one of my sketch books and set to work to bring it to life for the original quilt in *Quilts in the Cotswolds,* the 21st book in the series. I chose to create this version in stronger contrasts, which are definitely enhanced by these gorgeously coloured huts.

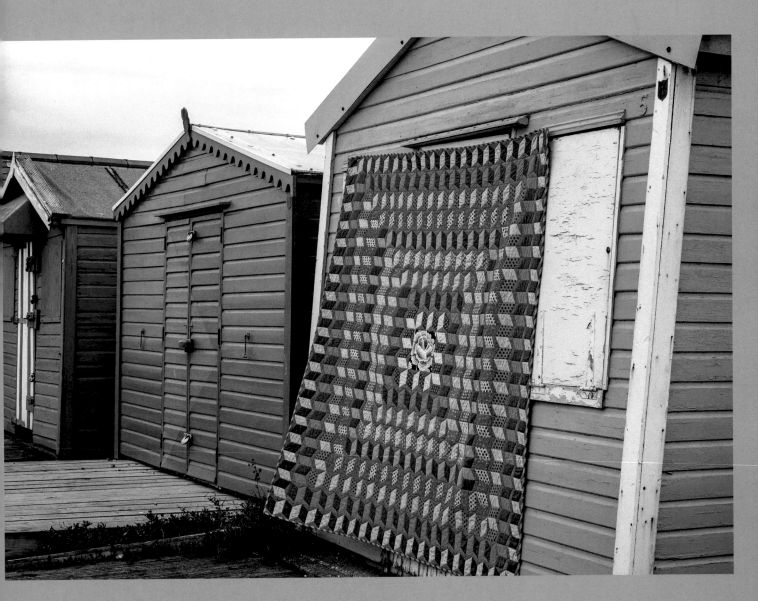

Water Garden
by Kaffe Fassett

The great black towers used for drying fishing nets and this black boat provided the perfect setting for this dark version of *Spring Garden*, originally designed by Liza for our 3rd *Patchwork and Quilting* book in the original Rowan series. I had fun changing her spring colours to this deep cobalt and purple mood – in stark contrast to the original version.

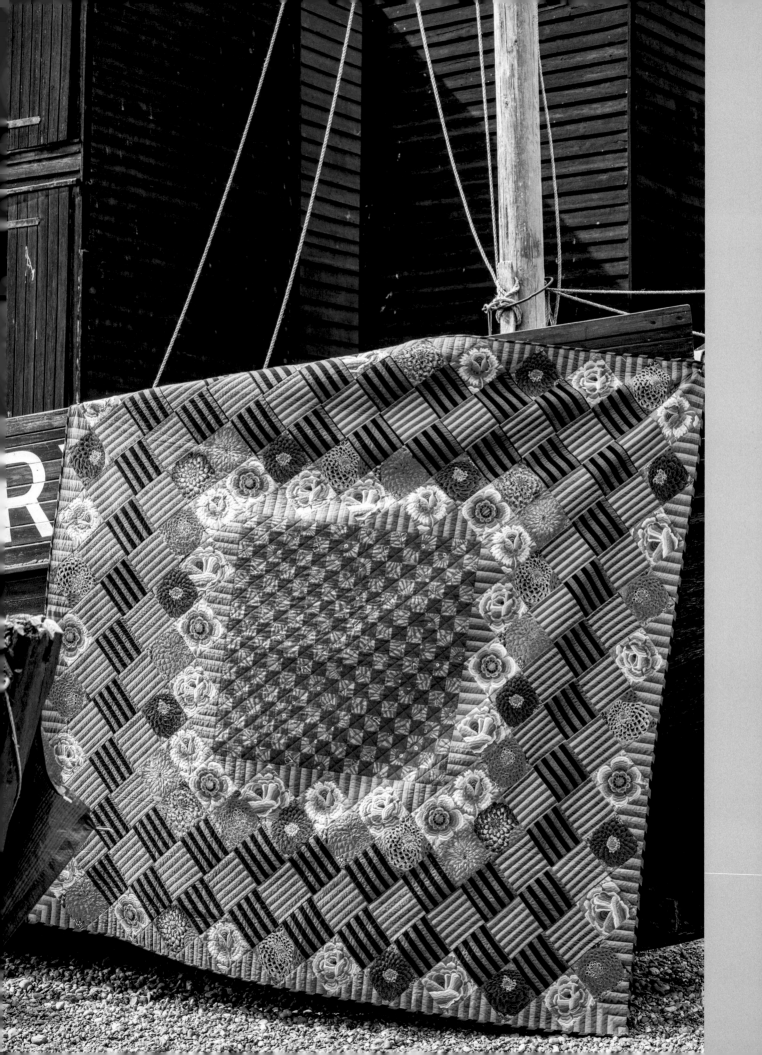

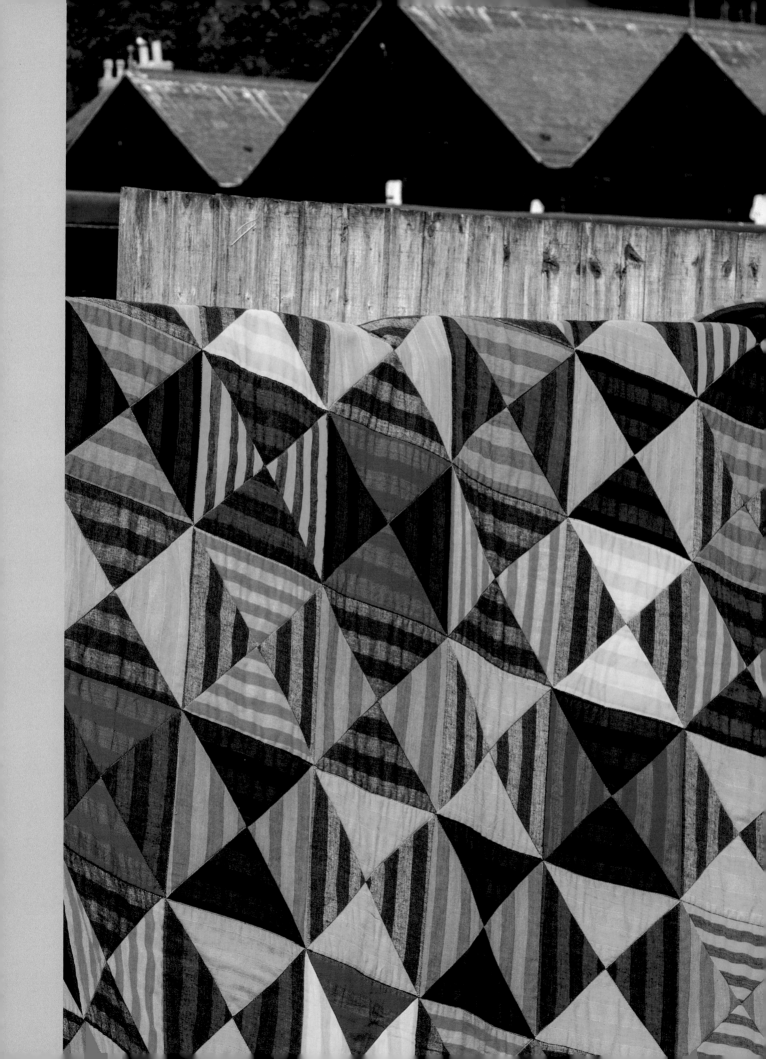

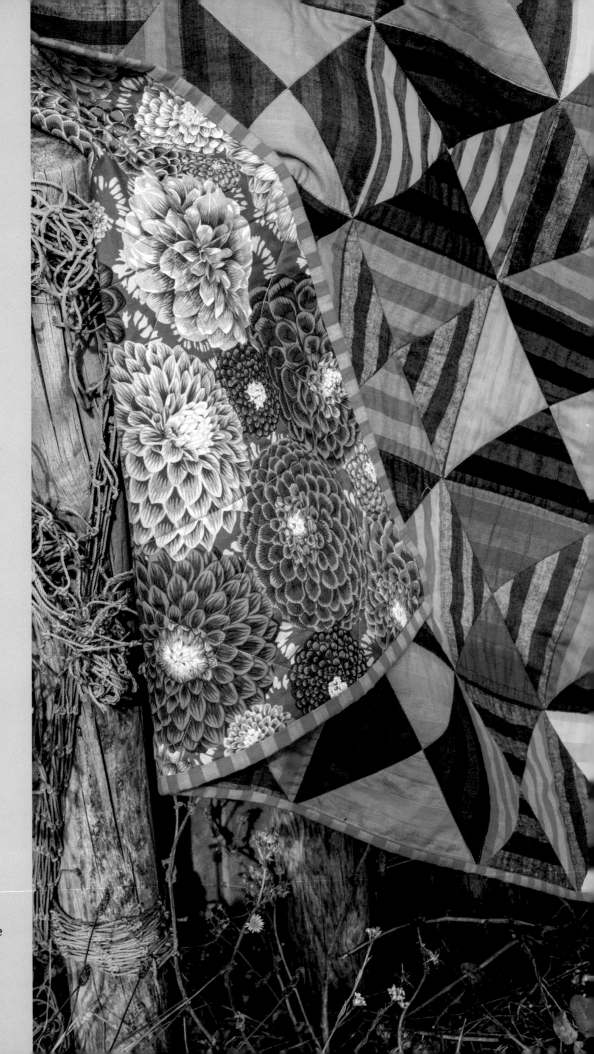

Hourglass Stripes
by Kaffe Fassett

I used all my hand-woven stripes to create this hourglass quilt, which was based on the *Striped Triangle* quilt in my 1st *Patchwork and Quilting* book in the series. I like the way this weathered fence on the beach makes the dusky palette come alive.

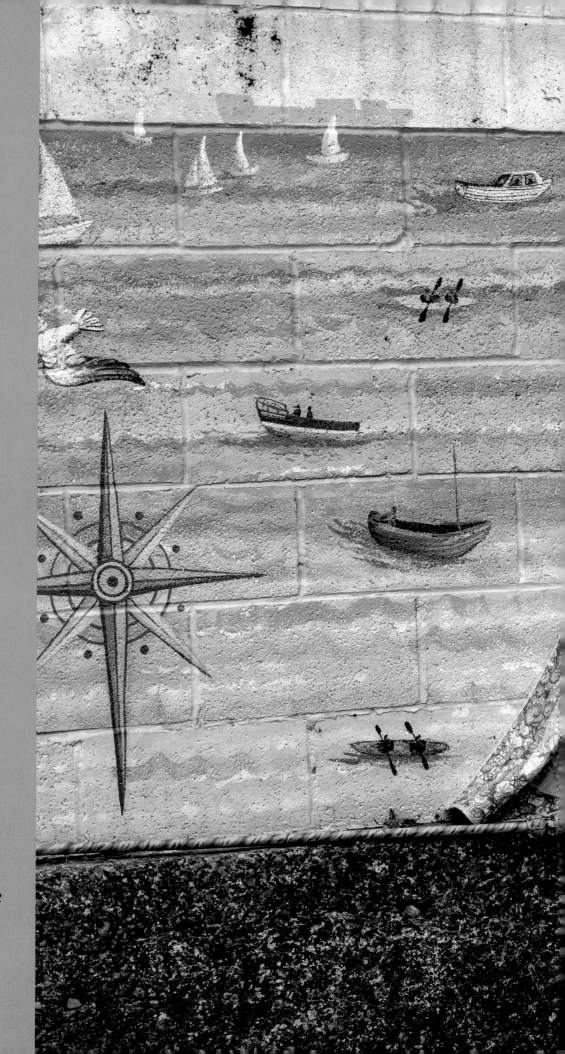

Lorna Doone
by Liza Prior Lucy

Liza made this faithful
rendition of Corienne
Kramer's design from *Quilt
Grandeur* (the 15th book
in the series). The delicate
pastel duck-egg and pink
tones look so alive on this
quiet little seaside mural.

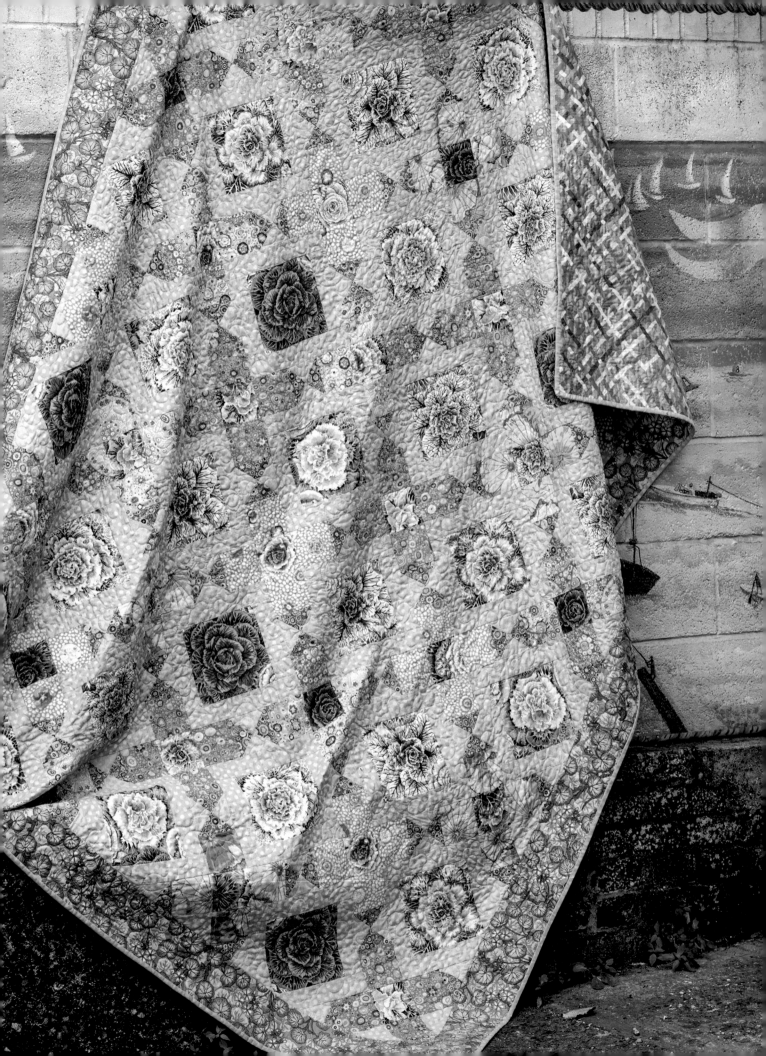

Blooming Snowballs
by Kaffe Fassett

This pastel and high-contrast quilt, based on a design first seen in *Quilts in Ireland* (the 19th book in the series), found the perfect setting on this old fishing boat, laid to rest on Hastings beach. The flaky off-white surface is just the sort of wind-, rain- and salt-eroded background that brings our delicate pastels and shady tones to life.

Cabanas
by Liza Prior Lucy

Liza recreated this jazzier version of her *Cassetta* quilt from *Quilts in Italy*, the 19th book in the series. The bold stripes and high colours give it a fresh new look, which is brought to life on this seaside café booth.

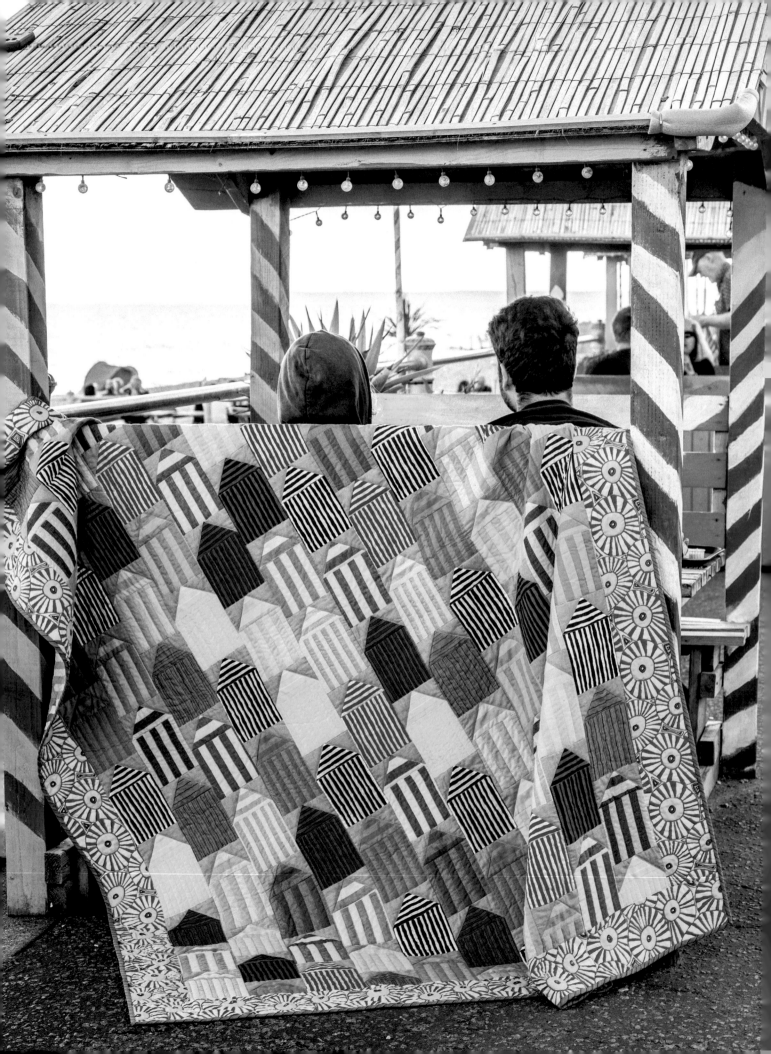

Pastel Fiesta
by Kaffe Fassett

The first version of *Fiesta*, which appeared in *A Colourful Journey* (the 5th book in the series), was in spicy hot shades. For this book, thinking of the glorious light colours of seaside towns, I used all our soft pastels instead, photographed here against the ice-cream colours of the beach huts.

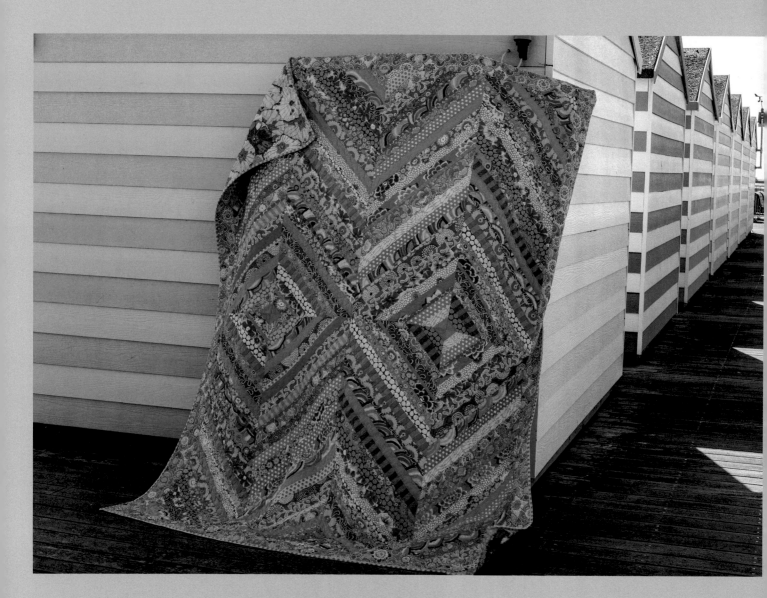

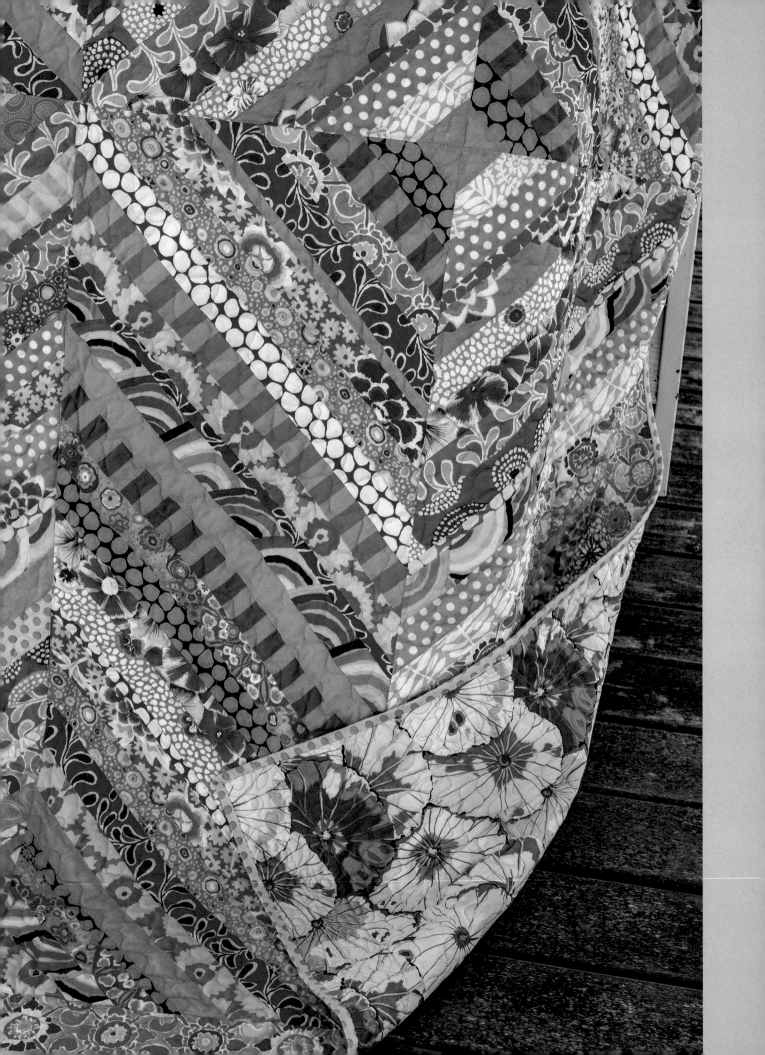

Vintage Stars
by Kaffe Fassett

Liza used this double-star block for her New Orleans Star Quilt in *Kaleidoscope of Quilts* (the 8th book in the series). Here, I've gathered all the dusty, earthy-coloured prints together to create this version that looks so much at home on an old brick wall in Hastings.

While our Kaffe Fassett Collective fabrics are best known for a brilliantly coloured palette, we do try to supply a comprehensive paintbox in many different colour moods for our quilting fans.

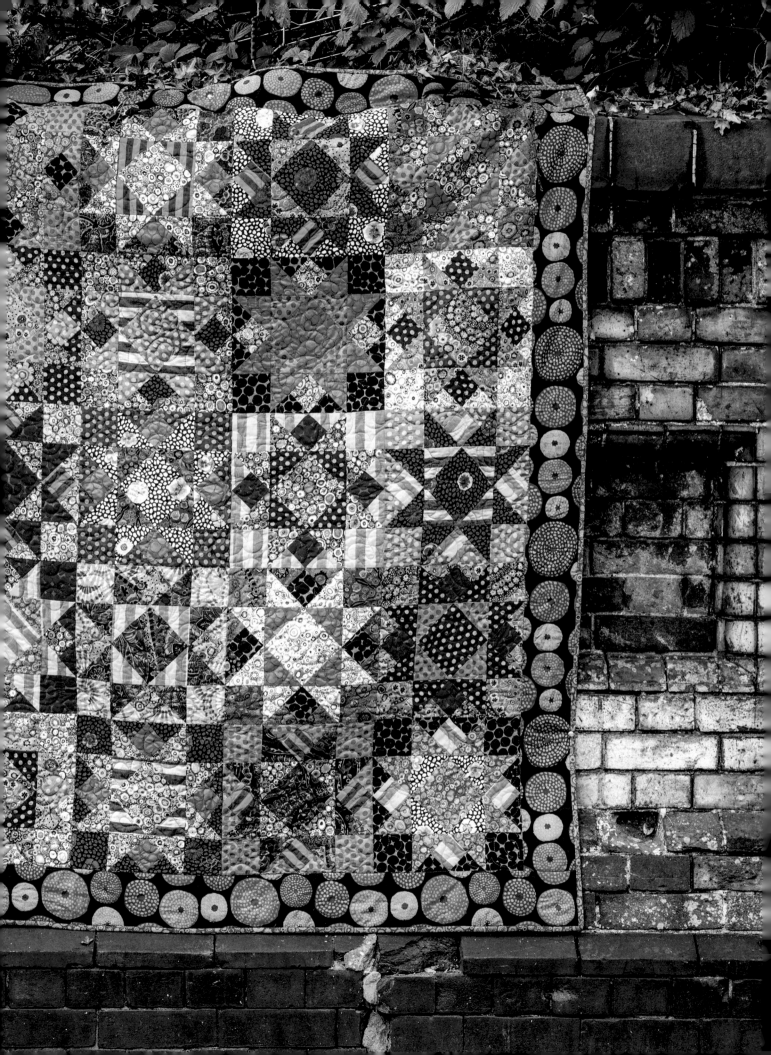

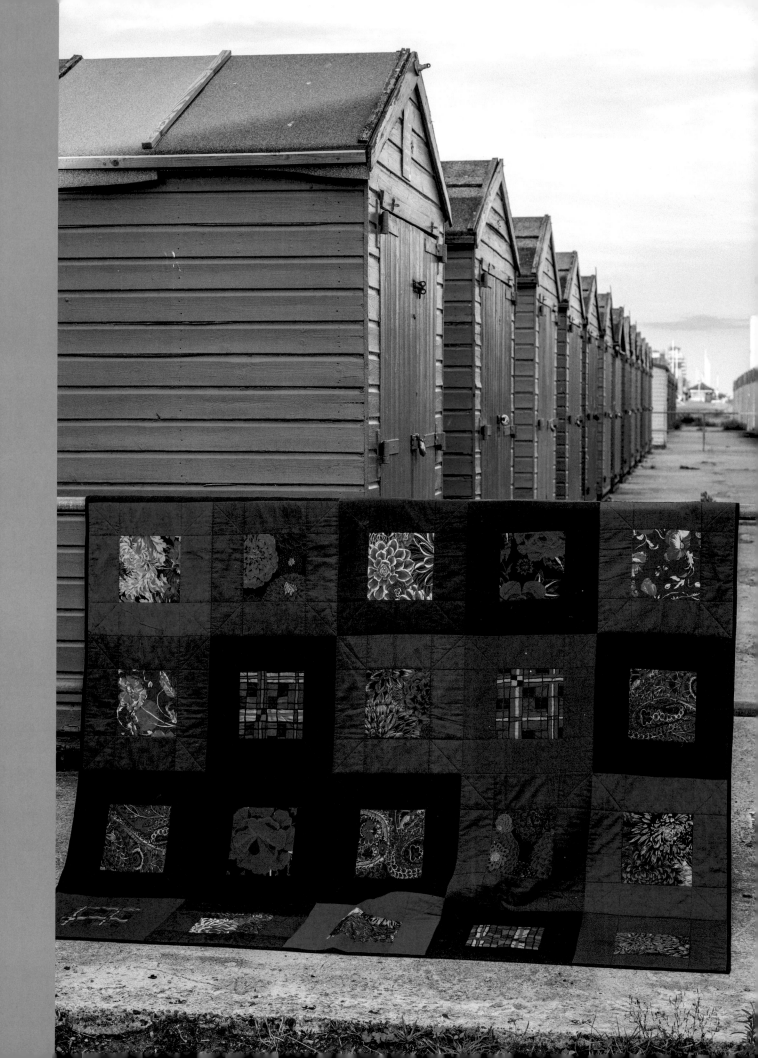

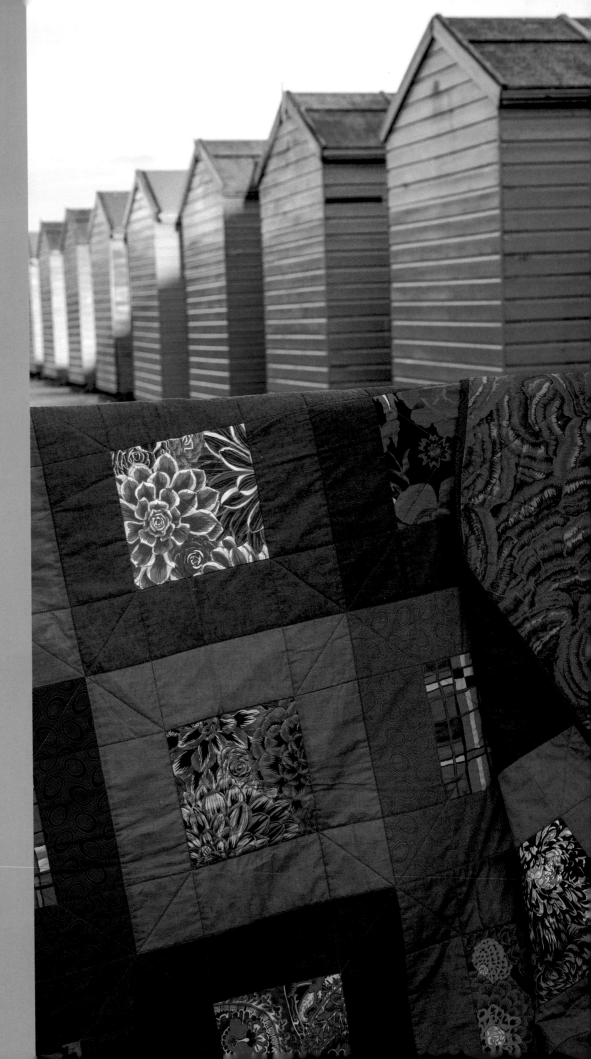

Maroon Frames
by Kaffe Fassett

These coloured beach huts make our *Maroon Frames* quilt really glow. The simple layout with bold 'mats' around our large-scale prints packs quite a punch. In *Quilts in the Sun*, (the 9th book in the series) the same bold layout was used to create two very different effects.

Autumn Postcard
by Liza Prior Lucy

This quilt was specially selected for those quilters who love a detailed challenge! Liza excelled herself on this golden autumn-toned version of a vintage quilt in the Victoria and Albert Museum archive, which she first recreated in *Quilt Road,* the 7th book in our series. Its warm tones glow on this ochre-coloured tractor on the beach.

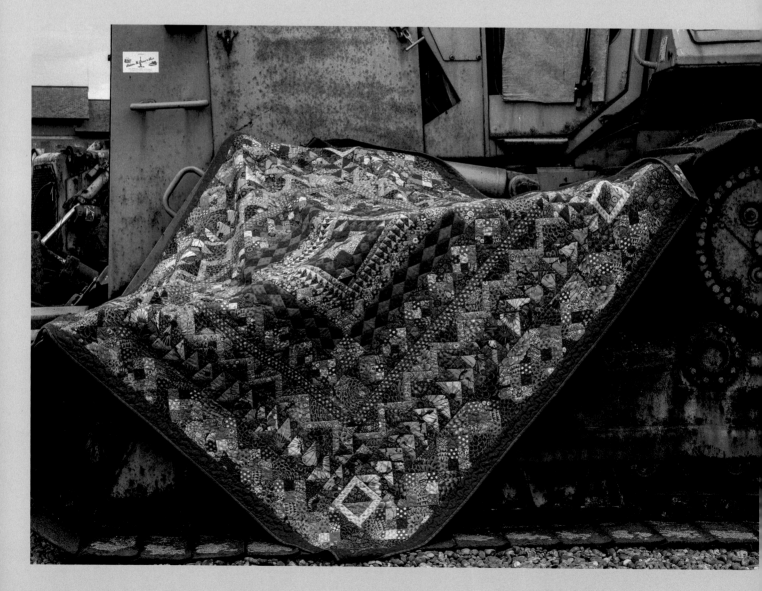

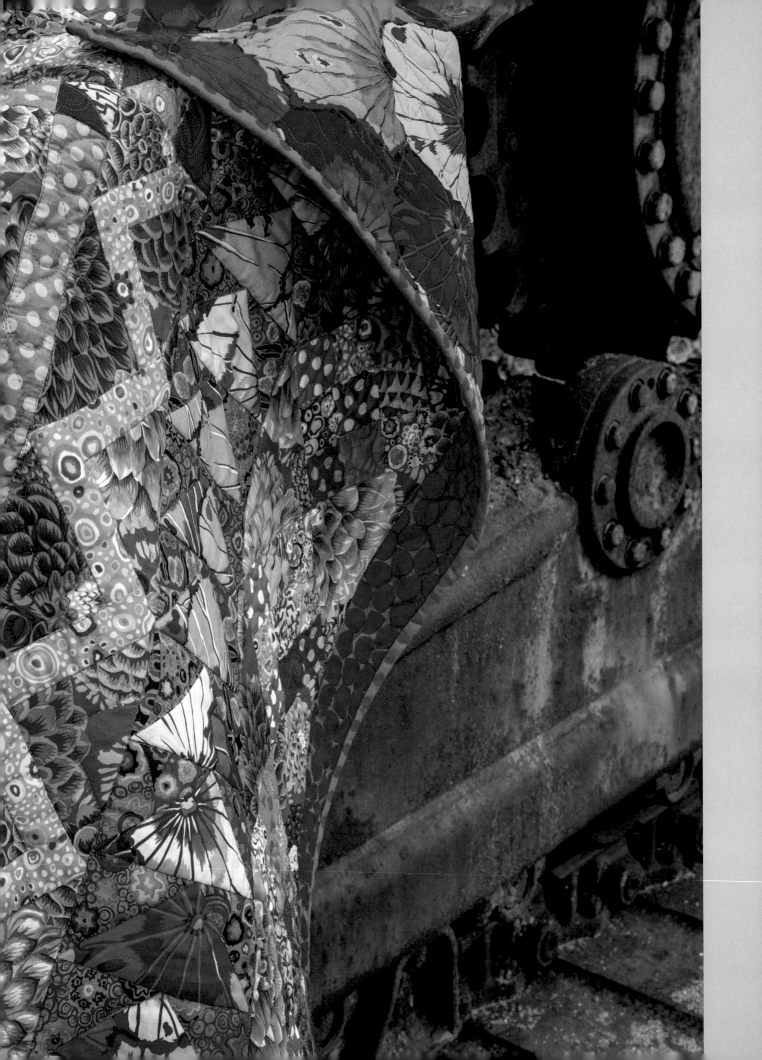

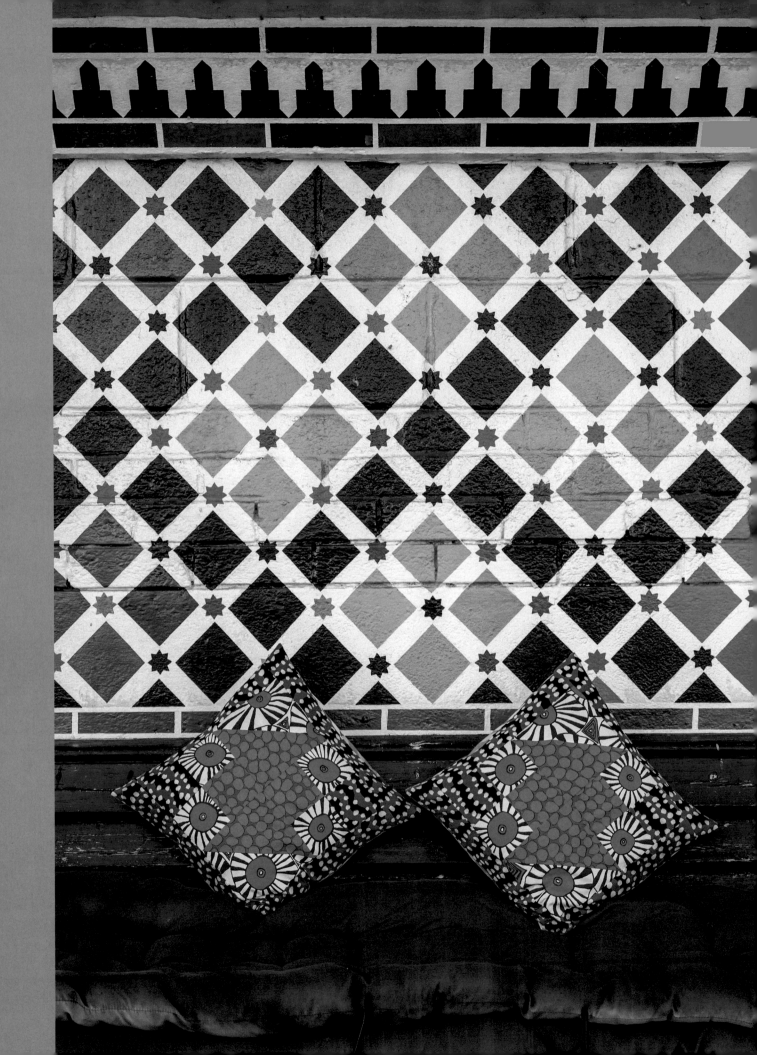

Jiggery Pokery Cushion
by Kaffe Fassett

Jiggery Pokery featured as a quilt in *Quilt Romance,* our 11th book in the series. I thought the block would make an eye-catching cushion. Here, it contrasts nicely with the Islamic tile painting behind a seaside bench and it makes good use of some of Brandon's lively prints.

Fruit Sorbet Cushion
by Kaffe Fassett

Based on the *Fruits of the Forest* quilt in *Quilts in Burano*, our 22nd book in the series, this cushion design was inspired by the seaside pastels, to which our pinwheel cushion with its optimistic colour palette is well suited.

Marble Tile Cushion
by Kaffe Fassett

I have taken the design for this cushion from my *Marble Tiles* quilt in *Quilts in Wales*, the most recent book in the series. I used one of my favourite Woven Stripes in dark grey and mauve, as the three layers of the striped fabric were an exciting contrast to the centre. A whole quilt could be made using the more contrasting colourways of our Woven Stripes on all the blocks, to great effect.

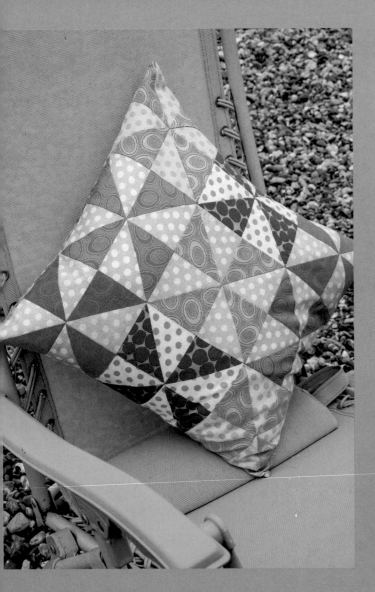

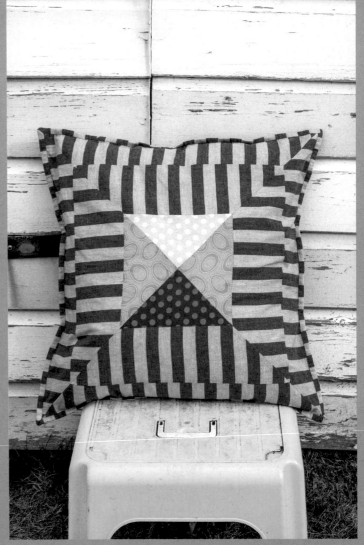

Little Jars
by Kaffe Fassett

The original of this quilt
in my 4th book in the
series didn't attract much
attention. But I was fond
of it nevertheless, partly
because I love (and also
have) a good collection of
Oriental vases. Our brighter
prints come into their own
in this new version, with
the striped tops to each
block creating a good
graphic repetition. The
beach huts behind were
helpfully painted in just the
right high pastels to make
our quilt sing.

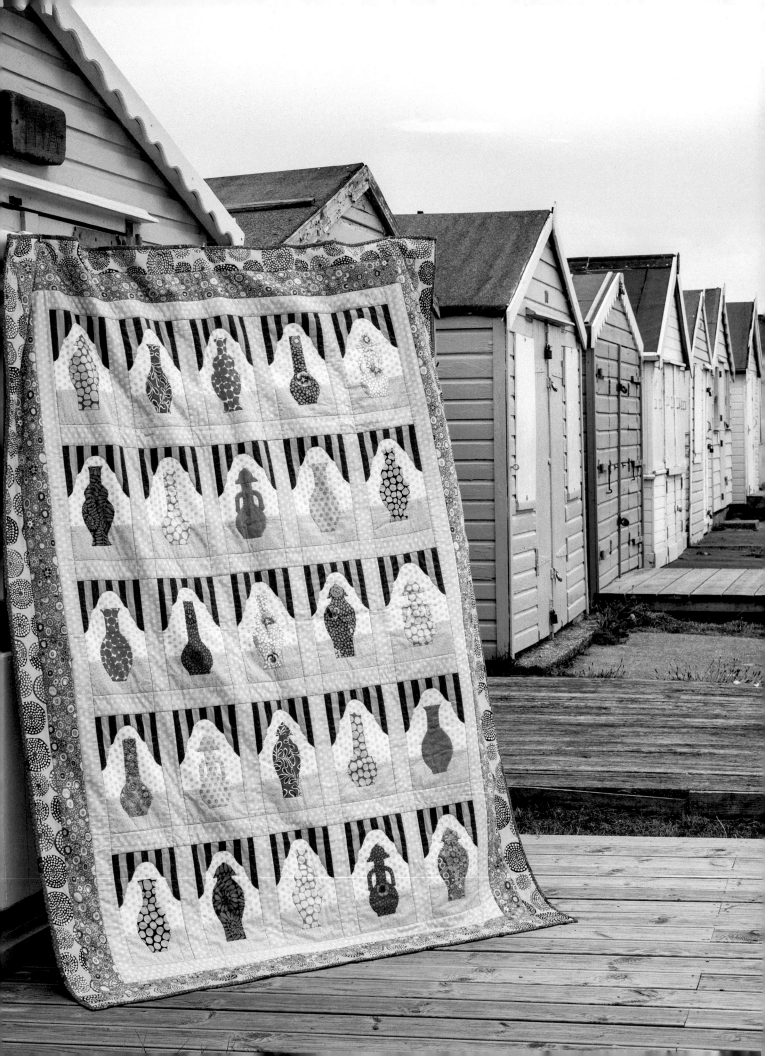

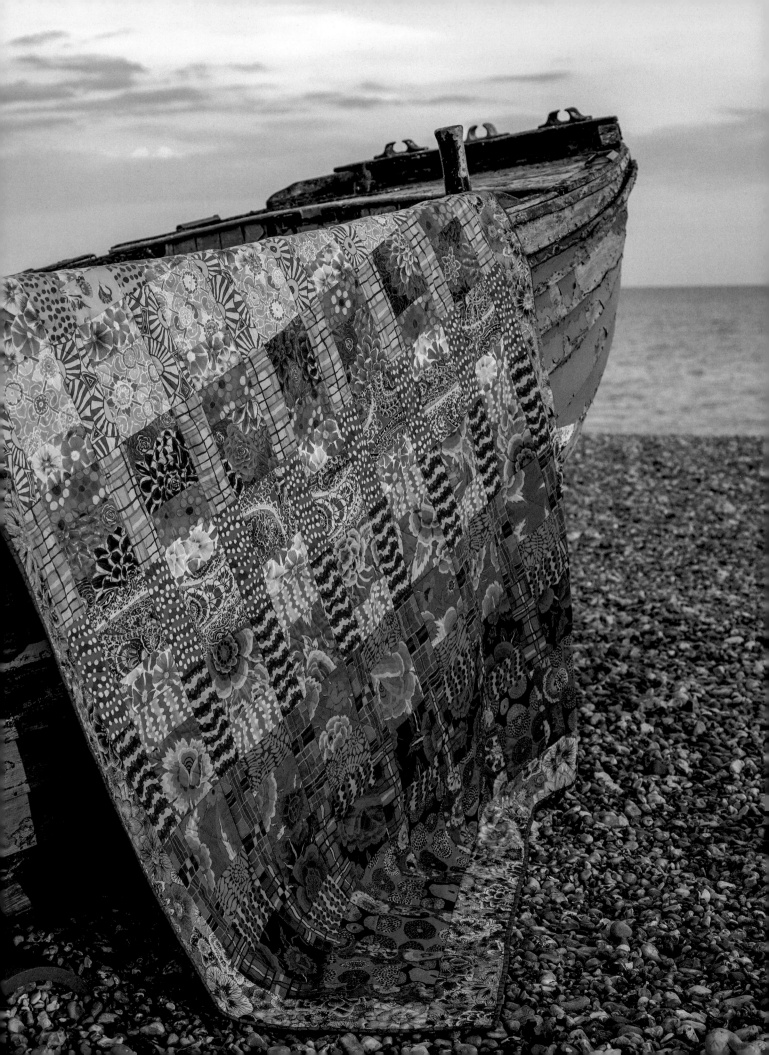

Colour Garden
by Kaffe Fassett

The first version of this quilt was designed by Roberta Horton for *Country Garden Quilts,* the 10th book in our series. It was immensely popular so I have created my own version here. We were lucky to find this beautiful peeling pink boat to show off the new colours.

Flower Boxes
by Kaffe Fassett

This is the type of layout that showcases our large-scale prints so elegantly. It featured originally as Yellow Panels in *Quilts en Provence* (the 12th book in the series). For my new version, I chose mostly deep colours for the florals, set against black backgrounds, to give the whole quilt a stained-glass effect. The dark sashing holds it all together with a sharp style. The blue house and buoy-covered shed make a great setting for the quilt.

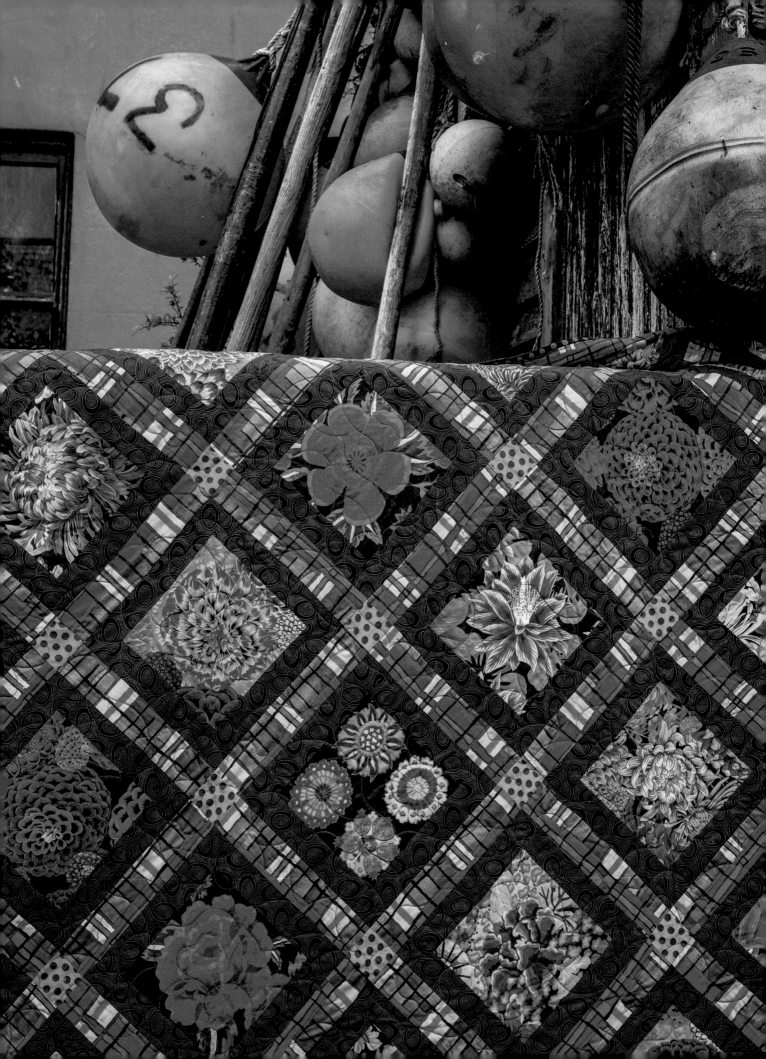

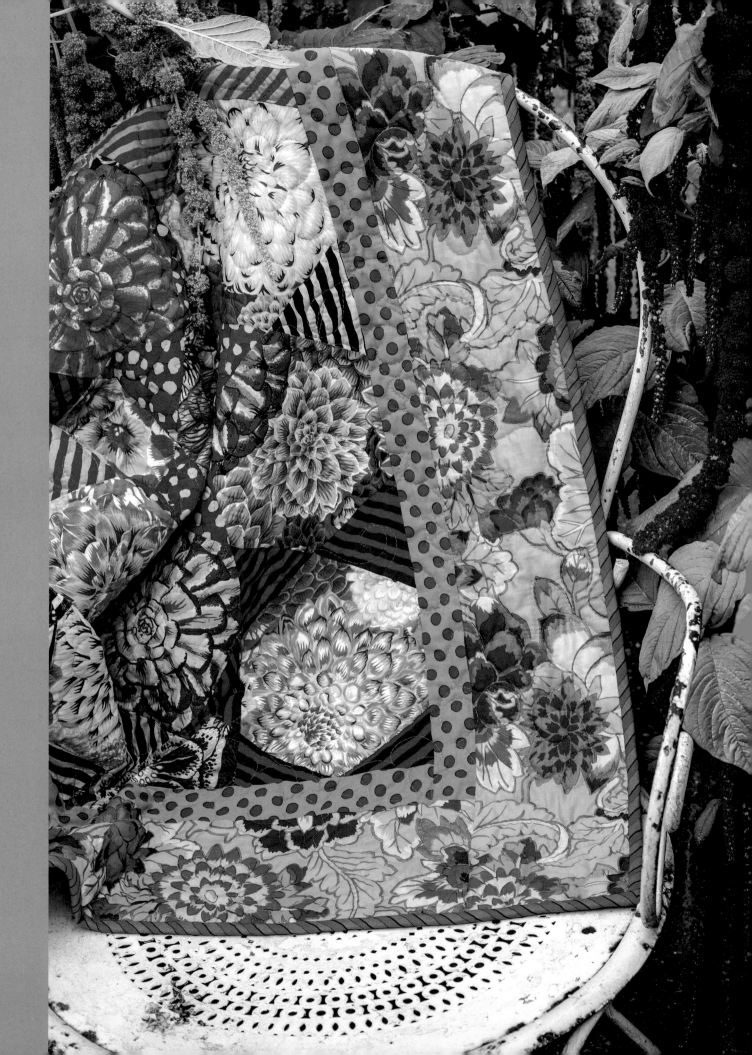

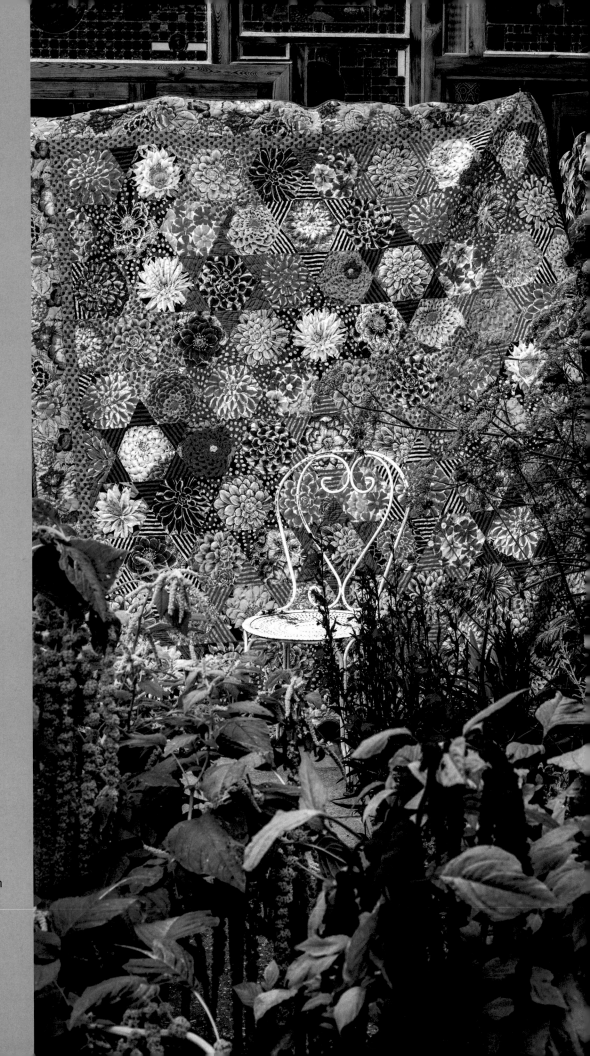

Succulent Hexagons
by Kaffe Fassett

Judy Baldwin designed and
made the original quilt,
Mediterranean Hexagons,
for *Quilts in Morocco* (the
16th book in the series).
As much as I like my new
version, I'd advise anyone
trying to recreate it to
keep all the prints to one
comprehensive theme.
I started with Brandon's
Comb Stripes but then
added a few other prints on
the points. With hindsight,
I should have kept them
all in Comb Stripes (in
differing colourways) as
this would have added
clarity to the layout.

Shady Parterre
by Kaffe Fassett

I've always admired the great Victorian industrial structures in Britain – the underpinnings of Hastings Pier are such a great example. The light at the end of a summer day was glowing on the water and our new version of the *Ancient Glade* quilt from *Quilts in an English Village* (the 23rd book in the series) echoes exactly the rusty tones of the iron pilings.

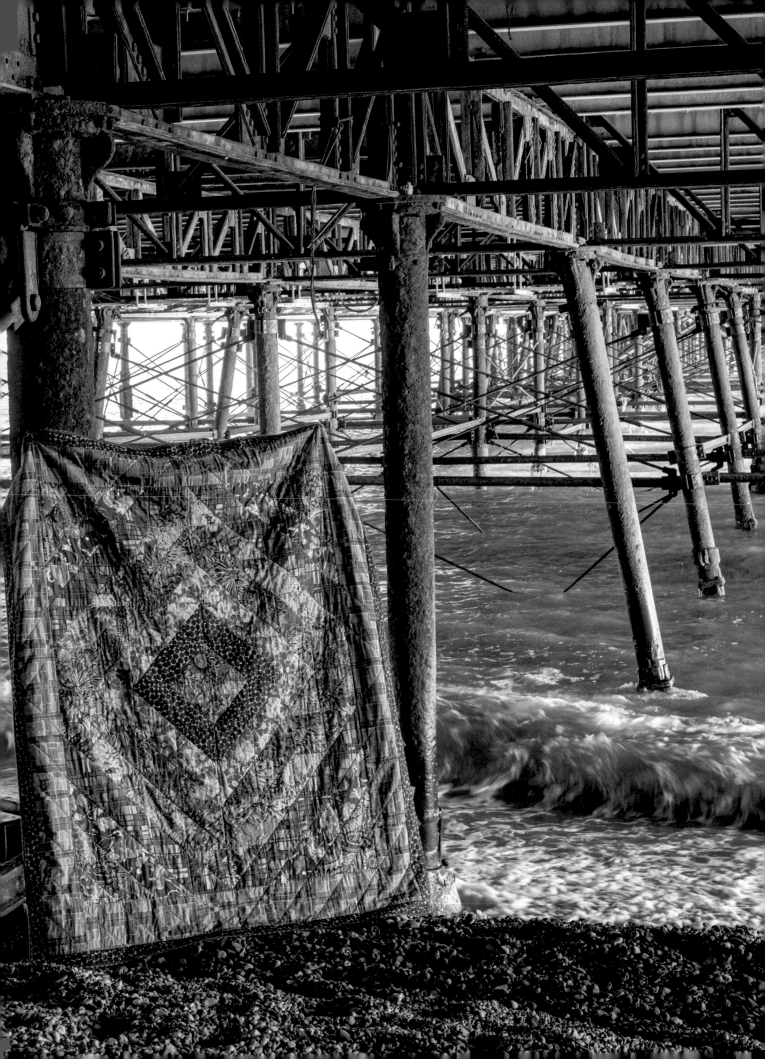

Spot Swatches
by Kaffe Fassett

For this sunny version of the *Swatches* quilt from my 2nd *Patchwork and Quilting* book in the series, I did all the sashing in Brandon's yellow Jumble fabric and picked all the spotty prints in high pastels that just shine out of the yellow base. Weren't we lucky to find this rusty yellow boat to display it on?

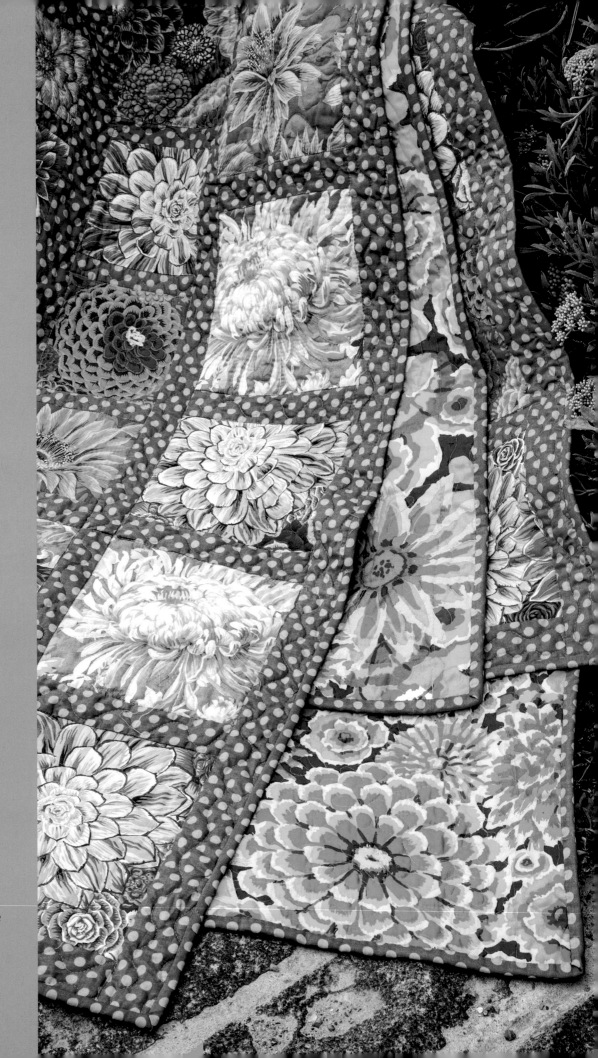

Green Squares
by Kaffe Fassett

The original design for
Red Squares featured in
Heritage Quilts (the 17th
book in the series). Much
as I loved the first one,
this lush green version
is now my favourite and
looks so at home near the
rocky coast at Rock-a-Nore
beach. I particularly like
the blue border around
the central square and the
green spot sashing.

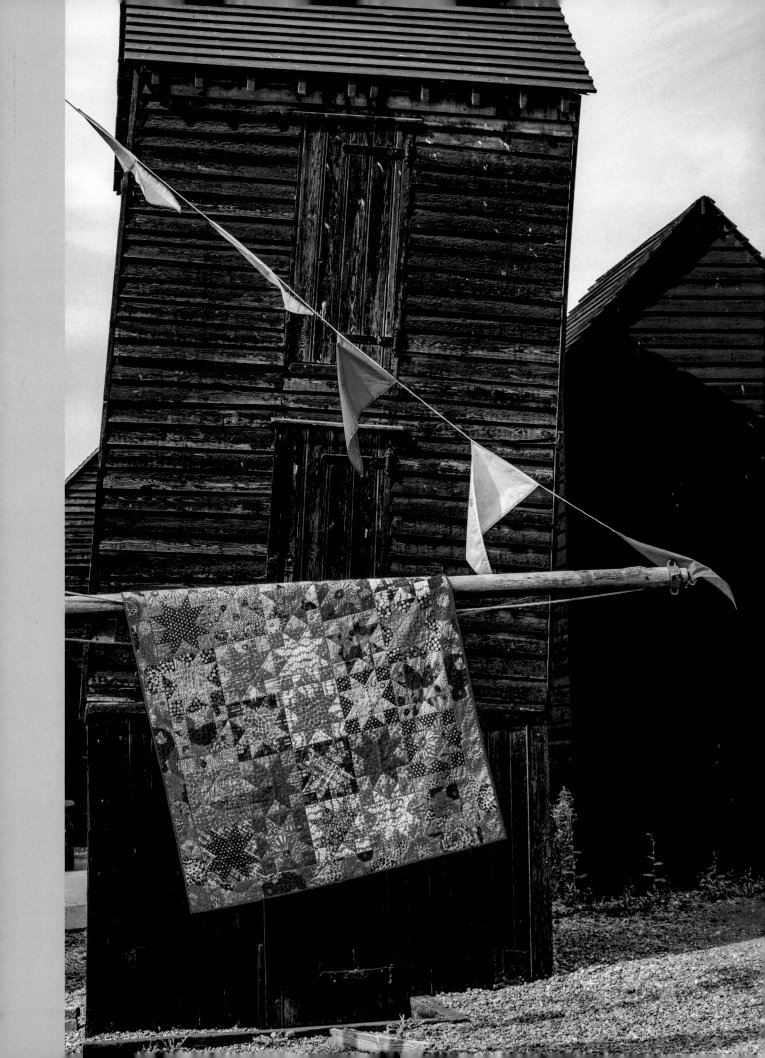

Cool Stars
by Kaffe Fassett

The chance to gather all
our deepest cool colours
for this new take on
my *Blue Star* quilt from
Caravan of Quilts (the
6th book in the series)
made it a joy to make. It
is seen here enhanced
by the black, fishing-net
drying towers on Hastings
beach. You could redo this
layout using either all the
warm-coloured prints in
our collection or in greys
and pastels, or perhaps
in fashionable black and
white/high contrast.

Shadow Boxes
by Kaffe Fassett

This layout first appeared
in *Quilts in Sweden* (the
13th book in the series), as
my *Dark Windows* quilt with
its bright autumnal tones.
Here I've chosen another
dark blue palette with
highlights of hot reds and
cool greens. The fishing
boat sets off the colours
wonderfully.

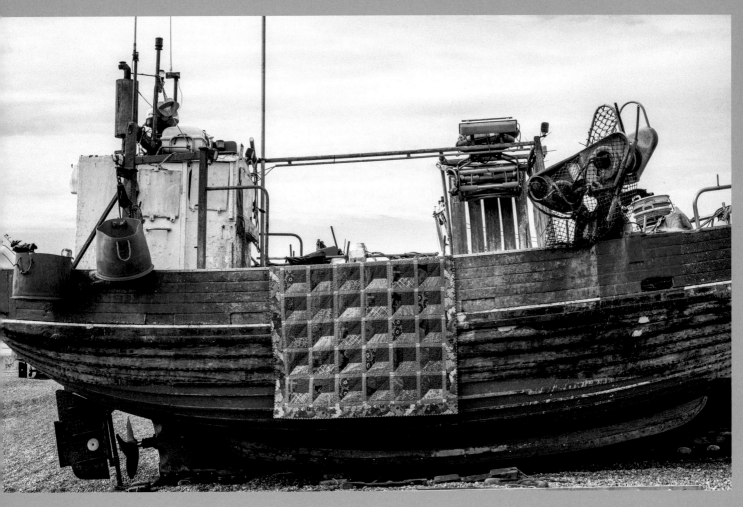

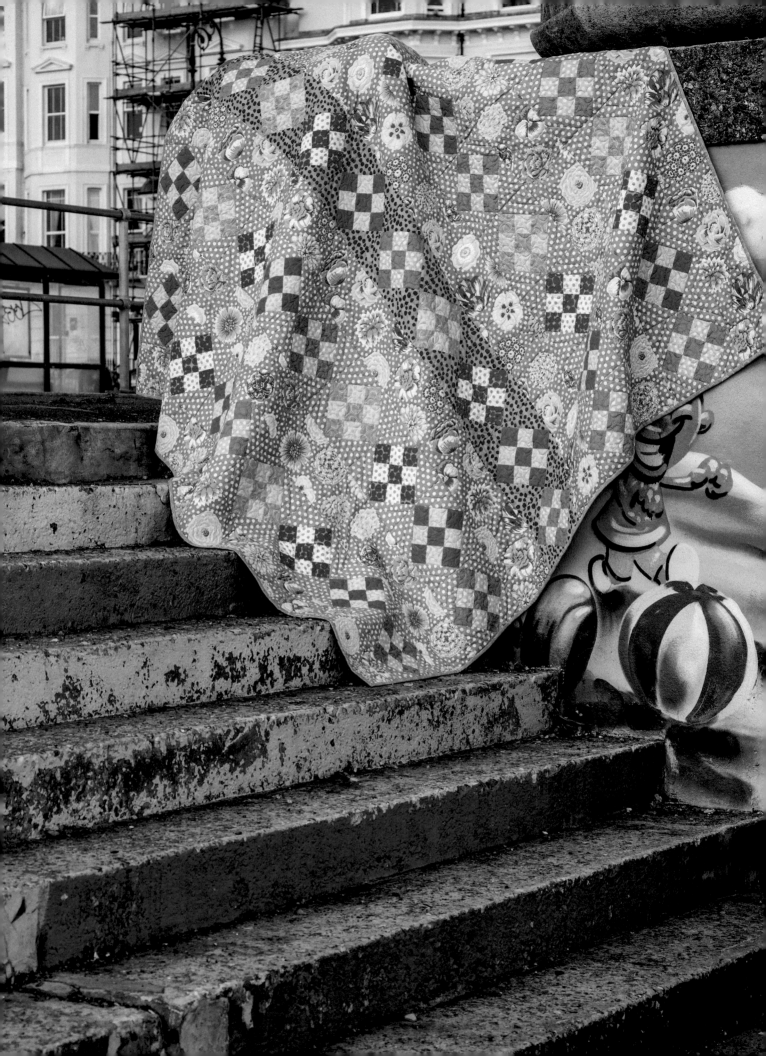

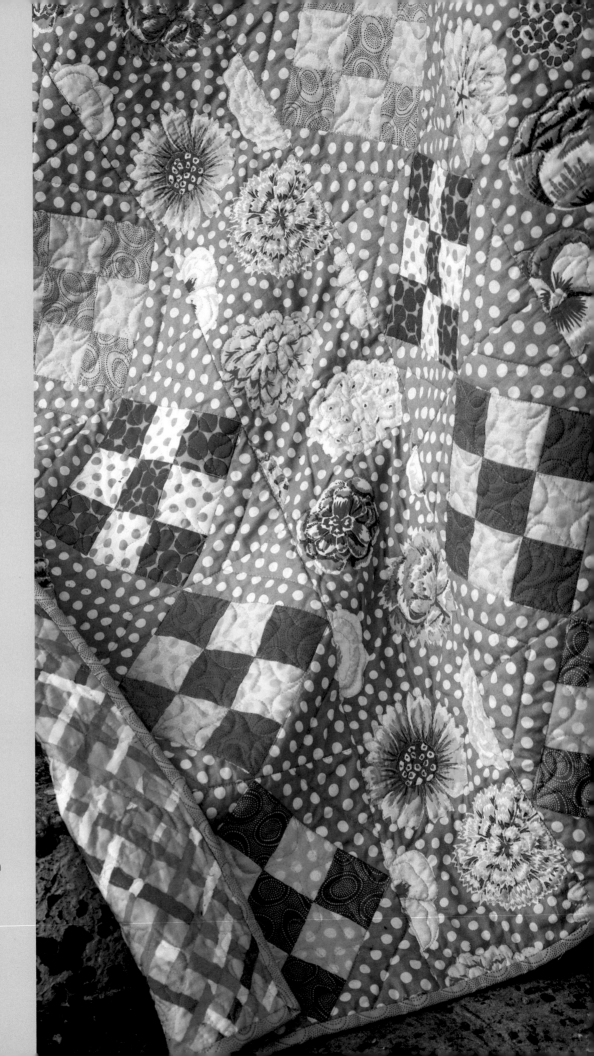

Love in the Mist
by Kaffe Fassett

I created this pastel
version of a quilt called
Contrast Columns from
Quilts in America (the 20th
book in the series), which,
as the name suggests
was in stronger contrast.
This little mural and the
painted stairs on Hastings
beach set the colours in a
lovely warm mood.

hourglass stripes *

Kaffe Fassett

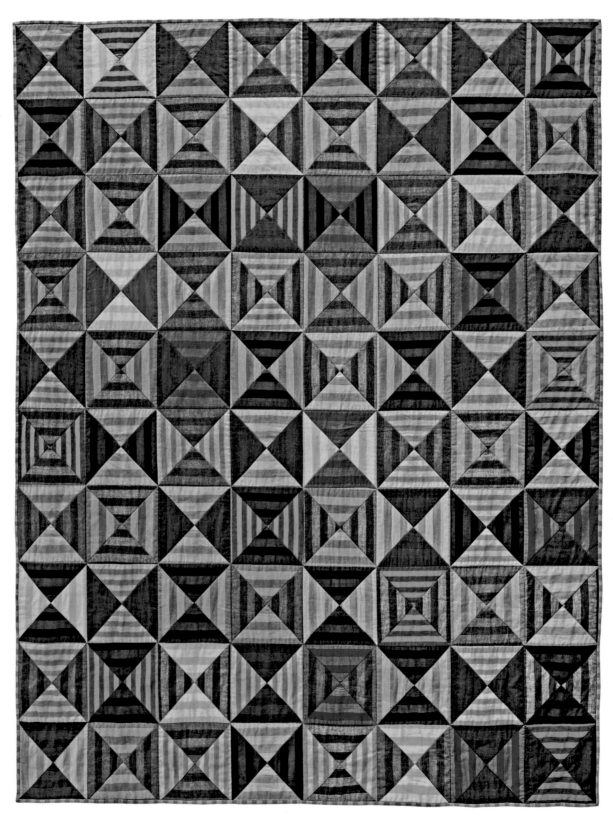

This simple quilt uses my latest range of wide and narrow stripes. Do not worry too much about making the stripes perfectly straight – they can wiggle a bit – and do not match up the stripes on each square – let them be relaxed!

SIZE OF FINISHED QUILT
75in x 60in (191cm x 152cm)

FABRICS
Fabrics have been calculated at a maximum width of 40in (102cm). Fabrics have been given a number – see Fabric Swatch Diagram for details.

Patchwork Fabrics
WIDE STRIPE
Fabric 1	Cranberry	¾yd (70cm)
Fabric 2	Moss	¾yd (70cm)
Fabric 3	Peat	¾yd (70cm)
Fabric 4	Russet	¾yd (70cm)
Fabric 5	Aloe	⅜yd (40cm)
Fabric 6	Burn	¾yd (70cm)
Fabric 7	Heather	¾yd (70cm
Fabric 8	Chestnut	⅜yd (40cm)

NARROW STRIPE
| Fabric 9 | Plaster | ¾yd (70cm) |

*see also Binding Fabric
| Fabric 10 | Mallard | ⅝yd (60cm) |

Backing and Binding Fabrics
FLORA
| Fabric 11 | Antique | 4¾yd (4.4m) |

NARROW STRIPE
| Fabric 9 | Plaster | ⅝yd (60cm) |

*see also Patchwork Fabrics

Batting
84in x 69in (213cm x 175cm)

PATCHES
Patches are right-angle triangles cut from strips that are cut along the stripes (see the Cutting Diagram on page 56). The patches are sewn into hourglass blocks and set in 10 rows of 8 blocks each.

FABRIC SWATCH DIAGRAM

Patchwork Fabrics

Fabric 1
WIDE STRIPE
Cranberry
SS01CY

Fabric 2
WIDE STRIPE
Moss
SS01MS

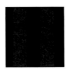
Fabric 3
WIDE STRIPE
Peat
SS01PZ

Fabric 4
WIDE STRIPE
Russet
SS01RT

Fabric 5
WIDE STRIPE
Aloe
SS01AO

Fabric 6
WIDE STRIPE
Burn
SS01BU

Fabric 7
WIDE STRIPE
Heather
SS01HE

Fabric 8
WIDE STRIPE
Chestnut
SS01CX

Fabric 9
NARROW STRIPE
Plaster
SS02PJ

Fabric 10
NARROW STRIPE
Mallard
SS02ML

Backing and Binding Fabrics

Fabric 11
FLORA
Antique
PJ114AN

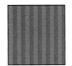
Fabric 9
NARROW STRIPE
Plaster
SS02PJ

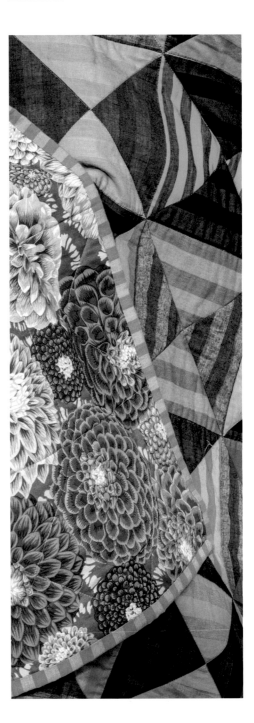

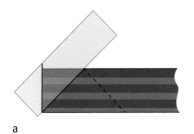
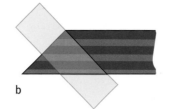

a b c

CUTTING OUT

Kaffe's Shot Stripes run down the length of the fabric. Strips are therefore cut down the length of the fabric so that right-angled triangles can be cut across the stripes. For best results, press using spray starch before cutting.

Note: if you are using a different fabric that has stripes running across the width, then cut strips across the width and adjust fabric quantities accordingly.

Hourglass Blocks

Cut strips 4⅜in (11.1cm) wide **along the length of the stripes,** ie down the length of the fabric. Referring to the Cutting Diagram, use the 45° line on your ruler to cut right-angled triangles along the strip. Cut the left side of the triangle (a), then rotate the ruler to cut the right hand side (b), and so on (c). Each ¾yd (70cm) strip will yield 5 triangles, each ⅜yd (40cm) strip will yield 2 triangles and each ⅝yd (60cm) strip will yield 3 triangles. Cut a total of 320 triangles from fabrics as follows:

Fabric 1 (8 strips) 38 triangles;
Fabric 2 (8 strips) 38 triangles;
Fabric 3 (8 strips) 40 triangles;
Fabric 4 (8 strips) 38 triangles;
Fabric 5 (8 strips) 16 triangles;
Fabric 6 (8 strips) 40 triangles;
Fabric 7 (8 strips) 40 triangles;
Fabric 8 (8 strips) 16 triangles;
Fabric 9 (8 strips) 36 triangles;
Fabric 10 (6 strips) 18 triangles.

Backing

From Fabric 11 cut 2 pieces 40in x 84in (102cm x 213cm).

Binding

From Fabric 9 cut 8 strips 2½in (6.4cm) wide. Remove selvedges and sew end to end with 45° seams (see page 157).

BLOCK ASSEMBLY DIAGRAM

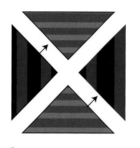

a b c

MAKING THE QUILT

Using a design wall will help to place patches in the required layout.
Use ¼in (6mm) seams throughout.

Making the Blocks

Take care when handling and sewing the triangles as the bias edge is liable to stretch. A spritz of spray starch can help with this.

Referring to the Block Assembly Diagram and the quilt photograph, make 80 hourglass blocks, using a pair of dark triangles and a pair of light triangles in each block to ensure a good contrast in tone. It isn't necessary to copy each combination exactly – you can make several different combinations for an interesting mix. Referring to the Block Assembly Diagram, sew the triangles together, dark triangles to light (a), pressing seams towards the darker triangles; then sew the two pairs of triangles together (b). Lightly press seams to one side of the finished block (c).

Assembling the Quilt

Referring to the Quilt Assembly Diagram and the quilt photograph, lay out the blocks in 10 rows of 8, alternating the blocks that have dark triangles on the top and bottom with those that have

dark triangles on the sides. Placement does not need to be identical to the photograph. Make sure you stand back and, using either an optical reducing glass or a photo on your mobile phone, check that there are no areas where similar colours and shapes form 'clumps': the aim is to keep all the blocks well differentiated from each other.

When you are happy with your layout, sew the blocks together one row at a time, pressing seams in opposite directions on alternate rows – odd rows to the left, even rows to the right – to allow the finished seams to lie flat. Sew the rows together, taking care to align crossing seams.

FINISHING THE QUILT

Remove selvedges and sew the two Fabric 11 backing pieces together; trim to form a piece 84in x 69in (213cm x 175cm).

Press the quilt top. Layer the quilt top, batting and backing, and baste together (see page 156).
Quilt as desired.
Trim the quilt edges and attach the binding (see page 157).

QUILT ASSEMBLY DIAGRAM

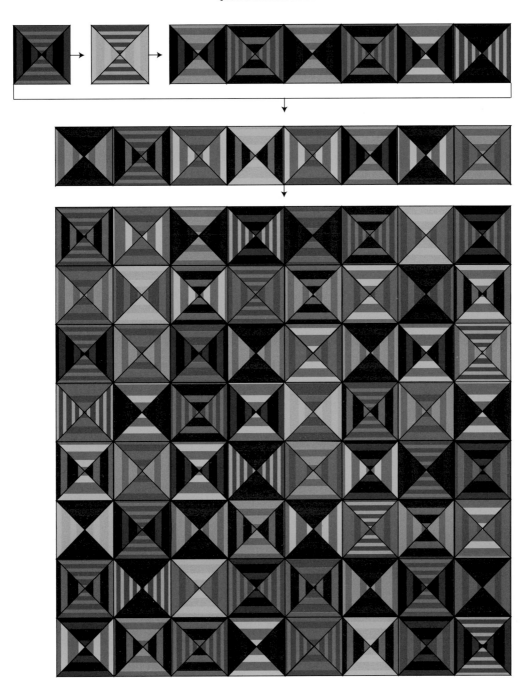

Fabric 1 Fabric 3 Fabric 5 Fabric 7 Fabric 9

Fabric 2 Fabric 4 Fabric 6 Fabric 8 Fabric 10

cool stars **

Kaffe Fassett

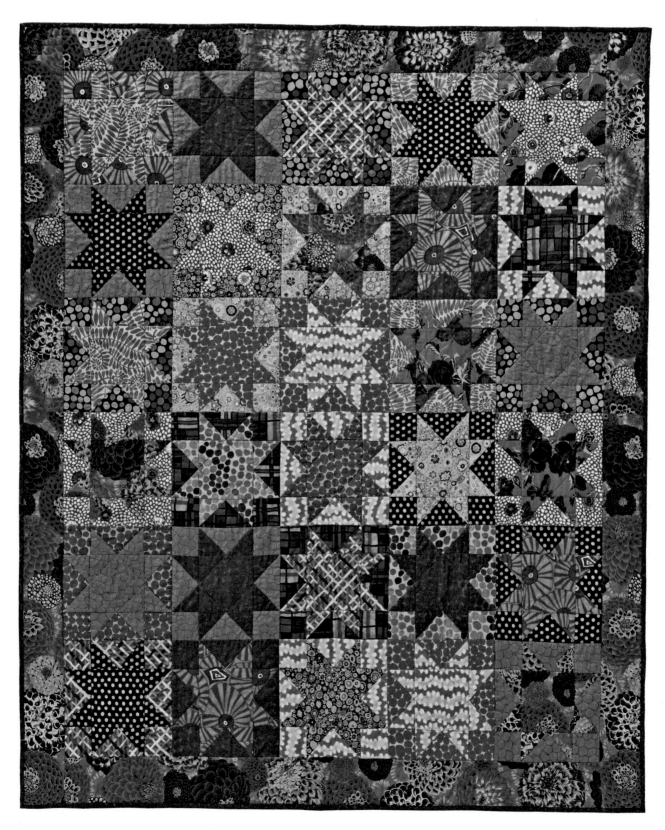

This new take on my *Blue Star* quilt shows off some of the more recent blues in the Kaffe Fassett Collective.

SIZE OF FINISHED QUILT
74in x 63in (188cm x 160cm)

FABRICS
Fabrics have been calculated at a maximum width of 40in (102cm). Fabrics have been given a number – see Fabric Swatch Diagram for details.

Patchwork Fabrics
FLORA		
Fabric 1	Blue	1¼yd (1.2m)
MAD PLAID		
Fabric 2	Cobalt	⅜yd (40cm)
JUMBLE		
Fabric 3	Aqua	⅜yd (40cm)
Fabric 4	Royal	⅜yd (40cm)
Fabric 5	Ocean	½yd (50cm)
Fabric 6	Teal	⅜yd (40cm)
FLOWER DOT		
Fabric 7	Black	½yd (50cm)
Fabric 8	Blue	⅜yd (40cm)
BUBBLE STRIPE		
Fabric 9	Aqua	½yd (50cm)
BROLLIES		
Fabric 10	Blue	½yd (50cm)
FRONDS		
Fabric 11	Green	½yd (50cm)
CHECKMATE		
Fabric 12	Dark	⅜yd (40cm)
PAPERWEIGHT		
Fabric 13	Jewel	¼yd (25cm)
GUINEA FLOWER		
Fabric 14	Cobalt	½yd (50cm)
SPOT		
Fabric 15	Violet	½yd (50cm)
MILLEFIORE		
Fabric 16	Jade	⅜yd (40cm)
MEADOW		
Fabric 17	Teal	⅜yd (40cm)

Backing and Binding Fabrics
MILLEFIORE extra wide backing		
Fabric 18	Blue	2yd (1.9m)
JUMBLE		
Fabric 19	Lapis	⅝yd (60cm)

Batting
83in x 72in (211cm x 183cm)

FABRIC SWATCH DIAGRAM

Patchwork Fabrics

Fabric 1
FLORA
Blue
PJ114BL

Fabric 2
MAD PLAID
Cobalt
BM37CB

Fabric 3
JUMBLE
Aqua
BM53AQ

Fabric 4
JUMBLE
Royal
BM53RY

Fabric 5
JUMBLE
Ocean
BM53ON

Fabric 6
JUMBLE
Teal
BM53TE

Fabric 7
FLOWER DOT
Black
BM77BK

Fabric 8
FLOWER DOT
Blue
BM77BL

Fabric 9
BUBBLE STRIPE
Aqua
BM82AQ

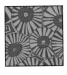
Fabric 10
BROLLIES
Blue
BM83BL

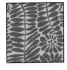
Fabric 11
FRONDS
Green
BM85GN

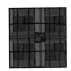
Fabric 12
CHECKMATE
Dark
BM86DK

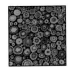
Fabric 13
PAPERWEIGHT
Jewel
GP20JE

Fabric 14
GUINEA FLOWER
Cobalt
GP59CB

Fabric 15
SPOT
Violet
GP70VI

Fabric 16
MILLEFIORE
Jade
GP92JA

Fabric 17
MEADOW
Teal
PJ116TE

Backing and Binding Fabrics

Fabric 18
MILLEFIORE
Blue
QB06BL

Fabric 19
JUMBLE
Lapis
BM53LP

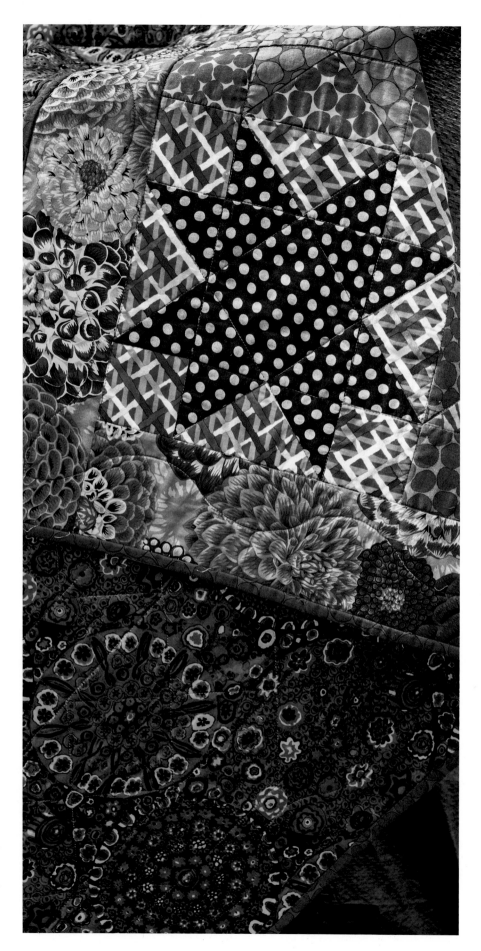

PATCHES

This traditional Sawtooth Star block is made using two sizes of square patches and two sizes of triangle patches, making finished 11in (27.9cm) star blocks.

CUTTING OUT

Fabric is cut across the width unless otherwise stated.

When cutting different pieces from the same fabric, always cut the larger pieces first. For this quilt, cut pieces in the following order:

Background Triangles

From each of the fabrics listed below, cut 1 strip 6¾in (17.1cm) wide and cross cut squares at 6¾in (17.1cm). Cut each square twice diagonally to make 4 quarter-square triangles from each square. Retain the rest of the fabric strip for pieces below. Cut a total of 120 large triangles from strips as follows:

Fabric 2 1 square – 4 triangles;
Fabric 3 2 squares – 8 triangles;
Fabric 4 4 squares – 16 triangles;
Fabric 5 1 square – 4 triangles;
Fabric 6 2 squares – 8 triangles;
Fabric 7 3 squares – 12 triangles;
Fabric 8 1 square – 4 triangles;
Fabric 9 3 squares –12 triangles;
Fabric 10 1 square – 4 triangles;
Fabric 11 2 squares – 8 triangles;
Fabric 12 2 squares – 8 triangles;
Fabric 13 1 square – 4 triangles;
Fabric 14 2 squares – 8 triangles;
Fabric 15 2 squares – 8 triangles;
Fabric 16 2 squares – 8 triangles;
Fabric 17 1 square – 4 triangles.

Centre Squares

Trim down the remaining strips from above to 6in (15.2cm) wide, and from Fabric 1 Flora Blue cut 1 strip 6in (15.2cm) wide. Cross cut squares at 6in (15.2cm). Cut a total of 30 squares from fabrics as follows:

Fabric 1 (1 strip) 3 squares;
Fabric 2 2 squares;
Fabric 3 1 squares;
Fabric 4 2 squares;
Fabric 5 1 square;
Fabric 6 3 squares;
Fabric 8 1 square;
Fabric 9 2 squares;
Fabric 10 3 squares;
Fabric 11 2 squares;
Fabric 12 1 square;

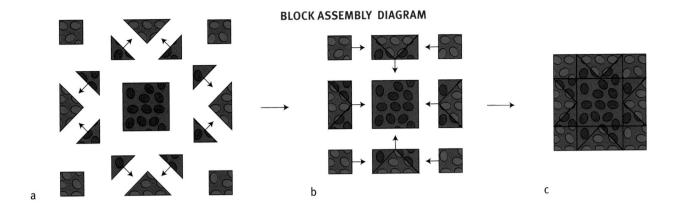

a b c

Fabric 13 1 square;
Fabric 14 2 squares;
Fabric 15 3 squares;
Fabric 16 1 squares;
Fabric 17 2 squares.

Star Triangles
Trim down the remaining strips from those listed above to 3⅝in (9.2cm) wide and cut additional strips as indicated below 3⅝in (9.2cm) wide. Cross cut squares at 3⅝in (9.2cm). Cut each square once diagonally to make two half-square triangles from each square. Each full strip will yield 11 squares (22 triangles). Cut a total of 240 triangles from fabrics as follows:
Fabric 1 (1 strip) 12 squares – 24 triangles;
Fabric 2 (1 strip) 8 squares – 16 triangles;
Fabric 3 4 squares – 8 triangles;
Fabric 4 (1 strip) 8 squares – 16 triangles;
Fabric 5 4 squares – 8 triangles;
Fabric 6 (1 strip) 12 squares – 24 triangles;
Fabric 8 4 squares – 8 triangles;
Fabric 9 (1 strip) 8 squares – 16 triangles;
Fabric 10 (1 strip) 12 squares – 24 triangles;
Fabric 11 (1 strip) 8 squares – 16 triangles;
Fabric 12 4 squares – 8 triangles;
Fabric 13 4 squares – 8 triangles;
Fabric 14 (1 strip) 8 squares – 16 triangles;
Fabric 15 (1 strip) 12 squares – 24 triangles;
Fabric 16 4 squares – 8 triangles;
Fabric 17 (1 strip) 8 squares – 16 triangles.

Corner Squares
Trim down the remaining strips to 3¼in (8.3cm) and cut additional strips as needed at 3¼in (8.3cm) wide. Cross cut squares at 3¼in (8.3cm). Each full strip will yield 12 squares. Cut a total of 120 squares from fabrics as follows:
Fabric 2 (1 strip) 4 squares;
Fabric 3 (1 strip) 8 squares;
Fabric 4 (2 strips) 16 squares;
Fabric 5 (1 strip) 4 squares;
Fabric 6 (1 strip) 8 squares;
Fabric 7 (1 strip) 12 squares;
Fabric 8 (1 strip) 4 squares;
Fabric 9 (1 strip) 12 squares;
Fabric 10 (1 strip) 4 squares;
Fabric 11 (1 strip) 8 squares;
Fabric 12 (1 strip) 8 squares;
Fabric 13 (1 strip) 4 squares;
Fabric 14 (1 strip) 8 squares;
Fabric 15 (1 strip) 8 squares;
Fabric 16 (1 strip) 8 squares;
Fabric 17 (1 strip) 4 squares.

Border
From Fabric 1 cut 7 strips 4½in (11.4cm) wide. Join strips end to end using ¼in (6mm) seams, and press seams open. From the length, cut as follows:
Side borders: 2 pieces 66½in x 4½in (168.9cm x 11.4cm) long; **top and bottom borders:** 2 pieces 63½in x 4½in (161.3cm x 11.4cm) long.

Backing
From Fabric 18 cut a piece 83in x 72in (211cm x 183cm).

Binding
From Fabric 19 cut 8 strips 2½in (6.4cm) wide. Remove selvedges and sew end to end with 45° seams (see page 157).

MAKING THE QUILT
Using a design wall will help to place patches in the required layout.
Use ¼in (6mm) seams throughout.

Making the Blocks
Referring to the Block Assembly Diagram, for each block select 8 star triangles and a matching centre square, along with 4 background triangles and 4 background corner squares. Sew 2 star triangles to each background triangle (a) and press seems towards the background triangle. Sew the pieces into 3 rows (b), pressing seams towards the background, then sew the 3 rows together (c).

Piece 30 blocks and lay them out, referring to the Quilt Assembly Diagram on page 62 and the quilt photograph for fabric and block placement.
Sew together one row at a time, pressing seams in opposite directions on alternate rows – odd rows to the left, even rows to the right – to allow the finished seams to lie flat, taking care to align crossing seams.

Borders
Pin, then sew the longer side borders to the centre; press, pin, then sew the top and bottom borders to the centre to complete the quilt top.

FINISHING THE QUILT
Press the quilt top. Layer the quilt top, batting and backing, and baste together (see page 156).
Quilt as desired.
Trim the quilt edges and attach the binding (see page 157).

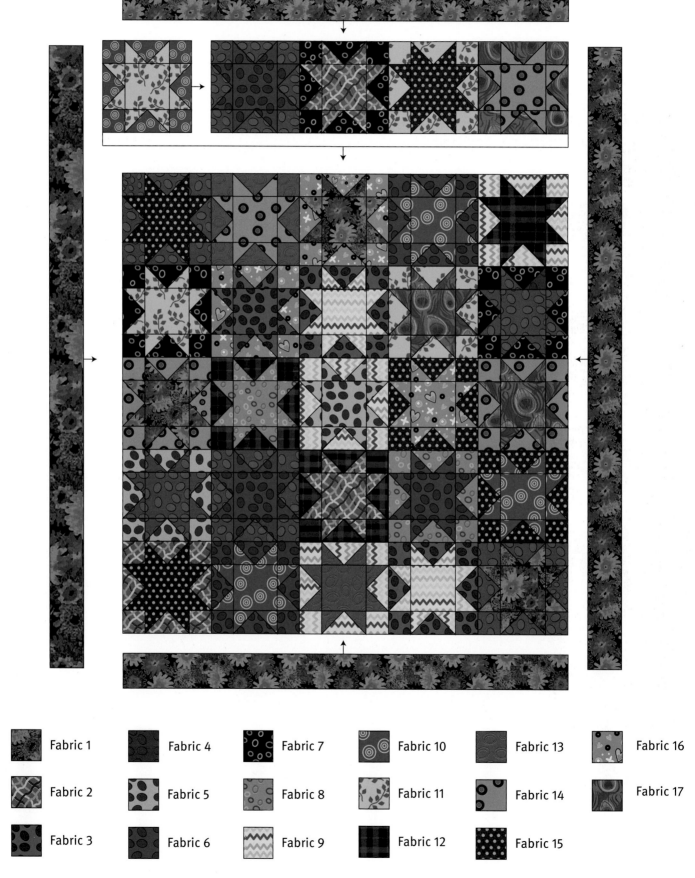

	Fabric 1		Fabric 4		Fabric 7		Fabric 10		Fabric 13		Fabric 16
	Fabric 2		Fabric 5		Fabric 8		Fabric 11		Fabric 14		Fabric 17
	Fabric 3		Fabric 6		Fabric 9		Fabric 12		Fabric 15		

spot swatches *

Kaffe Fassett

For this quilt I have made good use of a selection of the Spot fabrics in Brandon's and my Classic fabric ranges.

SIZE OF FINISHED QUILT
81in x 81in (206cm x 206cm)

FABRICS
Fabrics have been calculated at a maximum width of 40in (102cm). Fabrics have been given a number – see Fabric Swatch Diagram for details.

Patchwork Fabrics
JUMBLE

Fabric 1	Gold	3¾yd (3.5m)
Fabric 2	Cobalt	¼yd (25cm)
Fabric 3	Scarlet	¼yd (25cm)
Fabric 4	Bubblegum	¼yd (25cm)
Fabric 5	Tangerine	¼yd (25cm)
Fabric 6	Moss	¼yd (25cm)
Fabric 7	Rose	⅜yd (40cm)

MILLEFIORE

Fabric 8	Green	¼yd (25cm)

FLOWER DOT

Fabric 9	Jolly	⅜yd (40cm)
Fabric 10	Mauve	¼yd (25cm)

TONAL FLORAL

Fabric 11	Gold	¼yd (25cm)

SPOT

Fabric 12	Gold	¼yd (25cm)
Fabric 13	Ochre	¼yd (25cm)
Fabric 14	Paprika	¼yd (25cm)
Fabric 15	Turquoise	¼yd (25cm)

BUBBLE STRIPE

Fabric 16	Purple	¼yd (25cm)

FISH LIPS

Fabric 17	Green	¼yd (25cm)

GUINEA FLOWER

Fabric 18	Apricot	¼yd (25cm)

ROMAN GLASS

Fabric 19	Lavender	¼yd (25cm)

DISKS

Fabric 20	Pink	¼yd (25cm)
Fabric 21	Lime	⅜yd (40cm)

TWIG

Fabric 22	Yellow	¼yd (25cm)

LUCY

Fabric 23	White	¼yd (25cm)

COMB STRIPE

Fabric 24	Yellow	⅝yd (60cm)

Backing and Binding Fabrics
MAD PLAID extra wide backing

Fabric 25	Grey	2½yd (2.3m)

JUMBLE

Fabric 26	Lapis	¾yd (70cm)

Batting
89in x 89in (226cm x 226cm)

PATCHES
Feature squares are 4in (10.2cm) finished and are separated by narrow sashing strips 1½in (3.8cm) finished. The 144 sashed squares are set in 12 rows of 12 blocks, surrounded by 3 borders. Borders 1 and 3 use the same fabric as the sashing.

CUTTING OUT
Fabric is cut across the width unless otherwise stated. When required strips are longer than 40in (102cm) – the usable width of the fabric – remove selvedges and join strips end to end to obtain the required length, use ¼in (6mm) seams and press seams open. From the length, cut the required pieces.

Feature Squares
Cut strips 4½in (11.4cm) wide and cross cut squares at 4½in (11.4cm). Each strip will yield 8 squares. Cut a total of 144 squares from fabrics as follows:
Fabric 2 (1 strip) 7 squares;
Fabric 3 (1 strip) 6 squares;
Fabric 4 (1 strip) 5 squares;
Fabric 5 (1 strip) 4 squares;
Fabric 6 (1 strip) 6 squares;
Fabric 7 (2 strips) 9 squares;
Fabric 8 (1 strip) 7 squares;
Fabric 9 (2 strips) 11 squares;
Fabric 10 (1 strip) 7 squares;
Fabric 11 (1 strip) 7 squares;
Fabric 12 (1 strip) 6 squares;
Fabric 13 (1 strip) 5 squares;
Fabric 14 (1 strip) 5 squares;
Fabric 15 (1 strip) 7 squares;
Fabric 16 (1 strip) 7 squares;
Fabric 17 (1 strip) 6 squares;
Fabric 18 (1 strip) 7 squares;
Fabric 19 (1 strip) 5 squares;
Fabric 20 (1 strip) 5 squares;
Fabric 21 (2 strips) 9 squares;
Fabric 22 (1 strip) 8 squares;
Fabric 23 (1 strip) 5 squares.

Sashing
Vertical sashing strips: From Fabric 1 cut 7 strips 4½in (11.4cm) wide and cross cut sashing pieces 2in x 4½in (5.1cm x 11.4cm). Each strip will yield 20 pieces. Cut 132 pieces in total for the vertical sashing strips in each row.
Horizontal sashing strips: Also from Fabric 1 cut 18 strips 2in (5.1cm) wide. Sew the strips together end to end with straight seams and press seams open. From the length, cut 11 strips 2in x 65in (5.1cm x 165.1cm) for the horizontal strips between each row.

Borders 1 and 3
From the remaining Fabric 1 cut 15 strips 3½in (8.9cm) wide. Sew the strips together end to end with straight seams and press seams open. From the length, cut pieces as follows:
Border 1 sides: 2 pieces 3½in x 65in (8.9cm x 165.1cm);
Border 1 top and bottom: 2 pieces 3½in x 71in (8.9cm x 180.3cm);
Border 3 sides: 2 pieces 3½in x 75in (8.9cm x 190.5cm);
Border 3 top and bottom: 2 pieces 3½in x 81in (8.9cm x 205.7cm).

Border 2
The stripes on Brandon's Comb Stripe fabric run across the width, so to achieve the comb effect, cut border strips *down the length* of the fabric, across the stripes.
From Fabric 24 cut 14 strips 2½in (6.4cm) wide down the length of the fabric. Sew the strips together end to end with straight seams and press seams open. From the length, cut pieces as follows:
Border 2 sides: 2 pieces 2½in x 71in (6.4cm x 180.3cm);
Border 2 top and bottom: 2 pieces 2½in x 75in (6.4cm x 190.5cm).

Backing
From Fabric 25 cut a piece 89in x 89in (226cm x 226cm).

Binding
From Fabric 26 cut 9 strips 2½in (6.4cm) wide. Remove selvedges and sew end to end with 45° seams (see page 157).

FABRIC SWATCH DIAGRAM

Patchwork Fabrics

Fabric 1
JUMBLE
Gold
BM53GD

Fabric 2
JUMBLE
Cobalt
BM53CB

Fabric 3
JUMBLE
Scarlet
BM53SC

Fabric 4
JUMBLE
Bubblegum
BM53BB

Fabric 5
JUMBLE
Tangerine
BM53TN

Fabric 6
JUMBLE
Moss
BM53MS

Fabric 7
JUMBLE
Rose
BM53RO

Fabric 8
MILLEFIORE
Green
GP92GN

Fabric 9
FLOWER DOT
Jolly
BM77JY

Fabric 10
FLOWER DOT
Mauve
BM77MV

Fabric 11
TONAL FLORAL
Gold
GP197GD

Fabric 12
SPOT
Gold
GP70GD

Fabric 13
SPOT
Ochre
GP70OC

Fabric 14
SPOT
Paprika
GP70PP

Fabric 15
SPOT
Turquoise
GP70TQ

Fabric 16
BUBBLE STRIPE
Purple
BM82PU

Fabric 17
FISH LIPS
Green
BM07GN

Fabric 18
GUINEA FLOWER
Apricot
GP59AP

Fabric 19
ROMAN GLASS
Lavender
GP01LV

Fabric 20
DISKS
Pink
GP193PK

Fabric 21
DISKS
Lime
GP193LM

Fabric 22
TWIG
Yellow
GP196YE

Fabric 23
LUCY
White
PJ112WH

Fabric 24
COMB STRIPE
Yellow
BM84YE

Backing and Binding Fabrics

Fabric 25
MAD PLAID
Grey
QB02GY

Fabric 26
JUMBLE
Lapis
BM53LP

MAKING THE QUILT

Using a design wall will help to place patches in the required layout.
Use ¼in (6mm) seams throughout.

Centre

Lay out the feature squares on a design wall in 12 rows of 12 squares, referring to the Quilt Assembly Diagram and the quilt photograph for placement.
Sew together one row at a time, inserting a 2in x 4½in (5.1cm x 11.4cm) vertical sashing strip between each square. Press seams towards the sashing strips.
Pin, then sew the rows together, inserting a 2in x 65in (5.1cm x 165.1cm) horizontal sashing strip between each pieced row. Press seams towards the sashing strips.

Borders 1, 2 and 3

Starting with Border 1, sew on each border in turn, attaching the shorter side borders first, followed by the longer top and bottom borders. Pin before sewing each border to prevent stretching the edges.

FINISHING THE QUILT

Press the quilt top. Layer the quilt top, batting and backing, and baste together (see page 156).
Quilt as desired.
Trim the quilt edges and attach the binding (see page 157).

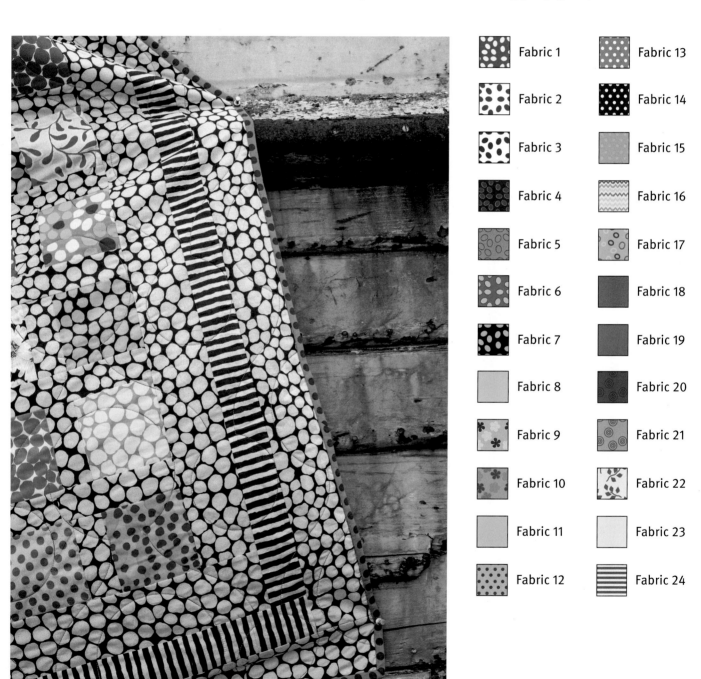

Fabric 1

Fabric 2

Fabric 3

Fabric 4

Fabric 5

Fabric 6

Fabric 7

Fabric 8

Fabric 9

Fabric 10

Fabric 11

Fabric 12

Fabric 13

Fabric 14

Fabric 15

Fabric 16

Fabric 17

Fabric 18

Fabric 19

Fabric 20

Fabric 21

Fabric 22

Fabric 23

Fabric 24

QUILT ASSEMBLY DIAGRAM

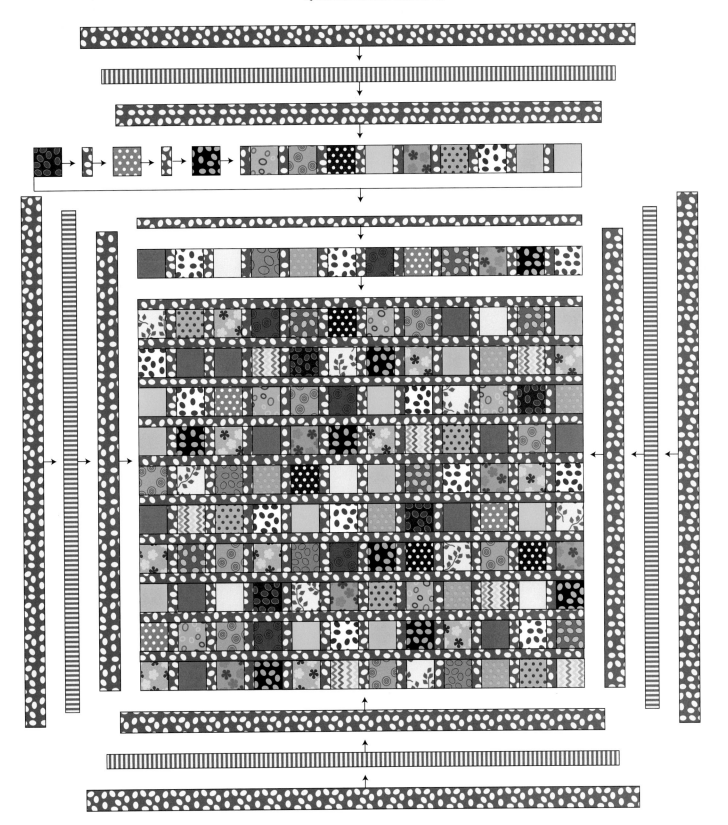

maroon frames *

Kaffe Fassett

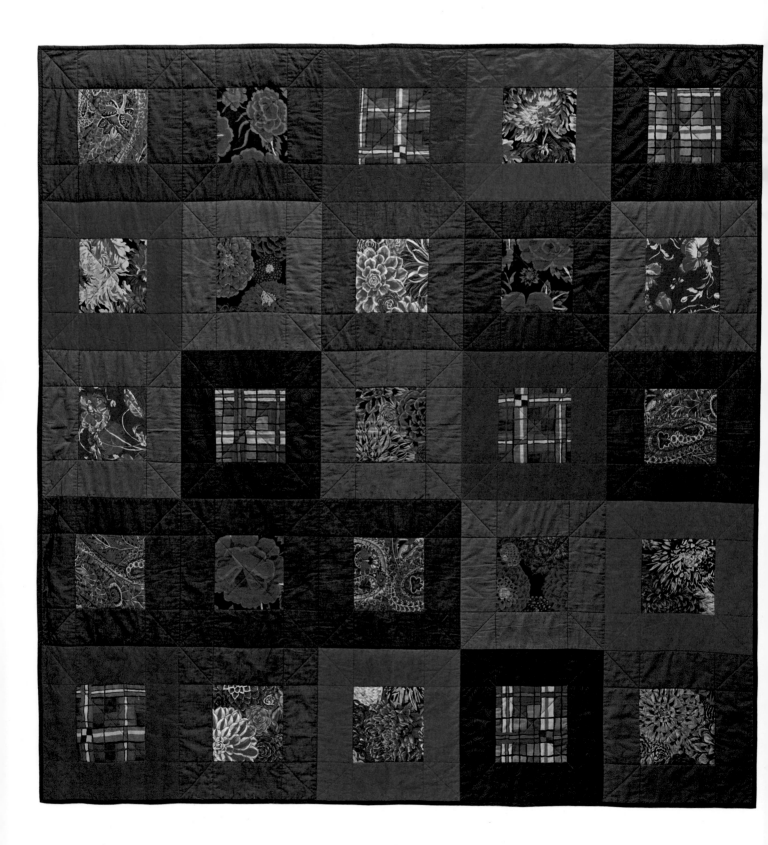

I have used this block in two previous designs, but this version really glows with the choice of the current berry tones in both prints and Shot Cottons.

SIZE OF FINISHED QUILT
75in x 75in (191cm x 191cm)

FABRICS
Fabrics have been calculated at a maximum width of 40in (102cm). Fabrics have been given a number – see Fabric Swatch Diagram for details.

Patchwork Fabrics

CHECKMATE		
Fabric 1	Dark	¼yd (25cm)
Fabric 2	Pink	¼yd (25cm)
PAISLEY JUNGLE		
Fabric 3	Rust	¼yd (25cm)
EMBROIDERED SHAWL		
Fabric 4	Red	¼yd (25cm)
JAPANESE CHRYSANTHEMUM		
Fabric 5	Scarlet	¼yd (25cm)
SHAGGY		
Fabric 6	Black	¼yd (25cm)
HOUSE LEEKS		
Fabric 7	Dark	¼yd (25cm)
Fabric 8	Red	¼yd (25cm)
FLORA		
Fabric 9	Dark	¼yd (25cm)
MEADOW		
Fabric 10	Purple	¼yd (25cm)
ABORIGINAL DOT		
Fabric 11	Orchid	⅝yd (60cm)
* see also Binding Fabric		
Fabric 12	Plum	⅝yd (60cm)
SHOT COTTON		
Fabric 13	Wine	¾yd (70cm)
Fabric 14	Heliotrope	¾yd (70cm)
Fabric 15	Blood Orange	½yd (50cm)
Fabric 16	Pimento	⅝yd (60cm)
Fabric 17	Aubergine	½yd (50cm)
Fabric 18	Plum	¾yd (70cm)

Backing and Binding Fabrics
TREE FUNGI extra wide backing

Fabric 19	Pink	2⅜yd (2.2m)
ABORIGINAL DOT		
Fabric 11	Orchid	⅝yd (60cm)
* see also Patchwork Fabrics		

Batting
84in x 84in (213cm x 213cm)

FABRIC SWATCH DIAGRAM

Patchwork Fabrics

Fabric 1
CHECKMATE
Dark
BM086DK

Fabric 2
CHECKMATE
Pink
BM086PK

Fabric 3
PAISLEY JUNGLE
Rust
GP060RU

Fabric 4
EMBROIDERED SHAWL
Red
GP106RD

Fabric 5
JAPANESE CHRYSANTHEMUM
Scarlet
PJ041SC

Fabric 6
SHAGGY
Black
PJ072BK

Fabric 7
HOUSE LEEKS
Dark
PJ113DK

Fabric 8
HOUSE LEEKS
Red
PJ113RD

Fabric 9
FLORA
Dark
PJ114DK

Fabric 10
MEADOW
Purple
PJ116PU

Fabric 11
ABORIGINAL DOT
Orchid
GP071OD

Fabric 12
ABORIGINAL DOT
Plum
GP071PL

Fabric 13
SHOT COTTON
Wine
SC103WN

Fabric 14
SHOT COTTON
Heliotrope
SC106HL

Fabric 15
SHOT COTTON
Blood Orange
SC110BO

Fabric 16
SHOT COTTON
Pimento
SC116PI

Fabric 17
SHOT COTTON
Aubergine
SC117AB

Fabric 18
SHOT COTTON
Plum
SC119PL

Backing and Binding Fabrics

Fabric 19
TREE FUNGI
Pink
QP001PK

Fabric 11
ABORIGINAL DOT
Orchid
GP071OD

PATCHES

The blocks are simple 7½in (19.1cm) finished centre squares, each framed with a 3¾in (9.5cm) border made up of two long rectangles and two short rectangles. Finished blocks are 15in (38.1cm) square. Patches are set in 5 rows of 5.

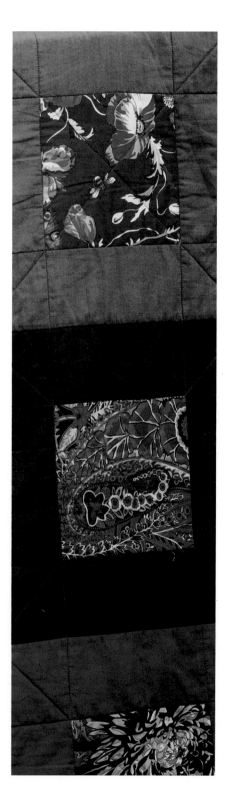

CUTTING OUT

Fabric is cut across the width unless otherwise stated.

Centre Squares

Cut a strip 8in (20.3cm) wide from each fabric and cross cut squares at 8in (20.3cm). Each strip will yield 4 squares. Cut a total of 25 squares from fabrics as follows:

Fabric 1 3 squares;
Fabric 2 3 squares;
Fabric 3 4 squares;
Fabric 4 3 squares;
Fabric 5 2 squares;
Fabric 6 2 squares;
Fabric 7 2 squares;
Fabric 8 2 squares;
Fabric 9 2 squares;
Fabric 10 2 squares.

Frames

Each block requires:
2 long rectangles cut 4¼in x 15½in (10.8cm x 39.4cm);
2 short rectangles cut 4¼in x 8in (10.8cm x 20.3cm).

Cut strips 4¼in (10.8cm) wide. Each strip will yield either 1 long and 3 short rectangles or 2 long and 1 short rectangles. Always cut the long rectangles first.
Cut a total of 50 long and 50 short rectangles from fabrics as follows:
Fabric 11 (4 strips) 6 long and 6 short rectangles;
Fabric 12 (4 strips) 6 long and 6 short rectangles;
Fabric 13 (5 strips) 8 long and 8 short rectangles;
Fabric 14 (5 strips) 8 long and 8 short rectangles;
Fabric 15 (3 strips) 4 long and 4 short rectangles;
Fabric 16 (4 strips) 6 long and 6 short rectangles;
Fabric 17 (3 strips) 4 long and 4 short rectangles;
Fabric 18 (5 strips) 8 long and 8 short rectangles.

Backing

From Fabric 19 cut a piece 84in x 84in (213cm x 213cm).

BLOCK ASSEMBLY DIAGRAM

Binding

From Fabric 11 cut 8 strips 2½in (6.4cm) wide. Remove selvedges and sew end to end with 45° seams (see page 157).

MAKING THE QUILT

Using a design wall will help to place patches in the required layout.
Use ¼in (6mm) seams throughout.

Blocks

Referring to the Quilt Assembly Diagram and the quilt photograph, select a centre square, 2 long and 2 short matching frame rectangles. Referring to the Block Assembly Diagram, sew the short frame rectangles to opposite sides of the centre square and press seams towards the frames. Sew the long frame rectangles to the other 2 sides and press seams towards the frames.
Make 25 blocks.

Assembling the Quilt

Lay out the blocks in 5 rows of 5, referring to the Quilt Assembly Diagram and the quilt photograph.
Note: The position of the long and short rectangles alternates between the sides or top and bottom across the whole quilt. Sew together one row at a time, pressing seams in opposite directions on alternate rows – odd rows to the left, even rows to the right – to allow the finished seams to lie flat. Sew the rows together, taking care to align crossing seams.

FINISHING THE QUILT

Press the quilt top. Layer the quilt top, batting and backing, and baste together (see page 156).
Quilt as desired.
Trim the quilt edges and attach the binding (see page 157).

QUILT ASSEMBLY DIAGRAM

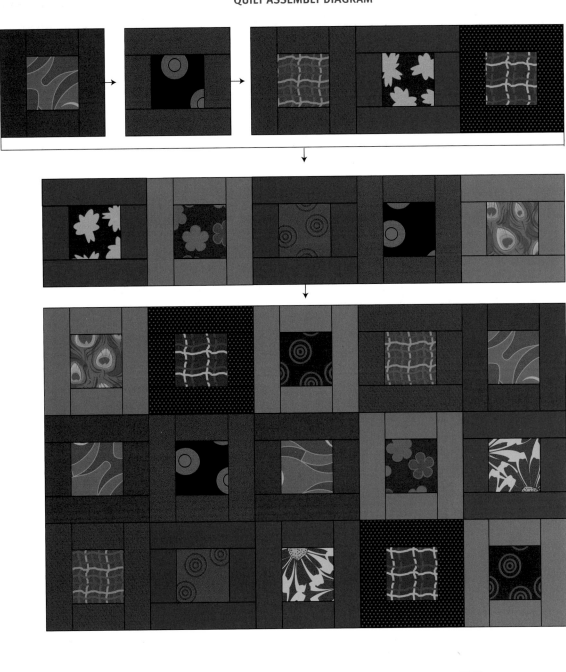

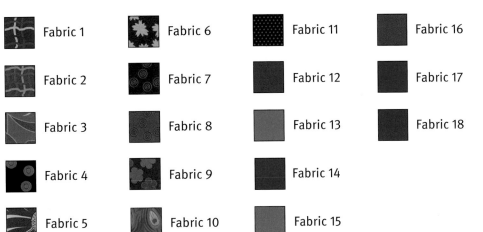

Fabric 1	Fabric 6	Fabric 11	Fabric 16
Fabric 2	Fabric 7	Fabric 12	Fabric 17
Fabric 3	Fabric 8	Fabric 13	Fabric 18
Fabric 4	Fabric 9	Fabric 14	
Fabric 5	Fabric 10	Fabric 15	

blooming snowballs **

Kaffe Fassett

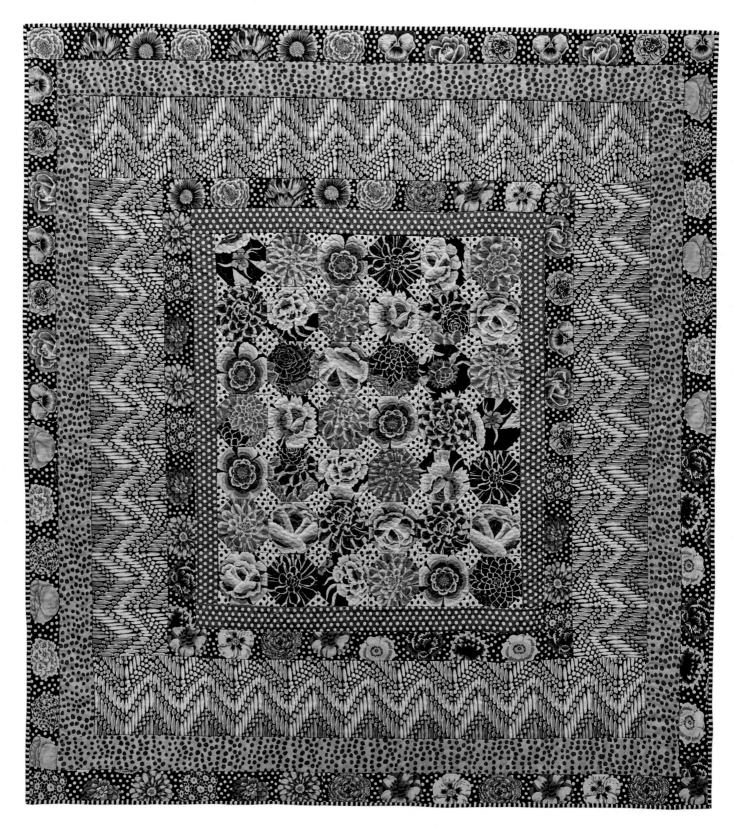

This version of the contrasting snowball-block quilt benefits from the latest collections of contrast flowers, both in the snowball block for the centre medallion and in the five concentric borders.

SIZE OF FINISHED QUILT
78½in x 73in (199cm x 185cm)

FABRICS
Fabrics have been calculated at a maximum width of 40in (102cm). Fabrics have been given a number – see Fabric Swatch Diagram for details.

Patchwork Fabrics
EMBROIDERED SHAWL
Fabric 1	Black	1½yd (1.4m)

HOUSE LEEKS
Fabric 2	Contrast	1½yd (1.4m)

SPOT
Fabric 3	White	⅝yd (60cm)
Fabric 4	Charcoal	⅜yd (40cm)

BIG BLOOMS
Fabric 5	Black	1⅝yd (1.5m)

BEADED CURTAIN
Fabric 6	Pastel	2⅞yd (2.7m)

BUBBLE STRIPE
Fabric 7	Purple	⅞yd (85cm)

Backing and Binding Fabrics
ONION RINGS
FABRIC 8	Black	2¼yd (2.1m)

COMB STRIPE
Fabric 9	White	⅝yd (60cm)

Batting
87in x 81in (221cm x 206cm)

PATCHES
Octagonal snowball blocks from Fabrics 1 and 2 make up the centre medallion of the quilt, set in 7 rows of 6 blocks. These are each made using a feature fussy-cut flower square and 4 small background squares in Fabric 3.

CUTTING OUT
Fabric is cut across the width unless otherwise stated.
When required strips are longer than 40in (102cm) – the usable width of the fabric – remove selvedges and sew strips end to end to obtain the required length, using ¼in (6mm) seams and pressing seams open.

Snowball Block – Large Squares
From Fabric 1 and Fabric 2 cut a total of 42 fussy-cut 6in (15.2cm) squares as follows. Using a clear acrylic 6in (15.2cm) ruler, position it on the fabric to centre a 6in (15.2cm) square over one of the flower motifs, then cut it out. Cut 21 floral motifs from each fabric. (Extra fabric has been allowed for this.)

Snowball Block – Small Squares
From Fabric 3 cut 9 strips 2in (5.1cm) wide and cross cut 20 squares at 2in (5.1cm) from each strip; 168 squares in total.

Note: With so many border pieces – some very similar in length – it is best to label them to avoid confusion.

Border 1
From Fabric 4 cut 4 strips 3in (7.6cm) wide and cut pieces as follows:
4 pieces 39in x 3in (99.1cm x 7.6cm) for the sides; 2 pieces 38½in x 3in (97.8cm x 7.6cm) for the top and bottom.

Borders 2 and 5
From Fabric 5 cut 13 strips 3½in (8.9cm) wide, centering the flower motifs along each strip (extra fabric has been allowed for this). Remove selvedges and trim back to between the flower motifs, then sew together piece to piece. From the length, and centering the flower motifs along each piece, cut pieces as follows:
Border 5: Cut 2 pieces 73in x 3½in (185.4cm x 8.9cm) for the sides; cut 2 pieces 73½in x 3½in (186.7cm x 8.9cm) for the top and bottom.
Border 2: Cut 2 pieces 44in x 3½in (111.8cm x 8.9cm) for the sides; cut 2 pieces 44½in x 3½in (113cm x 8.9cm) for the top and bottom.

Border 3
This border is fussy cut and the strips are pattern-matched when joined together so the borders are mirrored across the quilt and down the centre.
From Fabric 6 cut 8 strips 8½in (21.6cm) wide, making sure that each strip is cut starting at the same point in the pattern and includes the same colours across each strip. The pattern repeat on Fabric 6 is just over 12in (30.5cm) long, so you will have some narrow strips left over

FABRIC SWATCH DIAGRAM

Patchwork Fabrics

Fabric 1
EMBROIDERED SHAWL
Black
GP106BK

Fabric 2
HOUSE LEEKS
Contrast
PJ113CN

Fabric 3
SPOT
White
GP070WH

Fabric 4
SPOT
Charcoal
GP070CC

Fabric 5
BIG BLOOMS
Black
GP091BK

Fabric 6
BEADED CURTAIN
Pastel
GP191PT

Fabric 7
BUBBLE STRIPE
Purple
BM082PU

Backing and Binding Fabrics

Fabric 8
ONION RINGS
Black
QB001BK

Fabric 9
COMB STRIPE
White
BM084WH

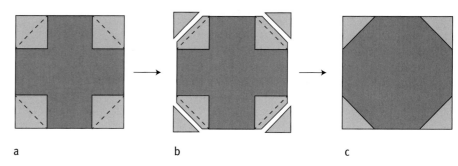

a b c

after cutting the border pieces. (Extra fabric has been allowed for this.)
Sew strips together, matching the pattern, into 4 sets of 2 strips each. Referring to the quilt photograph, for each set of 2 strips, mark out the required length so that each end of the strip mirrors the other end. Cut pieces as follows:
2 pieces 50in x 8½in (127cm x 21.6cm) for the sides; 2 pieces 60½in x 8½in (153.7cm x 21.6cm) for the top and bottom.

Border 4

From Fabric 7 cut 7 strips 4in (10.2cm) wide, remove selvedges and sew end to end. Cut pieces as follows:
2 pieces 66in x 4in (167.6cm x 10.2cm) for the sides; 2 pieces 67½in x 4in (171.4cm x 10.2cm) for the top and bottom.

Backing

From Fabric 8 cut a piece 87in x 81in (221cm x 206cm).

Binding

From Fabric 9 cut 16 strips *down the length* (across the stripes) 2½in (6.4cm) wide. Remove selvedges and sew end to end with 45° seams (see page 157).

MAKING THE QUILT

Using a design wall will help to place patches in the required layout.
Use ¼in (6mm) seams throughout.

Snowball Blocks

Referring to the Block Assembly Diagram, take a large square and 4 small squares. Position a small square right sides together on each corner of the large square and sew diagonally (a). Trim off excess, leaving a ¼in (6mm) seam allowance (b). Press seams towards corners to finish the block (c). Make 42 blocks.

Centre Medallion

Referring to the Quilt Assembly Diagram and the quilt photograph, lay out the blocks in 7 rows of 6 snowball blocks. Sew together one row at a time, pressing seams in opposite directions on alternate rows – odd rows to the left, even rows to the right – to allow the finished seams to lie flat. Sew the rows together, taking care to align crossing seams.

Borders

For each of the five borders, attach the shorter sides first, followed by the longer top and bottom, pinning before sewing each one to prevent stretching the edges. Lightly press each border before adding the next.

FINISHING THE QUILT

Press the quilt top. Layer the quilt top, batting and backing, and baste together (see page 156).
Quilt as desired.
Trim the quilt edges and attach the binding (see page 157).

QUILT ASSEMBLY DIAGRAM

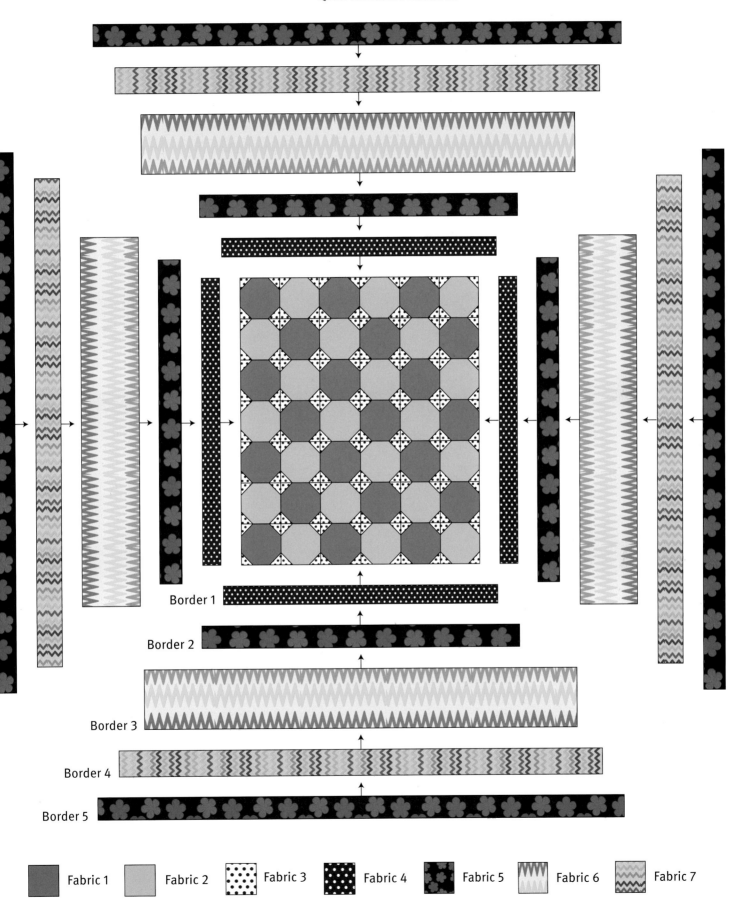

Border 1
Border 2
Border 3
Border 4
Border 5

Fabric 1 Fabric 2 Fabric 3 Fabric 4 Fabric 5 Fabric 6 Fabric 7

water garden **

Kaffe Fassett

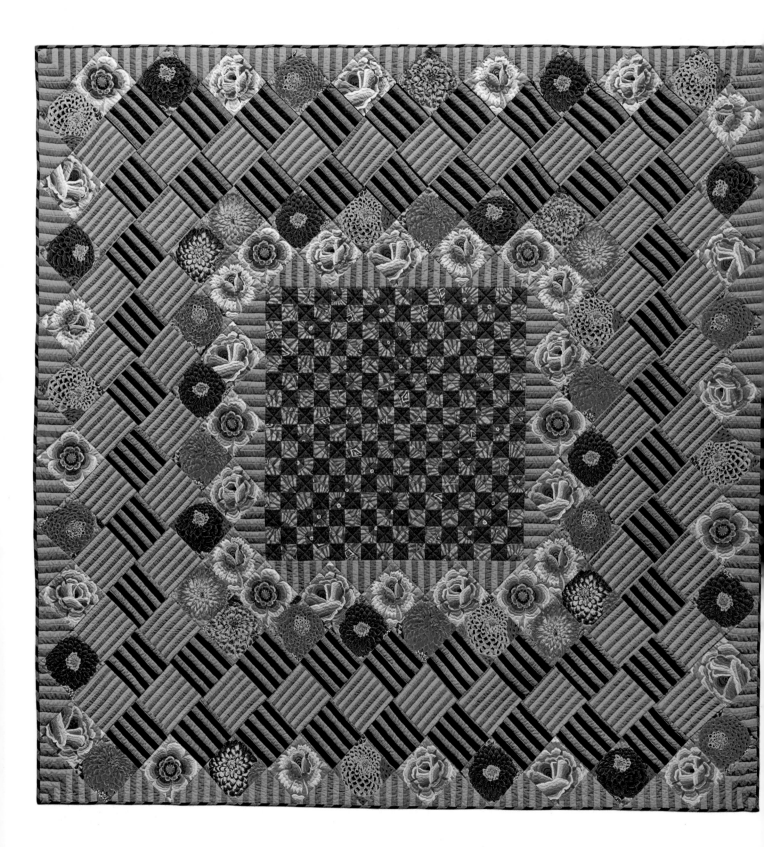

This quilt of simple squares is made spectacular by the use of fussy-cut flowers and by setting the outer squares in rows on point.

SIZE OF FINISHED QUILT
93in x 93in (236cm x 236cm)

FABRICS
Fabrics have been calculated at a maximum width of 40in (102cm). Fabrics have been given a number – see Fabric Swatch Diagram for details.

Patchwork Fabrics
BROLLIES
Fabric 1 Blue ¾yd (70cm)
ABORIGINAL DOT
Fabric 2 Plum ¾yd (70cm)
WIDE STRIPE
Fabric 3 Embers 1⅜yd (1.3m)
Fabric 4 Fjord 1½yd (1.4m)
* see also Binding Fabric
NARROW STRIPE
Fabric 5 Mallard 1½yd (1.4m)
EMBROIDERED SHAWL
Fabric 6 Blue 3½yd (3.3m)
FLORA
Fabric 7 Blue 3yd (2.8m)

Backing and Binding Fabrics
LOTUS LEAF wide backing fabric
Fabric 8 Purple 2⅞yd (2.7m)
WIDE STRIPE
Fabric 4 Fjord ⅞yd (85cm)
* see also Patchwork Fabrics

Batting
102in x 102in (259cm x 259cm)

PATCHES
The centre is a checkerboard of alternating 2⅛in (5.4cm) finished squares. It is surrounded by 6 rounds of finished 6in (15.2cm) squares set on point with right-angled setting triangles. The first 2 rounds are fussy-cut flowers, followed by 3 striped rows and a final flower round.

FABRIC SWATCH DIAGRAM

Patchwork Fabrics

Fabric 1
BROLLIES
Blue
BM83BL

Fabric 2
ABORIGINAL DOT
Plum
GP71PL

Fabric 3
WIDE STRIPE
Embers
SS01EB

Fabric 4
WIDE STRIPE
Fjord
SS01FJ

Fabric 5
NARROW STRIPE
Mallard
SS02ML

Fabric 6
EMBROIDERED SHAWL
Blue
GP106BL

Fabric 7
FLORA
Blue
PJ114BL

Backing and Binding Fabrics

Fabric 8
LOTUS LEAF
Purple
QB07PU

Fabric 4
WIDE STRIPE
Fjord
SS01FJ

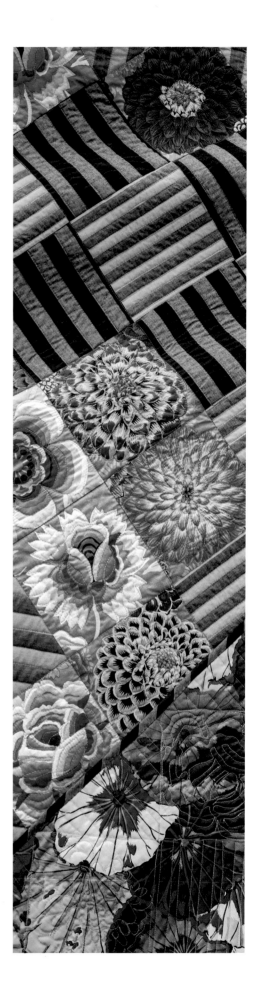

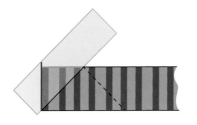

a

b

c

CUTTING OUT

Fabric is cut across the width unless otherwise stated.

Centre Squares

Note: Strip piecing is commonly used for piecing a checkerboard in alternating fabrics, but to avoid distortion the traditional method is used here.
Cut 9 strips 2⅝in (6.7cm) wide from each of Fabric 1 and Fabric 2. Cross cut squares at 2⅝in (6.7cm) from strips until you have 128 squares in each fabric, 256 in total.

Setting Triangles

From Fabric 3 cut 9 strips 4⅞in (12.4cm) wide. Referring to the Triangle Cutting Diagram, use the 45° line on your ruler to cut right-angled triangles along the strips. Cut the left side of the triangle (a), then rotate the ruler to cut the right-hand side (b), and so on (c). Cut 60 right-angled triangles. Each strip will yield 7 triangles. Set aside 4 sets of 2 triangles with closely aligning stripes for the corners.

Striped Squares

Cut 8 strips 6½in (16.5cm) wide from each of Fabric 4 and Fabric 5. Cross cut squares at 6½in (16.5cm) from the strips. Each strip will yield 6 squares. Cut 48 squares in each fabric, 96 squares in total.

Flower Squares

Flower squares are fussy cut from Fabric 6 and Fabric 7. Mark and cut out a 6½in (16.5cm) square template from template plastic or use a 6½in (16.5cm) square acrylic ruler, if preferred. Centre the template over each flower motif, draw around and cut out the squares. Cut out 40 flower motifs from Fabric 6 and 44 flower motifs from Fabric 7. (Extra fabric has been allowed for this.)

Backing

Remove selvedges and trim Fabric 8 to 102in x 102in (259cm x 259cm).

Binding

From Fabric 4 cut 10 strips 2½in (6.4cm) wide. Remove selvedges and sew end to end with 45° seams (see page 157).

MAKING THE QUILT

Using a design wall will help to place patches in the required layout.
Use ¼in (6mm) seams throughout.

Centre

Referring to the Quilt Assembly Diagram and the quilt photograph, sew alternating centre squares in Fabrics 1 and 2 together into 16 rows of 16 squares each. Press seams in opposite directions on alternate rows – odd rows to the left, even rows to the right – to allow the finished seams to lie flat. Sew the rows together, checking the squares alternate row by row and taking care to align crossing seams.

Laying out the Blocks

Position the quilt centre on your design wall. Around the centre, lay out blocks as follows with 4 setting triangles in Fabric 3 along each edge of the centre; a row of Fabric 6 flower squares on all 4 sides; and a row of Fabric 7 flower squares on all 4 sides.

Important: Make sure stripes run in the right direction. Fabric 4 striped squares all have stripes running diagonally from the upper left side to the lower right side. Fabric 5 striped squares all have stripes running diagonally from the lower left side to the upper right side.

On the left and right sides add:
a row of Fabric 5 striped squares; a row of Fabric 4 striped squares; a second row of Fabric 5 striped squares.

Then on the top and bottom add:
a row of Fabric 4 striped squares; a row of Fabric 5 striped squares; a second row of Fabric 4 striped squares.
Add a full round of flower squares in alternating Fabric 6 and Fabric 7 and complete the layout with a full round of Fabric 3 setting triangles.

Triangular Setting Sections

Referring to the Quilt Assembly Diagram and the quilt photograph, on all 4 sides, sew together a triangular section to fit each side of the centre square, each with 4 diagonal rows made up as follows: 4 setting triangles in Fabric 3; 3 flower squares in Fabric 6; 2 fabric squares in Fabric 7; 1 striped square in either Fabric 5 for the sides or Fabric 4 for the top and bottom.

Large Corner Sections

Still referring to the Quilt Assembly Diagram and the quilt photograph, make up 4 large corner sections in diagonal rows edged with setting triangles. Make the lower left and upper right corners to fit the quilt centre, then make the upper left and lower right corners to complete the quilt top. Sew together one row at a time, pressing seams in opposite directions on alternate rows – odd rows to the left, even rows to the right – to allow the finished seams to lie flat. Sew the rows together, taking care to align crossing seams.

FINISHING THE QUILT

Press the quilt top. Layer the quilt top, batting and backing, and baste together (see page 156).
Quilt as desired.
Trim the quilt edges and attach the binding (see page 157).

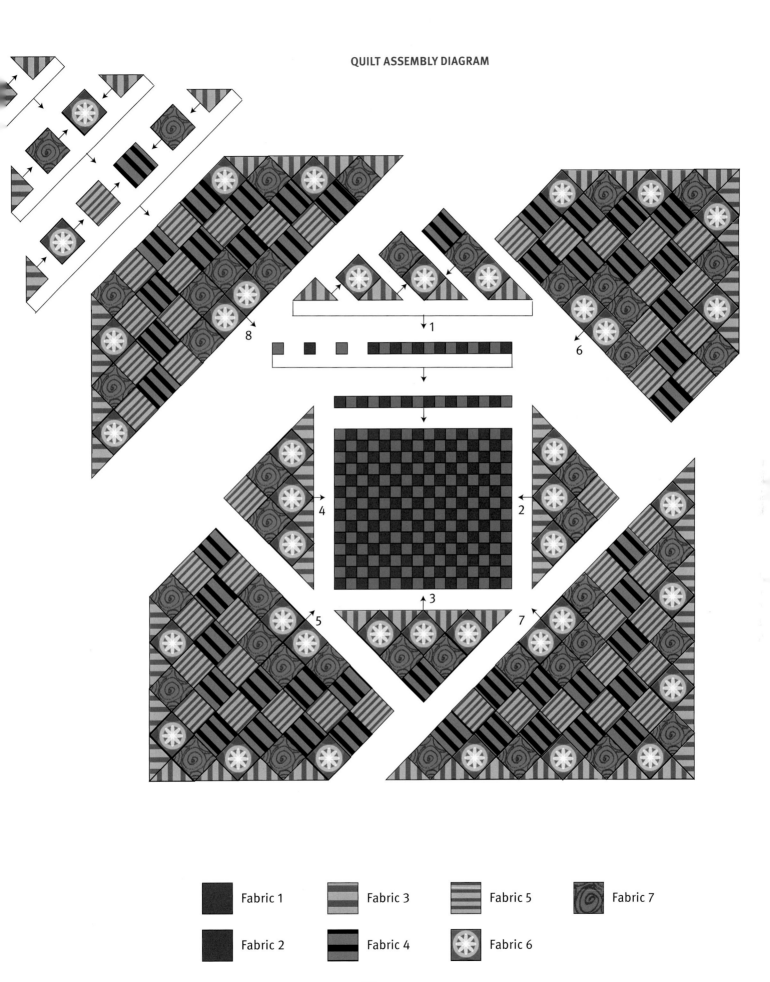

Fabric 1

Fabric 2

Fabric 3

Fabric 4

Fabric 5

Fabric 6

Fabric 7

lorna doone **

Liza Prior Lucy

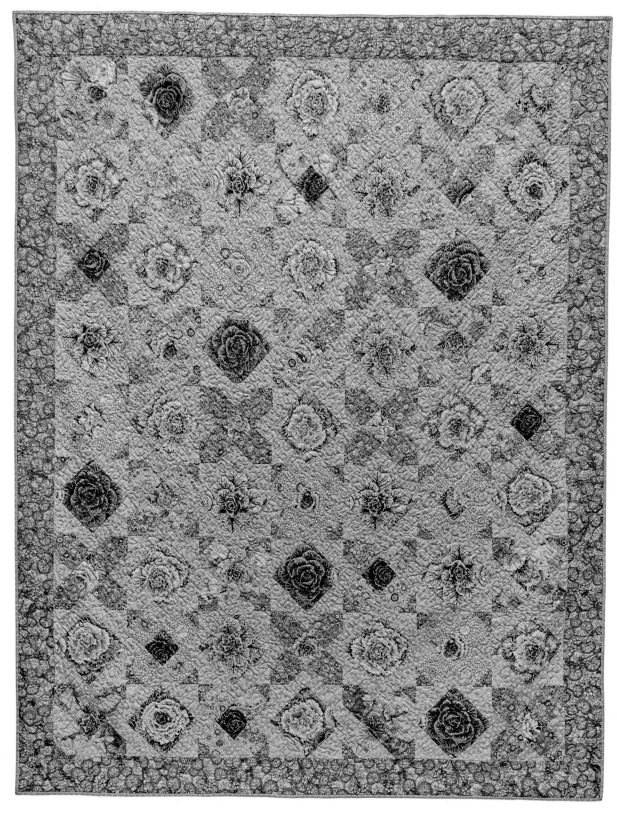

The updated version of this quilt uses mostly the original fabrics that are still in the Kaffe Fassett Collective's Classics range. The feature squares are fussy cut to show off the ornamental cabbage centres of the Brassica print.

SIZE OF FINISHED QUILT
98in x 79in (249cm x 200cm)

FABRICS
Fabrics have been calculated at a maximum width of 40in (102cm). Fabrics have been given a number – see Fabric Swatch Diagram for details.

Patchwork Fabrics
BRASSICA
Fabric 1 Pastel 3yd (2.8m)
SPOT
Fabric 2 Duck Egg 2½yd (2.3m)
* see also Binding Fabric
Fabric 3 Apple ¾yd (70cm)
PAPERWEIGHT
Fabric 4 Sludge ¾yd (70cm)
ROMAN GLASS
Fabric 5 Pink ½yd (50cm)
LOTUS LEAF
Fabric 6 Jade ½yd (50cm)
GUINEA FLOWER
Fabric 7 Turquoise ½yd (50cm)
MILLEFIORE
Fabric 8 Lilac ½yd (50cm)
CLIMBING GERANIUMS
Fabric 9 Grey 1½yd (1.4m)

Backing and Binding Fabrics
MAD PLAID extra wide backing
Fabric 10 Pastel 2½yd (2.3m)
SPOT
Fabric 2 Duck Egg ¾yd (70cm)
* see also Patchwork Fabrics

Batting
106in x 88in (269cm x 223cm)

PATCHES
Patches are squares, rectangles and triangles, cut from strips except for the large and small feature squares which are fussy cut to show off the cabbage motif centres of Fabric 1. Feature squares are set on point, each with a narrow frame, and are separated by pieced sashing. The sashing incorporates squares and hourglass blocks that form

Patchwork Fabrics

Fabric 1
BRASSICA
Pastel
PJ51PT

Fabric 2
SPOT
Duck Egg
GP70DE

Fabric 3
SPOT
Apple
GP70AL

Fabric 4
PAPERWEIGHT
Sludge
GP20SL

Fabric 5
ROMAN GLASS
Pink
GP01PK

Fabric 6
LOTUS LEAF
Jade
GP29JA

Fabric 7
GUINEA FLOWER
Turquoise
GP59TQ

Fabric 8
MILLEFIORE
Lilac
GP92LI

Fabric 9
CLIMBING GERANIUMS
Grey
PJ110GY

Backing and Binding Fabrics

Fabric 10
MAD PLAID
Pastel
QM02GY

Fabric 2
SPOT
Duck Egg
GP70DE

a secondary cross design between the feature squares. Setting triangles are used to complete the centre.

CUTTING OUT
Fabric is cut across the width unless otherwise stated. When required strips are longer than 40in (102cm) – the usable width of the fabric – remove selvedges and join strips end to end to obtain the required length, using ¼in (6mm) seams and pressing seams open. When cutting different pieces from the same fabric, always cut the larger pieces first.

Large and Small Feature Squares
Using template plastic, measure and cut out a square 7½in x 7½in (19.1cm x 19.1cm) for the large feature squares and

a square 4in x 4in (10.2cm x 10.2cm) for the small feature squares.
From Fabric 1 fussy cut 31 large feature squares 7½in x 7½in (19.9cm x 19.1cm), centring the template over a cabbage motif, marking and cutting out each square.
From the remaining Fabric 1 cut 32 small feature squares 4in x 4in (10.2cm x 10.2cm).

Feature Square Frames
From Fabric 2 cut 31 strips 2¼in (5.7cm) wide. From each strip cut 2 long rectangles 11in x 2¼in (27.9cm x 5.7cm) and 2 short rectangles 7½in x 2¼in (19.1cm x 5.7cm). This will give you a total of 62 long rectangles and 62 short rectangles.

Setting Triangles

From the remaining Fabric 2 cut a strip 6¼in (15.9cm) wide and cross cut 5 squares at 6¼in (15.9cm). Cut each square in half diagonally twice to yield 4 quarter-square triangles from each: 20 in total (of which you will need 18 as setting triangles).

Sashing Squares

From each of Fabrics 5, 6, 7 and 8 cut 4 strips 4in (10.2cm) wide and cross cut 32 squares at 4in (10.2cm) from each fabric. Each strip will yield 10 squares. Cut a total of 128 squares.

Hourglass Blocks

Note: The hourglass blocks in the middle of the sashing strips are made using quarter-square triangles (QSTs) to make the long triangles' edges (running along the grain) stable. The hourglass blocks around the edges of the quilt centre (joining the quilt border) are made using half-square triangles (HSTs) to make the short triangle edges (running along the grain) stable.

Sashing Hourglass Blocks: Cut 3 strips 4¾in (12.1cm) wide from each of Fabrics 3 and 4 and cross cut squares at 4¾in (12.1cm). Each strip will yield 8 squares. Cut a total of 24 squares from each fabric. Cross cut each square twice diagonally to make 4 QSTs from each square: a total of 96 QSTs from each fabric.

Edge Half-hourglass Blocks: Cut 2 strips 3⅜in (8.6cm) wide from the remaining Fabrics 3 and 4 and cross cut squares at 3⅜in (8.6cm). Each strip will yield 11 squares. Cut 14 squares from Fabric 3 and 16 squares from Fabric 4. Cross cut each square once diagonally to make 2 HSTs from each square: a total of 28 HSTs from Fabric 3 and 32 HSTs from Fabric 4.

Border

From Fabric 9 cut 9 strips 5½in (14cm) wide. Remove selvedges and sew strips together end to end using ¼in (6mm) seams, pressing seams open. From the length cut:
2 pieces 89½in x 5½in (227.3cm x 14cm) for the side borders; 2 pieces 79¾in x 5½in (202.6cm x 14cm) for the top and bottom borders.

Backing

Remove selvedges and trim Fabric 10 backing to 106in x 88in (269cm x 223cm).

Binding

From Fabric 2 cut 10 strips 2½in (6.4cm) wide. Remove selvedges and sew end to end with 45° seams (see page 157).

MAKING THE QUILT

Using a design wall will help to place patches in the required layout.
Use ¼in (6mm) seams throughout.

Making the Blocks

Feature Blocks: Referring to the Feature Block Assembly Diagram, sew 2 short frame rectangles in Fabric 2 to opposite sides of each feature square (a), press seams towards the frames, then sew 2 long frame rectangles in Fabric 2 to the remaining 2 sides (b) to complete the block. Make a total of 31 framed feature squares.

Sashing Hourglass Blocks: Referring to the Hourglass Block Assembly Diagram, make 48 hourglass blocks by sewing 2 sets of Fabrics 3 and 4 QSTs together

(a), pressing seams towards the darker fabric, then sewing the 2 pairs of QSTs together (b) to form the hourglass blocks (c).

Edge Half-hourglass Blocks: Using the smaller edge half-hourglass HSTs, sew together 28 sets of Fabrics 3 and 4 triangles to form 28 half-hourglass blocks for the quilt edges. Referring to the Hourglass Block Assembly Diagram, make 14 as shown in (d) and 14 as shown in (e).
Set the remaining 4 Fabric 4 triangles aside to use for the quilt corners.

Assembling the Quilt

Referring to the Quilt Assembly Diagram on page 84 and the quilt photograph, lay out the blocks in diagonal rows with sashing blocks laid out between each diagonal row. Take care to form the 'cross' design of the sashing with 4 matching squares joining the 4 sides of the small Fabric 1 squares, with an hourglass block between each cross section. Also take care to position the Fabric 4 triangles connecting to the cross sections. Check the whole layout is correct before sewing.

FEATURE BLOCK ASSEMBLY DIAGRAM

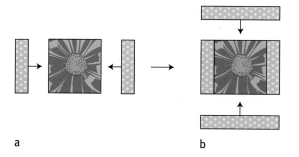

a b

HOURGLASS BLOCK ASSEMBLY DIAGRAM

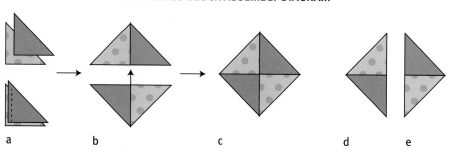

a b c d e

Referring to the Quilt Assembly
Diagram, sew each set of 3 sashing
squares together, pressing seams
away from the central hourglass block.
Carefully return each sashing set to the
layout. Add the edge half-hourglass
blocks to the layout edges, positioning
them as shown in the Quilt Assembly
Diagram. Add the 4 corner HSTs in
Fabric 4.
Note: You will notice that the framed
squares along the edges need trimming
to fit but do not do this until the quilt
centre is completely assembled.

Check the layout again and sew
together the triangular sashing
sections at the end of each row of
framed squares. Sew each diagonal
row of framed squares and sashing sets
together, and sew each diagonal row of
sashing sets and small feature squares
together.
To help seams lie flat, press seams
on sashing rows to the left and press
seams on framed square rows to the
right. Take care to align crossing seams.
Starting from the top left-hand corner,
as shown in the Quilt Assembly
Diagram, pin and then sew the diagonal
rows together.
Trim the framed squares to fit, making
sure you leave a ¼in (6mm) seam
allowance OUTSIDE the points of the
centre squares.

Border
Pin (to prevent stretching the borders),
then sew the Fabric 9 longer side
borders to the quilt centre. Press seams
towards the borders. Pin, then sew the
shorter top and borders to the centre to
complete the quilt top.

FINISHING THE QUILT
Remove selvedges and trim Fabric 10
backing fabric to form a piece 106in x
88in (269cm x 223cm).

Press the quilt top. Layer the quilt top,
batting and backing, and baste together
(see page 156).
Quilt as desired.
Trim the quilt edges and attach the
binding (see page 157).

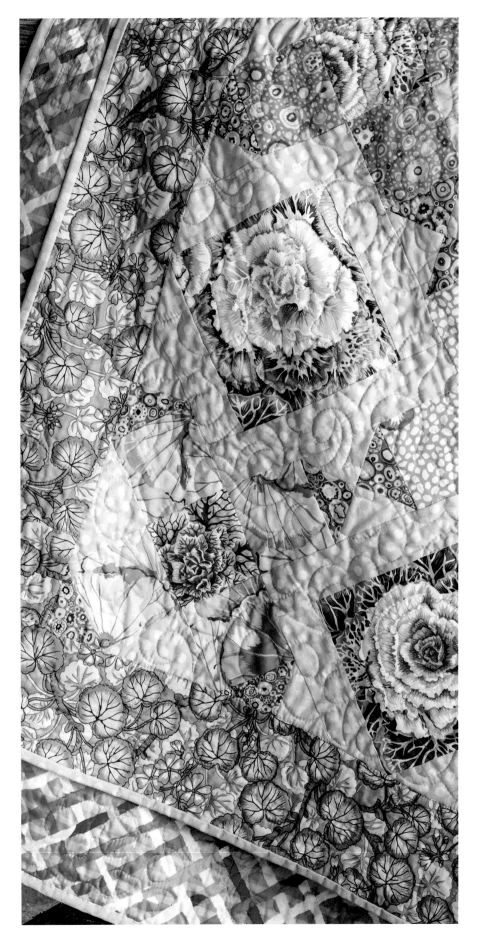

QUILT ASSEMBLY DIAGRAM

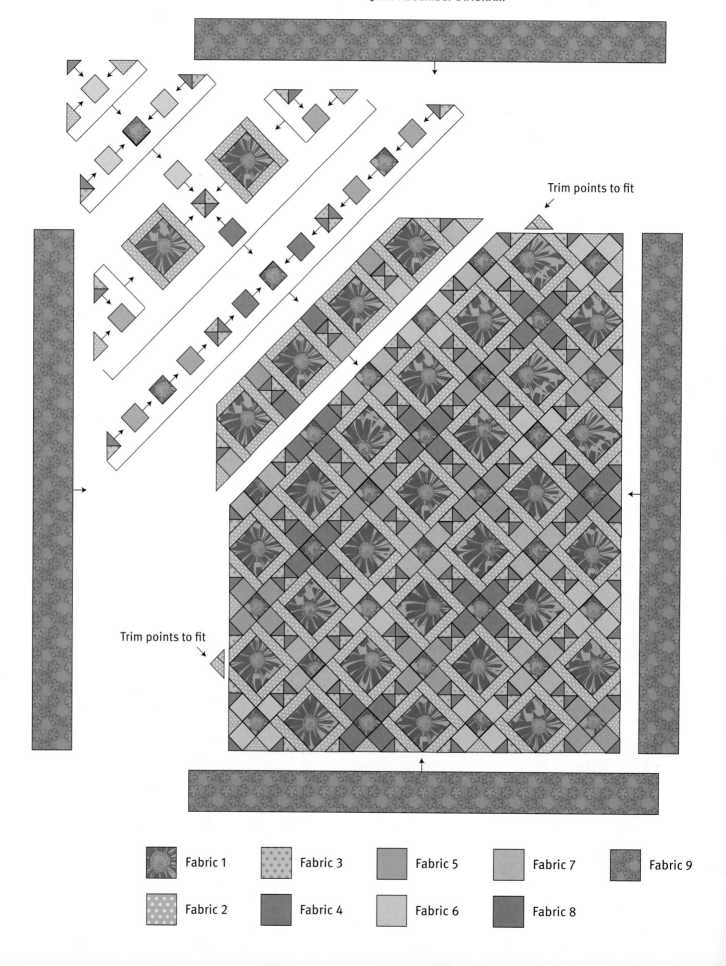

Trim points to fit

Trim points to fit

Fabric 1

Fabric 2

Fabric 3

Fabric 4

Fabric 5

Fabric 6

Fabric 7

Fabric 8

Fabric 9

pastel fiesta **

Kaffe Fassett

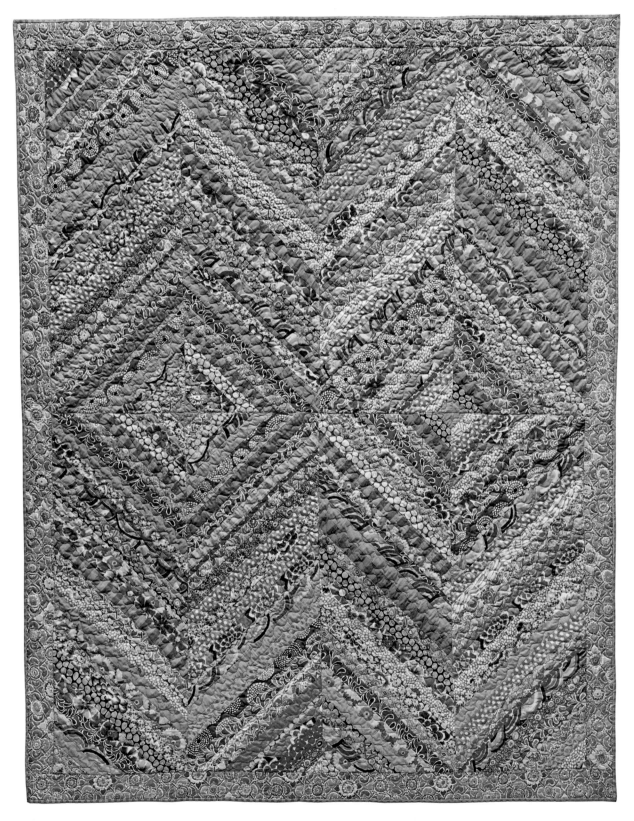

For this softer version of my *Fiesta* quilt, I chose a pastel selection of our more recent Classics fabrics along with plenty of light and pretty colourways from our recent collections. This is a scrappy quilt so you can have fun placing fabrics where you want, taking care not to make the stripes merge with similar patterns and tones, or follow the photograph to stick more closely to our arrangement.

SIZE OF FINISHED QUILT
91in x 71in (231cm x 180cm)

FABRICS
Fabrics have been calculated at a maximum width of 40in (102cm). Fabrics have been given a number – see Fabric Swatch Diagram for details.

Patchwork Fabrics
JUMBLE

Fabric 1	Cobalt	⅜yd (40cm)
Fabric 2	Lime	⅜yd (40cm)

ROMAN GLASS

Fabric 3	Lavender	⅜yd (40cm)

GUINEA FLOWER

Fabric 4	Grey	½yd (50cm)

SPOT

Fabric 5	Steel	⅜yd (40cm)
Fabric 6	China Blue	⅜yd (40cm)
Fabric 7	Turquoise	⅜yd (40cm)

* see also Binding Fabric
ABORIGINAL DOT

Fabric 8	Ocean	⅜yd (40cm)
Fabric 9	Turquoise	⅜yd (40cm)

SHADOW FLOWER

Fabric 10	Contrast	⅜yd (40cm)

DISKS

Fabric 11	Grey	⅜yd (40cm)

TWIG

Fabric 12	Grey	½yd (50cm)

TONAL FLORAL

Fabric 13	Beige	⅜yd (40cm)

FRONDS

Fabric 14	White	⅜yd (40cm)

NARROW STRIPE

Fabric 15	Gooseberry	⅜yd (40cm)

TUDOR

Fabric 16	Pastel	1⅝yd (1.5m)

RAINBOWS

Fabric 17	Grey	⅝yd (60cm)

SHOT COTTON

Fabric 18	Dawn	½yd (50cm)

JUMBLE

Fabric 19	Lemon	½yd (50cm)
Fabric 20	Rose	⅜yd (40cm)

ROMAN GLASS

Fabric 21	Pink	⅜yd (40cm)

GUINEA FLOWER

Fabric 22	Lavender	⅜yd (40cm)

MILLEFIORE

Fabric 23	Pink	½yd (50cm)

CHARLOTTE

Fabric 24	Pastel	⅝yd (60cm)

REGAL FANS

Fabric 25	Pastel	½yd (50cm)

PINWHEELS

Fabric 26	Spring	½yd (50cm)

TWIG

Fabric 27	Pink	½yd (50cm)

SHOT COTTON

Fabric 28	Strawberry Blonde	½yd (50cm)

WIDE STRIPE

Fabric 29	Cantaloupe	⅜yd (40cm)
Fabric 30	Salmon	⅜yd (40cm)

Backing and Binding Fabrics
LOTUS LEAF extra wide backing

Fabric 31	Jade	2¼yd (2.1m)

SPOT

Fabric 7	Turquoise	¾yd (70cm)

* see also Patchwork Fabrics

Batting
100in x 80in (254cm x 203cm)

Interfacing
Lightweight, non-woven sew-in (NOT fusible) 90cm-wide interfacing 5yds (4.65m)

BLOCKS
The quilt centre is made up of 8 blocks finished at 42in x 16in (106.7cm x 40.6cm), 2 each of 4 different variations. Blocks 1 and 3 are made using cooler (blue and green) **Fabrics 1–18**. Blocks 2 and 4 are made using warmer (pink and orange) **Fabrics 16–30**. Each pair of blocks sits diagonally opposite each other. The blocks are pieced randomly from narrow 1in (2.5cm) and 2in (5.1cm) strips, sewn together at a 45° angle with the help of a thin interfacing template that stays in place after completion.

CUTTING OUT
Fabric is cut across the width unless otherwise stated. When cutting different pieces from the same fabric, always cut the larger pieces first.

Border
From Fabric 21 cut 8 strips 4in (10.2cm) wide. Remove selvedges and sew the strips end to end, using ¼in (6mm) seams and press seams open. From the length cut:
2 pieces 84½in (214.6cm) long for the side borders; 2 pieces 71½in (181.6cm) long for the top and bottom borders. Retain the remaining Fabric 21 for quilt centre strips.

Corner Triangles
Cut squares 3in x 3in (7.6cm x 7.6cm) and cut each square in half diagonally once to form half-square triangles for the block corners. Cut squares from fabrics as follows:
Cut 4 squares (8 triangles) from the cool-coloured Fabrics 1–18 and 4 squares (8 triangles) from the warm-coloured Fabrics 16–30.

Centre Strips
Pastel Fiesta is a scrappy quilt that you can piece as you please using 1in (2.5cm) wide and 2in (5.1cm) wide strips. We have allowed enough fabric to cut 4 strips at 2in (5.1cm) wide and 4 strips at 1in (2.5cm) wide from each fabric, plus extra in those we used more of. Start by cutting 2 strips in each width and cut more as you need them.

Backing
Trim Fabric 31 extra wide backing to 100in x 80in (254cm x 203cm).

Binding
From Fabric 11 cut 9 strips 2½in (6.4cm) wide. Remove selvedges and sew end to end with 45° seams (see page 157).

MAKING THE QUILT
Using a design wall will help to place blocks in the required layout.
Use ¼in (6mm) seams throughout.

Making the Blocks
The blocks are foundation pieced using a guide of thin, lightweight, non-fusible interfacing that will be left in situ. Referring to the Block Assembly Diagram on page 88, make 8 interfacing guides, each measuring 42½in x 16½in (108cm x 42cm). Mark the paper with 45° diagonal lines, as shown (a), approximately every

FABRIC SWATCH DIAGRAM

Patchwork Fabrics

Fabric 1
JUMBLE
Cobalt
BM53CB

Fabric 2
JUMBLE
Lime
BM53LM

Fabric 3
ROMAN GLASS
Lavender
GP01LV

Fabric 4
GUINEA FLOWER
Grey
GP59GY

Fabric 5
SPOT
Steel
GP70ST

Fabric 6
SPOT
China Blue
GP70CI

Fabric 7
SPOT
Turquoise
GP70TQ

Fabric 8
ABORIGINAL DOT
Ocean
GP71ON

Fabric 9
ABORIGINAL DOT
Turquoise
GP71TQ

Fabric 10
SHADOW FLOWER
Contrast
GP187CN

Fabric 11
DISKS
Grey
GP193GY

Fabric 12
TWIG
Grey
GP196GY

Fabric 13
TONAL FLORAL
Beige
GP197BE

Fabric 14
FRONDS
White
BM85WH

Fabric 15
NARROW STRIPE
Gooseberry
SS02GY

Fabric 16
TUDOR
Pastel
GP175PT

Fabric 17
RAINBOWS
Grey
GP190GY

Fabric 18
SHOT COTTON
Dawn
SC121DN

Fabric 19
JUMBLE
Lemon
BM53LE

Fabric 20
JUMBLE
Rose
BM53RO

Fabric 21
ROMAN GLASS
Pink
GP01PK

Fabric 22
GUINEA FLOWER
Lavender
GP59LV

Fabric 23
MILLEFIORE
Pink
GP92PK

Fabric 24
CHARLOTTE
Pastel
GP186PT

Fabric 25
REGAL FANS
Pastel
GP188PT

Fabric 26
PINWHEELS
Spring
PJ117SP

Fabric 27
TWIG
Pink
GP196PK

Fabric 28
SHOT COTTON
Strawberry Blonde
SC122SB

Fabric 29
WIDE STRIPE
Cantaloupe
SS01CA

Fabric 30
WIDE STRIPE
Salmon
SS01SL

Backing and Binding Fabrics

Fabric 31
LOTUS LEAF
Jade
QB07JA

Fabric 7
SPOT
Turquoise
GP70TQ

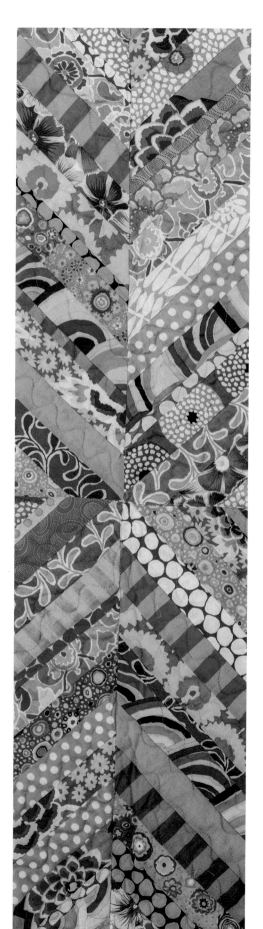

BLOCK ASSEMBLY DIAGRAM

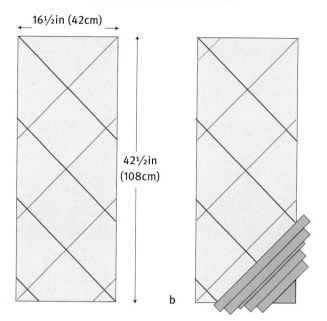

← 16½in (42cm) →

42½in (108cm)

a b

6in (15.2cm). The blue lines are guides for Blocks 1 and 3 (start piecing from the bottom right-hand corner) and the red lines are guides for Blocks 2 and 4 (start piecing from the bottom left-hand corner).

Referring to the photograph and Block Assembly Diagram, for Block 1 (using the cool-coloured Fabrics 1 to 18), position a corner triangle right-side up in the bottom right-hand corner on the interfacing guide; place a strip of the next fabric, right-side down, over the corner triangle. Pin along the stitching line and flip back to check the strip overlaps and completely covers the sides of the interfacing guide. Stitch the strip in place and gently press.

Continue adding strips in the same manner (b). Each time a new strip is added, press carefully and check the strips overlap the interfacing guide on both sides and are parallel with the blue diagonal lines on the guide. Complete the block with a corner triangle, sew in place, then trim the panel to fit the interfacing guide exactly. Make a second block identical to Block 1. Also using cool-coloured Fabrics 1 to 18, make 2 each of Block 3, again starting from the bottom right-hand corner.

Using the same method and starting with a warm-coloured triangle in the bottom left-hand corner, make 2 each of Blocks 2

and 4 using warm-coloured Fabrics 16 to 30, using the red diagonal lines to check the angle of the strips remains at 45°. Once the block is sewn and trimmed, if it has points or a crowded fabric intersection, trim away the interfacing from that point to reduce the bulk.

Centre

Arrange the 8 blocks, referring to the Quilt Assembly Diagram and quilt photograph, ensuring that each pair of blocks faces each other diagonally, rotating the lower block so that it is a mirror image of its upper diagonal block. Pin and sew the 4 upper blocks together, pressing seams to the right. Pin and sew the 4 lower blocks together, pressing seams to the left. Sew the 2 rows of blocks together and press.

Borders

Pin and sew the longer side borders to the centre, press then pin and sew the top and bottom borders to the centre to complete the quilt top.

FINISHING THE QUILT

Press the quilt top. Layer the quilt top, batting and backing, and baste together (see page 156).
Quilt as desired.
Trim the quilt edges and attach the binding (see page 157).

QUILT ASSEMBLY DIAGRAM

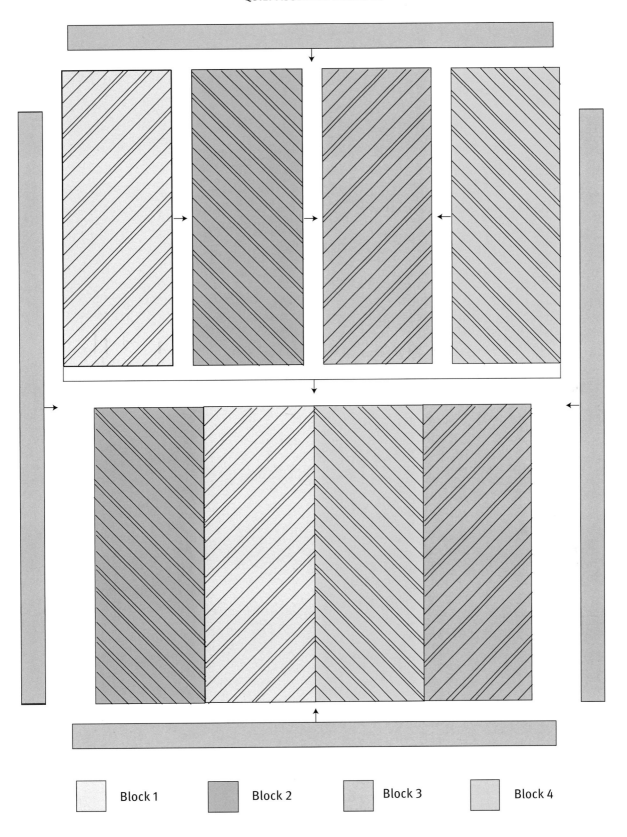

Block 1 Block 2 Block 3 Block 4

cabanas **

Liza Prior Lucy

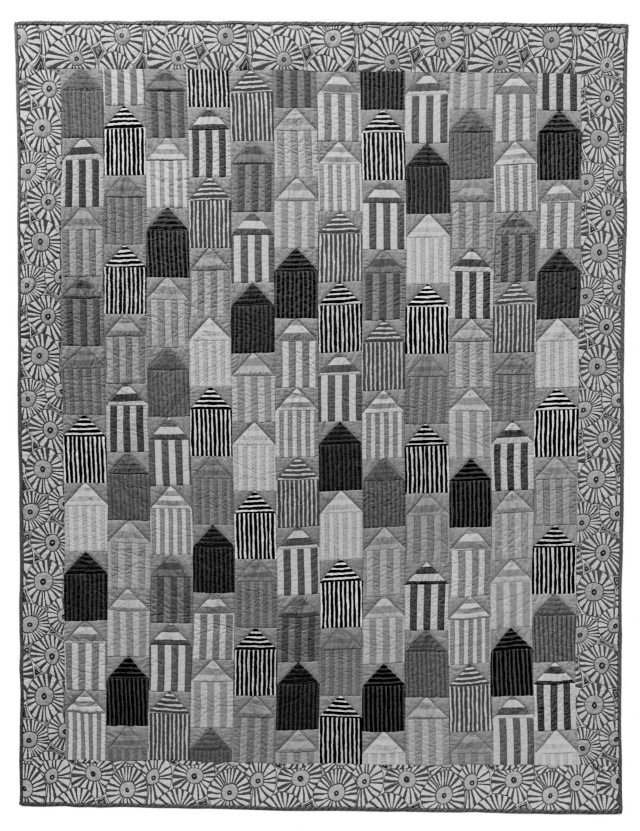

Liza's original design has been given a fresh new look with my current collection of Woven Stripes along with Brandon's Comb Stripes for the cabanas (beach huts), surrounded by a sea of Brandon's green Brollies. You will need to pay special attention to the direction of the stripes when you are cutting out the fabrics.

SIZE OF FINISHED QUILT
85in x 70in (216cm x 178cm)

FABRICS
Fabrics have been calculated at a maximum width of 40in (102cm). Fabrics have been given a number – see Fabric Swatch Diagram for details.

Patchwork Fabrics
BROLLIES
| Fabric 1 | Green | 1³⁄₈yd (1.3m) |

2¼yd (2.1m) if cut down fabric length to avoid seams
SHOT COTTON
| Fabric 2 | Galvanised | 1¼yd (1.2m) |

WIDE STRIPE
Fabric 3	Aloe	½yd (50cm)
Fabric 4	Cantaloupe	½yd (50cm)
Fabric 5	Burn	½yd (50cm)
Fabric 6	Apple	½yd (50cm)
Fabric 7	Salmon	½yd (50cm)
Fabric 8	Shell	½yd (50cm)
Fabric 9	Watermelon	⅝yd (70cm)

NARROW STRIPE
Fabric 10	Gooseberry	½yd (50cm)
Fabric 11	Plaster	½yd (50cm)
Fabric 12	Sulfur	½yd (50cm)

COMB STRIPE
| Fabric 13 | Blue | ½yd (50cm) |
| Fabric 14 | Orange | ½yd (50cm) |

* see also Binding Fabric
| Fabric 15 | Pink | ½yd (50cm) |
| Fabric 16 | Purple | ³⁄₈yd (40cm) |
| Fabric 17 | White | ³⁄₈yd (40cm) |
| Fabric 18 | Yellow | ½yd (50cm) |

Backing and Binding Fabrics
REGIMENTAL TIES
| Fabric 19 | Multi | 5¼yd (4.9m) |
COMB STRIPE
| Fabric 14 | Orange | ¾yd (70cm) |
* see also Patchwork Fabrics

Batting
94in x 79in (238cm x 200cm)

FABRIC SWATCH DIAGRAM

Patchwork Fabrics

Fabric 1
BROLLIES
Green
BM083GN

Fabric 2
SHOT COTTON
Galvanised
SC130GA

Fabric 3
WIDE STRIPE
Aloe
SS001AU

Fabric 4
WIDE STRIPE
Cantaloupe
SS001CA

Fabric 5
WIDE STRIPE
Burn
SS001BU

Fabric 6
WIDE STRIPE
Apple
SS001AL

Fabric 7
WIDE STRIPE
Salmon
SS001SL

Fabric 8
WIDE STRIPE
Shell
SS001SH

Fabric 9
WIDE STRIPE
Watermelon
SS001WL

Fabric 10
NARROW STRIPE
Gooseberry
SS002GY

Fabric 11
NARROW STRIPE
Plaster
SS002PJ

Fabric 12
NARROW STRIPE
Sulfur
SS002SU

Fabric 13
COMB STRIPE
Blue
BM084BL

Fabric 14
COMB STRIPE
Orange
BM084OR

Fabric 15
COMB STRIPE
Pink
BM084PK

Fabric 16
COMB STRIPE
Purple
BM084PU

Fabric 17
COMB STRIPE
White
BM084WH

Fabric 18
COMB STRIPE
Yellow
BM084YE

Backing and Binding Fabrics

Fabric 19
REGIMENTAL TIES
Multi
GP189MU

Fabric 14
COMB STRIPE
Orange
BM084OR

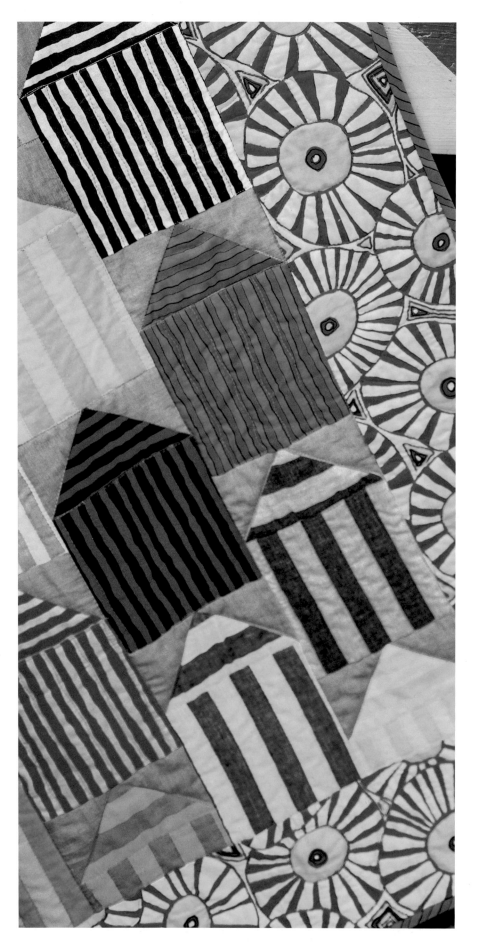

PATCHES

Patches are squares and triangles, all cut from strips.

Note: Cut patches according to the stripe direction on each fabric. Blocks are made of a matching striped square and triangle, and 2 small half-square triangles from the background fabric, Fabric 2. The cabana blocks are set in columns.

CUTTING OUT

Fabric is cut across the width unless otherwise stated. When cutting different pieces from the same fabric, always cut the larger pieces first.

Border

From Fabric 1 cut 8 strips 5½in (14cm) wide. Join strips end to end using ¼in (6mm) seams, and press seams open. Alternatively, if cutting down the fabric length to avoid seams in the border, cut 4 strips 5½in (14cm) wide down the length of the fabric. From the length/strips cut: 2 pieces 75½in (191.8cm) long for the side borders; 2 pieces 70½in (179.1cm) long for the top and bottom borders.

Background Triangles

From Fabric 2 cut 11 strips 3⅜in (8.6cm) and cross cut 120 squares at 3⅜in (8.6cm). Each strip will yield 11 squares. Cut each square in half diagonally once to make a total of 240 half-square triangles.

Cabana Squares

Cut strips 5½in (14cm) wide and cross cut squares at 5½in (14cm). Each strip will yield 7 squares. Cut a total of 117 squares from fabrics as follows:

Fabric 3 (1 strip) 7 squares;
Fabric 4 (1 strip) 7 squares;
Fabric 5 (1 strip) 7 squares;
Fabric 6 (1 strip) 7 squares;
Fabric 7 (1 strip) 7 squares;
Fabric 8 (1 strip) 7 squares;
Fabric 9 (2 strips) 8 squares;
Fabric 10 (1 strip) 6 squares;
Fabric 11 (1 strip) 7 squares;
Fabric 12 (2 strips) 8 squares;
Fabric 13 (2 strips) 8 squares;
Fabric 14 (2 strips) 8 squares;
Fabric 15 (2 strips) 8 squares;
Fabric 16 (1 strip) 7 squares;
Fabric 17 (1 strip) 7 squares;
Fabric 18 (2 strips) 8 squares;

Stripe direction

a b

Roof Triangles (fabrics with stripes running down the fabric)

Cut 1 strip 6¼in (15.9cm) wide from each of Fabrics 3, 4, 5, 6, 7, 8, 9, 10, 11 and 12. Cross cut rectangles 3⅛in x 6¼in (7.9cm x 15.9cm). Referring to the Roof Triangle Cutting Diagram (a), use a right-angled triangle template or the 45° line on your cutting ruler to trim each rectangle to a right-angled triangle. Cut rectangles and trim 76 triangles from fabrics as follows:

Fabric 3 7 triangles;
Fabric 4 8 triangles;
Fabric 5 7 triangles;
Fabric 6 7 triangles;
Fabric 7 8 triangles;
Fabric 8 7 triangles
Fabric 9 8 triangles;
Fabric 10 8 triangles;
Fabric 11 8 triangles:
Fabric 12 8 triangles.

Roof Triangles (fabrics with stripes running across the fabric)

Trim the remaining strips from Fabric 13, 14, 15 and 18 to 3⅛in (7.9cm) wide. Cut one strip 3⅛in (7.9cm) wide from each of Fabrics 16 and 17. Referring to the Cutting Diagram (b), use a right-angled triangle template or the 45° line on your cutting ruler to cut right-angled triangles across the strips, rotating the ruler 90° after each cut as shown. Cut 44 triangles from fabrics as follows:

Fabric 13 8 triangles;
Fabric 14 8 triangles;
Fabric 15 7 triangles
Fabric 16 7 triangles;
Fabric 17 7 triangles;
Fabric 18 7 triangles.

Partial-cabana Rectangles (fabrics with stripes running down the fabric)

From the following fabrics, trim the remaining strips to 4½in (11.4cm) wide and, ensuring the stripes run parallel with the shorter sides, cut 4 large partial-cabana rectangles 5½in x 4½in (14cm x 11.4cm) and 5 small partial-cabana rectangles 5½in x 1¾in (14cm x 4.4cm), as follows:

Fabric 3 1 large;
Fabric 4 1 small;
Fabric 5 1 large;
Fabric 6 1 large;
Fabric 7 1 small;
Fabric 8 1 large;
Fabric 10 2 small;
Fabric 11 1 small.

Partial-cabana Rectangles (fabrics with stripes running across the fabric)

Ensuring the stripes run parallel with the short sides, trim one of the cabana squares in each of Fabric 15 and Fabric 18 to large rectangles 5½in x 4½in (14cm x 11.4cm).
Ensuring the stripes run parallel with the short sides, trim one of the cabana squares in Fabric 14 to a small rectangle 5½in x 1¾in (14cm x 4.4cm).

Backing

From Fabric 19 cut 2 pieces 94in (238cm) long. Remove selvedges and sew together side to side. Trim to make a piece 94in x 79in (238cm x 200cm).

Binding

From Fabric 14 cut 9 strips 2½in (6.4cm) wide. Remove selvedges and sew end to end with 45° seams (see page 157).

MAKING THE QUILT

Using a design wall will help to place patches in the required layout.
Use ¼in (6mm) seams throughout.

Making the Blocks

Referring to the Block Assembly Diagram, make 120 roof sections, each using one roof triangle and two background triangles. Press seams towards the background triangles.
Match each roof section to a corresponding cabana square or small partial-cabana rectangle and sew together, checking the stripes run downwards from the roof rectangle. Press seams towards the cabana square.

Centre

Referring to the Quilt Assembly Diagram on page 94 and the quilt photograph, lay out the blocks in 12 columns of 10 cabanas each. Alternate rows have a large partial- cabana rectangle at the top and a small partial-cabana rectangle with attached roof at the bottom of the column.
Sew together one column at a time, pressing seams towards the cabana squares.
Pin the columns together to avoid stretching, then sew the columns together.

Borders

Pin, to prevent stretching, and sew the longer side borders to the centre. Press seams towards the border, then pin and sew the top and bottom borders to the centre to complete the quilt top.

FINISHING THE QUILT

Press the quilt top. Layer the quilt top, batting and backing, and baste together (see page 156).
Quilt as desired.
Trim the quilt edges and attach the binding (see page 157).

QUILT ASSEMBLY DIAGRAM

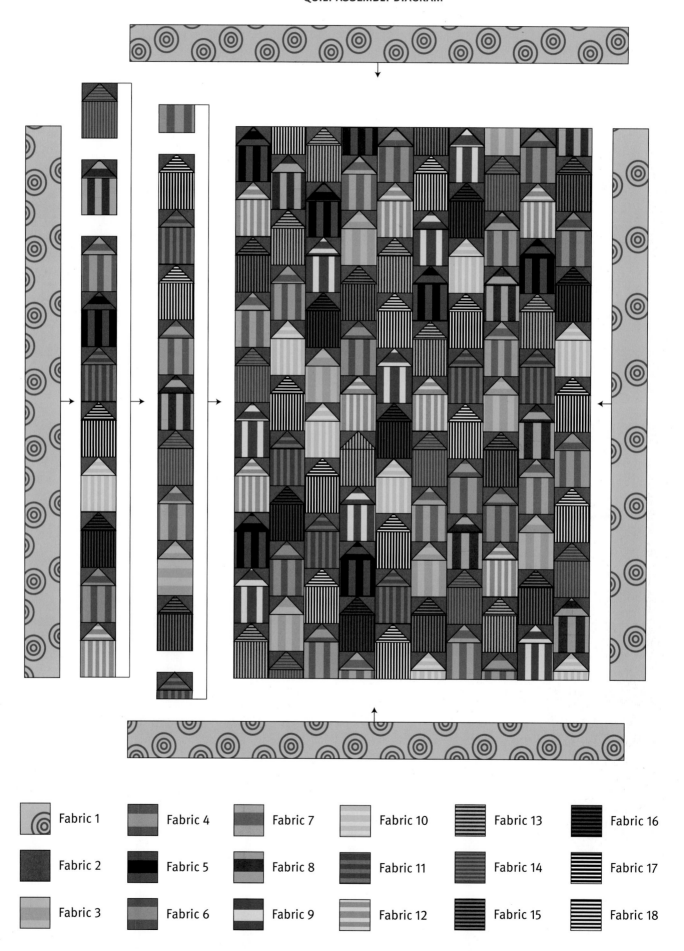

Fabric 1

Fabric 2

Fabric 3

Fabric 4

Fabric 5

Fabric 6

Fabric 7

Fabric 8

Fabric 9

Fabric 10

Fabric 11

Fabric 12

Fabric 13

Fabric 14

Fabric 15

Fabric 16

Fabric 17

Fabric 18

dusky ribbons ***

Kaffe Fassett

This soft, smoky version of the quilt that Liza originally worked out has been re-imagined in our current range of Classics fabrics, using my Spot, Aboriginal Dot and Shot Cottons along with Brandon's Jumble.

SIZE OF FINISHED QUILT
80in x 80in (203cm x 203cm)

FABRICS
Fabrics have been calculated at a maximum width of 40in (102cm). Fabrics have been given a number – see Fabric Swatch Diagram for details.

Patchwork Fabrics
EMBROIDERED SHAWL

Fabric 1	Black	½yd (50cm)

ABORIGINAL DOT

Fabric 2	Denim	3⅜yd (3.2m)
Fabric 3	Indigo	1yd (95cm)
Fabric 4	Wisteria	¾yd (70cm)
Fabric 5	Turquoise	¾yd (70cm)

SPOT

Fabric 6	Duck Egg	¼yd (25cm)
Fabric 7	Indigo	¼yd (25cm)
Fabric 8	Sage	⅜yd (40cm)
Fabric 9	Pacific	⅜yd (40cm)
Fabric 10	Mauve	½yd (50cm)
Fabric 11	Peacock	½yd (50cm)

JUMBLE

Fabric 12	Prune	¾yd (70cm)
Fabric 13	Aqua	¼yd (25cm)
Fabric 14	Maroon	½yd (50cm)
Fabric 15	Seafoam	¾yd (70cm)

SHOT COTTON

Fabric 16	Opal	½yd (50cm)
Fabric 17	Aubergine	½yd (50cm)
Fabric 18	Pesto	¾yd (70cm)

Backing and Binding Fabrics
MAD PLAID extra wide backing

Fabric 19	Turquoise	2½yd (2.3m)

NARROW STRIPE

Fabric 20	Mallard	¾yd (70cm)

Batting
88in x 88in (224cm x 224cm)

FABRIC SWATCH DIAGRAM

Patchwork Fabrics

Fabric 1
EMBROIDERED SHAWL
Black
GP106BK

Fabric 2
ABORIGINAL DOT
Denim
GP71DM

Fabric 3
ABORIGINAL DOT
Indigo
GP071IN

Fabric 4
ABORIGINAL DOT
Wisteria
GP71WS

Fabric 5
ABORIGINAL DOT
Turquoise
GP71TQ

Fabric 6
SPOT
Duck Egg
GP70DE

Fabric 7
SPOT
Indigo
GP70IN

Fabric 8
SPOT
Sage
GP70SJ

Fabric 9
SPOT
Pacific
GP70PF

Fabric10
SPOT
Mauve
GP70MV

Fabric 11
SPOT
Peacock
GP70PC

Fabric 12
JUMBLE
Prune
BM53PV

Fabric 13
JUMBLE
Aqua
BM53AQ

Fabric 14
JUMBLE
Maroon
BM53MM

Fabric 15
JUMBLE
Seafoam
BM53SE

Fabric 16
SHOT COTTON
Opal
SC114OP

Fabric 17
SHOT COTTON
Aubergine
SC117AB

Fabric 18
SHOT COTTON
Pesto
SC118PO

Backing and Binding Fabrics

Fabric 19
MAD PLAID
Turquoise
QB02TQ

Fabric 20
NARROW STRIPE
Mallard
SS02ML

TRIANGLE CUTTING DIAGRAM

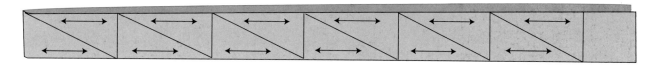

TEMPLATE

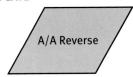

A/A Reverse

PATCHES

Finished blocks are 4in (10.2cm) squares and form 9 concentric borders around a central fussy-cut flower square.

Each block has 2 rectangles with either a dark or a light parallelogram patch cut from Template A/A Reverse, and two background triangle patches (refer to the Block Assembly Diagram).

For all the dark parallelogram patches, position Template A right-side up on a single layer of fabric (not folded), and for all the light parallelogram patches, position Template A wrong-side up on a single layer of fabric.

Background triangle patches are cut from rectangles (refer to the Triangle Cutting Diagram). Half the triangles need to be cut in one direction and half in the opposite direction, so folding the strip in half and cutting through both layers will yield both sets.

CUTTING OUT

Fabric is cut across the width unless otherwise stated. Parallelograms must be cut through a single strip of fabric, not a folded strip as the shape cannot be reversed. We recommend using spray starch on the Shot Cottons before cutting.

Centre

From Fabric 1 fussy cut a bloom centred in an 8½in (21.6cm) square. Plenty of fabric has been allowed for this.

Dark Parallelograms

Cut strips 2½in (6.4cm) wide. Use Template A right-side up on the front side of the fabric. Each strip will yield 10 parallelograms. Cut a total of 396 parallelograms from fabrics as follows:

Fabric 7 (2 strips) 12 parallelograms;
Fabric 9 (4 strips) 36 parallelograms;
Fabric 11 (6 strips) 60 parallelograms;
Fabric 12 (9 strips) 88 parallelograms;
Fabric 13 (3 strips) 28 parallelograms;
Fabric 14 (6 strips) 52 parallelograms;
Fabric 17 (5 strips) 44 parallelograms;
Fabric 18 (8 strips) 76 parallelograms.

Light Parallelograms

Cut strips 2½in (6.4cm) wide. Use Template A wrong-side up on the front side of the fabric. Each strip will yield 10 parallelograms. Cut a total of 396 parallelograms from fabrics as follows:

Fabric 4 (9 strips) 88 parallelograms;
Fabric 5 (9 strips) 88 parallelograms;
Fabric 6 (2 strips) 12 parallelograms;
Fabric 8 (4 strips) 36 parallelograms;
Fabric 10 (6 strips) 52 parallelograms;
Fabric 15 (8 strips) 76 parallelograms;
Fabric 16 (5 strips) 44 parallelograms.

Background Triangles

Referring to the Triangle Cutting Diagram, cut folded strips 1⅞in (4.8cm) wide and cross cut rectangles at 1⅞in x 3⅛in (4.8cm x 7.9cm). Each folded strip will yield 6 pairs of rectangles, therefore 24 triangles per strip. Keeping the pairs of rectangles together, cut diagonally from the top left corner to the bottom right corner of each rectangle. Each pair of rectangles will yield 2 triangles in one direction and 2 triangles in the opposite direction. Cut rectangles, then triangles, as follows:

Fabric 2 (54 strips) 640 rectangles – 1,280 triangles;
Fabric 3 (13 strips) 152 rectangles – 304 triangles.

Backing

Trim Fabric 19 to 88in x 88in (224cm x 224cm).

Binding

From Fabric 20 cut 9 strips 2½in (6.4cm) wide. Remove selvedges and sew end to end with 45° seams (see page 157).

MAKING THE QUILT

Using a design wall will help to place patches in the required layout.
Use ¼in (6mm) seams throughout.

Making the Blocks

Referring to the Block Assembly Diagram, sew corresponding Fabric 2 background triangles to parallelograms (a), press seams towards the background triangles and sew pairs of dark and light patches together (b) to form each block (c). Make a total of 396 blocks for the 9 borders as follows:
Border 1: 12 blocks in Fabric 6 and Fabric 7;
Border 2: 20 blocks in Fabric 4 and Fabric 12;
Border 3: 28 blocks in Fabric 5 and Fabric 13;
Border 4: 36 blocks in Fabric 8 and Fabric 9;

BLOCK ASSEMBLY DIAGRAM

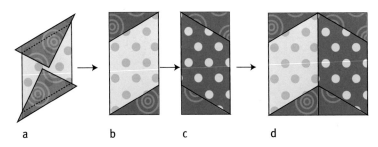

a b c d

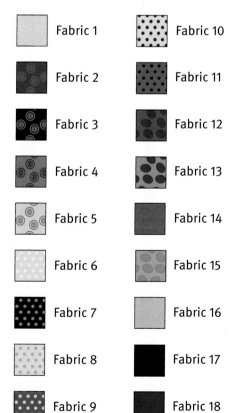

QUILT ASSEMBLY DIAGRAM 1

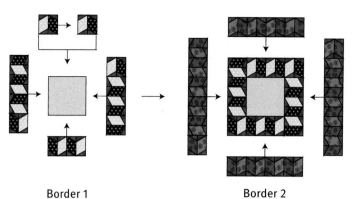

Border 1 Border 2

Border 5: 44 blocks in Fabric 16 and Fabric 17;
Border 6: 52 blocks in Fabric 10 and Fabric 14;
Border 7: 60 blocks in Fabric 5 and Fabric 11;
Border 8: 68 blocks in Fabric 4 and Fabric 12.
In the same way, sew corresponding Fabric 3 background triangles to parallelograms to make blocks for the outer border:
Border 9: 76 blocks in Fabric 15 and Fabric 18.

Centre

Using a design wall and referring to Quilt Assembly Diagram 1 and the quilt photograph, lay out the blocks in borders around the central flower block. Check the blocks are positioned correctly to maintain the folded ribbon pattern of light and dark. In particular, check the direction of the blocks at the corners of each border.

Sew each border onto the centre as shown in Quilt Assembly Diagram 1, sewing rows of blocks together for the top and bottom border, then sewing blocks together for the side borders.

For each border, first sew on the top and bottom border, then add the longer side borders.

Pin, to prevent stretching, and continue to sew each border in turn, referring to Quilt Assembly Diagram 2.

FINISHING THE QUILT

Press the quilt top. Layer the quilt top, batting and backing, and baste together (see page 156).
Quilt as desired.
Trim the quilt edges and attach the binding (see page 157).

Fabric 1 Fabric 10

Fabric 2 Fabric 11

Fabric 3 Fabric 12

Fabric 4 Fabric 13

Fabric 5 Fabric 14

Fabric 6 Fabric 15

Fabric 7 Fabric 16

Fabric 8 Fabric 17

Fabric 9 Fabric 18

QUILT ASSEMBLY DIAGRAM 2

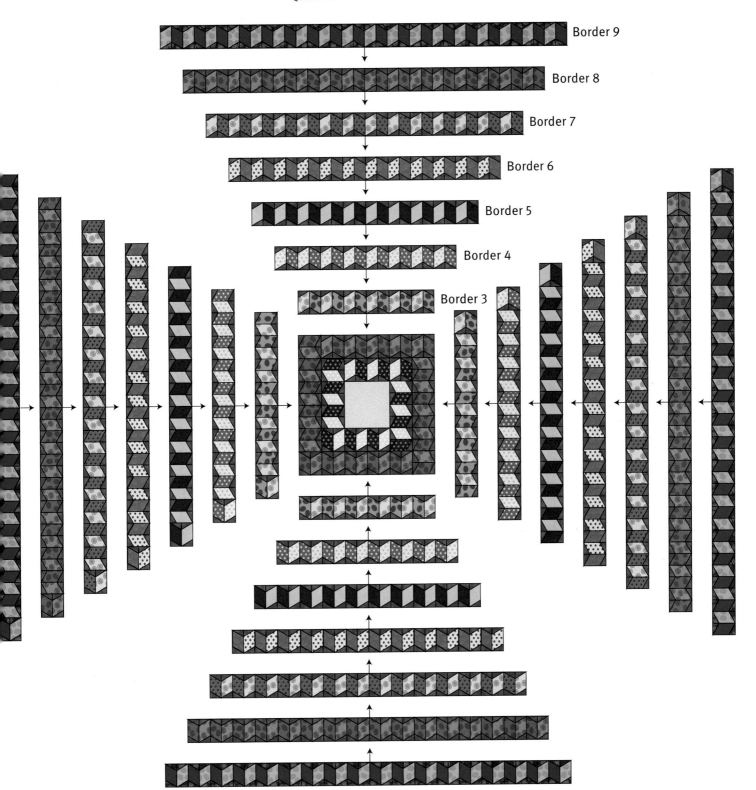

Border 9

Border 8

Border 7

Border 6

Border 5

Border 4

Border 3

trio of cushions *

Kaffe Fassett

Jiggery Pokery

These three cushions are inspired by quilts from our earlier books.

Jiggery Pokery is taken from the *Jiggery Pokery* quilt in *Quilt Romance*, my 11th book in the series. Made of two simple blocks, it features Brandon's new Brollies fabric. (We have included enough fabric in the Patchwork fabrics yardage to make a pair of cushions.)

Fruit Sorbet (see page 102) harks back to the *Fruits of the Forest* quilt in *Quilts in Burano* (22nd in the series). It can be made from scraps and would sit beautifully with our *Love in the Mist* quilt.

Marble Tile (see page 103) is a nod to the *Marble Tiles* quilt in *Quilts in Wales* (24th in the series). Using a single block is made more interesting by randomly arranging the stripy borders and binding.

Fruit Sorbet

Marble Tile

jiggery pokery

This fabric requirements for this cushion are sufficient to make two cushions, but instructions are for one only, so double up patch/border numbers if making two. Each cushion requires a 16in (40cm) cushion pad.

SIZE OF FINISHED CUSHION
16in x 16in (40cm x 40 cm)

FABRICS
Fabrics have been calculated at a maximum width of 40in (102cm). Fabrics have been given a number – see Fabric Swatch Diagram for details.

Patchwork Fabrics
JUMBLE
Fabric 1 Royal ¼yd (25cm)
BROLLIES
Fabric 2 Yellow ¼yd (25cm)
BUBBLE STRIPE
Fabric 3 Black ⅜yd (40cm)

Backing Fabric
REGIMENTAL TIES
Fabric 4 Multi ½yd (50cm)

FABRIC SWATCH DIAGRAM

Fabric 1
JUMBLE
Royal
BM53RY

Fabric 2
BROLLIES
Yellow
BM83YE

Fabric 3
BUBBLE STRIPE
Black
BM82BK

Backing Fabric

Fabric 4
REGIMENTAL TIES
Multi
GP189MU

ASSEMBLY DIAGRAM

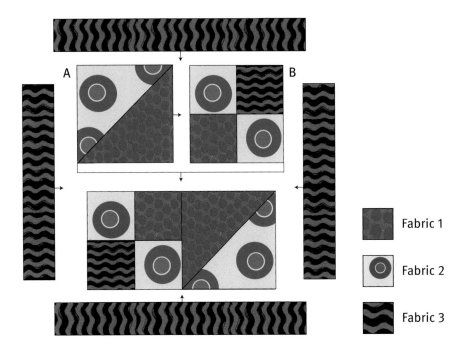

PATCHES
This cushion is made from square and triangle patches plus a border. Block A is made from half-square triangles cut from 6⅞in (17.5cm) squares. Block B is made from 3½in (8.9cm) squares. Both blocks are 6in (15.2cm) square finished.

CUTTING OUT
Block A
From each of Fabric 1 and 2 cut a square 6⅞in x 6⅞in (17.5cm x 17.5cm). Cut each square diagonally once to yield 2 half-square triangles from each fabric.

Block B
From each of Fabric 3 and the remaining Fabrics 1 and 2 cut a strip 3½in (8.9cm) wide and cross cut squares at 3½in (8.9cm) from fabrics as follows:
Fabric 1: 2 squares; Fabric 2: 4 squares; Fabric 3: 2 squares.

Border
From the remaining Fabric 3 cut 2 strips 2½in (6.4cm) wide and cut border pieces as follows: 2 longer pieces 16½in x 2½in (41.9cm x 6.4cm); 2 shorter pieces for the sides 12½in x 2½in (31.8cm x 6.4cm).

Backing
From Fabric 4 cut 2 pieces 16½in x 10in (41.9cm x 25.4cm).

MAKING THE CUSHION
Sew Fabric 1 and 2 triangles together to make 2 Block A squares and press seams towards darker fabric.
Referring to the Assembly Diagram, arrange 4 block B squares. Sew the squares together in pairs, then sew the pairs together. Make 2 blocks.
Arrange the 4 blocks together as shown in the Assembly Diagram. Sew the blocks together in 2 pairs, pressing seams towards the darker fabrics. Then sew pairs together to make the cushion centre.
Attach the shorter side borders first, pressing seams towards the borders; then pin, and sew the longer top and bottom borders.

FINISHING THE CUSHION
For the overlapping backing, place the two Fabric 4 backing pieces face up and turn over a small hem on each overlapping long side; press and stitch. Position the overlapping back pieces face down on the cushion top face up, and align all side edges of the cushion front and back pieces. Matching the corners, pin and sew a ¼in (6mm) seam all round. Trim the corners, turning the cushion right sides out through the overlapping backing pieces.

fruit sorbet

This pinwheel block cushion could be made from the scraps of any quilt. Make them into blocks featuring alternating light and dark fabric triangles.

SIZE OF FINISHED CUSHION
18in x 18in (46cm x 46cm)

FABRICS
Fabrics have been calculated at a maximum width of 40in (102cm). Fabrics have been given a number – see Fabric Swatch Diagram for details.

Patchwork Fabrics
SPOT
Fabric 1 Apple ⅛yd (15cm)
Fabric 2 Hydrangea ⅛yd (15cm)
Fabric 3 Silver ⅛yd (15cm)
Fabric 4 Sky ⅛yd (15cm)
ABORIGINAL DOT
Fabric 5 Turquoise ⅛yd (15cm)
Fabric 6 Wisteria ⅛yd (15cm)
Fabric 7 Cantaloupe ⅛yd (15cm)
JUMBLE
Fabric 8 Yellow ⅛yd (15cm)

Backing Fabric
BIG BLOOMS
Fabric 9 Pastel ⅝yd (60cm)

PATCHES
Pinwheel blocks are made from half-square triangles cut from 3⅞in (9.8cm) squares. Finished blocks are 6in (15.2cm) squares set in 3 rows of 3 squares.

CUTTING OUT
Fabric is cut across the width.

Pinwheel Triangles
Cut strips 3⅞in (9.8cm) wide and cross cut squares at 3⅞in (9.8cm). Cut each square diagonally once to yield 2 half-square triangles from each square. Cut 72 triangles from fabrics as follows:
Fabric 1 4 squares – 8 triangles;
Fabric 2 4 squares – 8 squares;
Fabric 3 6 squares – 12 triangles;
Fabric 4 4 squares – 8 triangles;
Fabric 5 6 squares – 12 triangles;
Fabric 6 4 squares – 8 triangles;
Fabric 7 4 squares – 8 triangles;
Fabric 8 4 squares – 8 triangles.

FABRIC SWATCH DIAGRAM

Patchwork Fabrics

Fabric 1
SPOT
Apple
GP70AL

Fabric 2
SPOT
Hydrangea
GP70HY

Fabric 3
SPOT
Silver
GP70SV

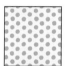
Fabric 4
SPOT
Sky
GP70SK

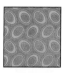
Fabric 5
ABORIGINAL DOT
Turquoise
GP71TQ

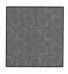
Fabric 6
ABORIGINAL DOT
Wisteria
GP71WS

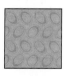
Fabric 7
ABORIGINAL DOT
Cantaloupe
GP71CA

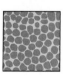
Fabric 8
JUMBLE
Yellow
BM53YE

Backing Fabric

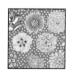
Fabric 9
BIG BLOOMS
Pastel
GP91PT

Backing
From Fabric 9 cut 2 pieces 18½in x 12½in (47cm x 31.8cm).

ASSEMBLY DIAGRAM

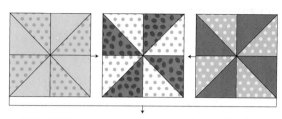

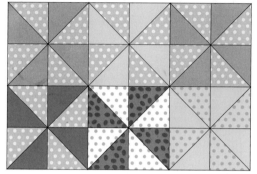

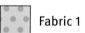 Fabric 1 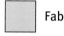 Fabric 5

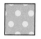 Fabric 2 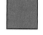 Fabric 6

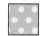 Fabric 3 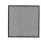 Fabric 7

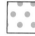 Fabric 4 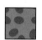 Fabric 8

MAKING THE CUSHION
Use ¼in (6mm) seams throughout.

Pinwheel Blocks
Referring to the Assembly Diagram, sew pairs of light and dark triangles together along the long edge to form a square and press seams towards the darker fabric. Sew pairs of squares together, then sew the pairs together to form each pinwheel block. Make 9 blocks in total.

Centre
Sew the blocks together into 3 rows of 3 blocks as shown in the Assembly Diagram. Press seams in opposite directions on each row. Sew the 3 rows together, carefully matching crossing seams.

FINISHING THE CUSHION
See page 101.

marble tile

The geometry of this single-block cushion is made interesting by the randomly arranged stripy borders and binding.

SIZE OF FINISHED CUSHION
19in x 19in (48cm x 48 cm)

FABRICS
Fabrics have been calculated at a maximum width of 40in (102cm). Fabrics have been given a number – see Fabric Swatch Diagram for details.

Patchwork Fabrics
SPOT
Fabric 1	Indigo	⅛yd (15cm)
Fabric 2	Silver	⅛yd (15cm)

ABORIGINAL DOT
Fabric 3	Ocean	⅛yd (15cm)

WIDE STRIPE
* Fabric 4	Shell	¾yd (70cm)

* includes Binding

Backing Fabric
SPOT
Fabric 5	Noir	⅝yd (60cm)

PATCHES
The cushion is made up of four triangles, each with a small centre right-angled triangle and two border strips sewn to the longer edge, making up four large triangles.

CUTTING OUT
Fabric is cut across the width unless otherwise stated.

Centre Triangles
From each of Fabrics 1, 2 and 3 cut a strip 4in (10.2cm) wide. Using the 45° marking on your ruler, cut one right-angled triangle from Fabrics 1 and 2, and cut 2 right-angled triangles from Fabric 3.

Borders
From Fabric 4 cut borders as follows:
Border 1: Cut 2 strips 4in (10.2cm) wide and cross cut 4 rectangles 15½in x 4in (39.4cm x 10.2cm).
Border 2: Cut 3 strips 3in (7.6cm) wide and cross cut 4 rectangles 21in x 3in (50.8cm x 7.6cm). Join strips end to end if required.

FABRIC SWATCH DIAGRAM

Patchwork Fabrics

Fabric 1
SPOT
Indigo
GP70IN

Fabric 2
SPOT
Silver
GP70SV

Fabric 3
ABORIGINAL DOT
Ocean
GP71ON

Fabric 4 and Binding
WIDE STRIPE
Shell
SS01SH

Backing Fabric

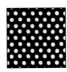

Fabric 5
SPOT
Noir
GP70NO

Binding
From Fabric 4 cut 2 strips 2½in (6.4cm) wide. Remove selvedges and sew end to end with 45° seams (see page 157).

Backing
From Fabric 5 cut 2 pieces 20½in x 15in (52.1cm x 38.1cm).

MAKING THE CUSHION
Use ¼in (6mm) seams throughout.

Assembling
Referring to the Assembly Diagram (a and b), make 4 triangles. Mark the centre of the long side of each triangle and the centre of the length of each of the Border 1 and 2 rectangles. Arrange the patches as shown, aligning the centres, then sew together. Press each seam towards the centre. Using a cutting mat, quilt

ASSEMBLY DIAGRAM

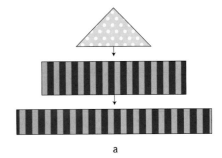

a

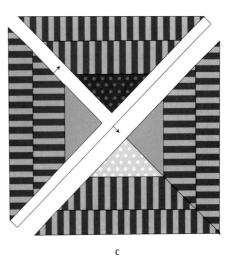

b

c

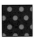 Fabric 1 Fabric 3

 Fabric 2 Fabric 4

ruler and rotary cutter, carefully line up the 45° angle for each quarter and cut diagonally (b) to make large triangles with long edges 19¾in (50.2cm) long. Sew the quarters of the cushion top together into two pairs, then sew the two halves together (c).

FINISHING THE CUSHION
See page 101.

flower boxes **

Kaffe Fassett

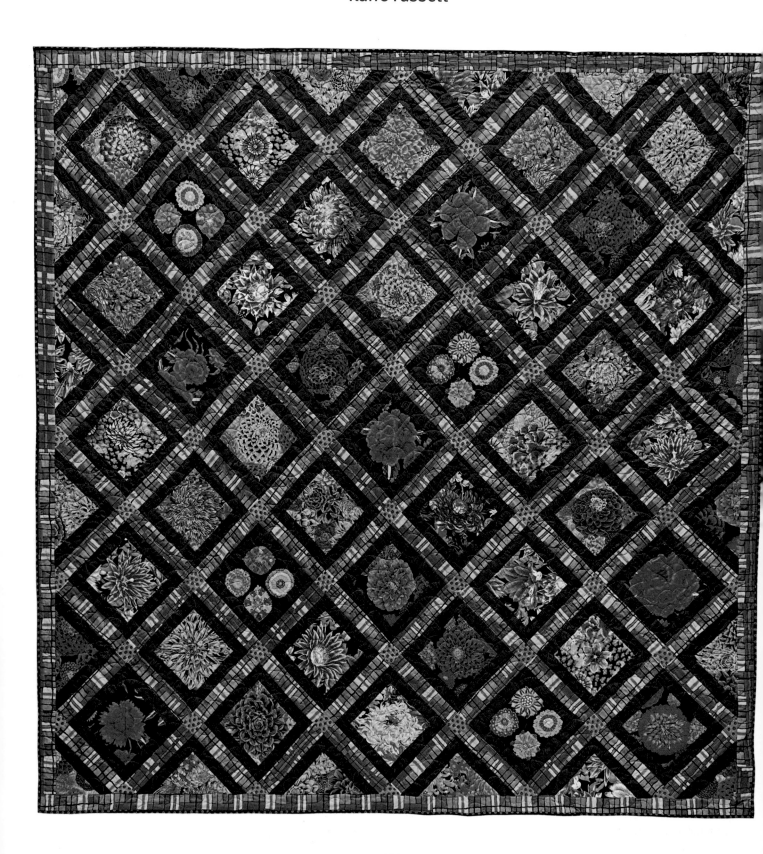

This reimagination of an original quilt shows off some of the Kaffe Fassett Collective's floral statement fabrics, given even more character by Brandon's Checkmate design for the sashing.

SIZE OF FINISHED QUILT
93in x 93in (236cm x 236cm)

FABRICS
Fabrics have been calculated at a maximum width of 40in (102cm). Fabrics have been given a number – see Fabric Swatch Diagram for details.

Patchwork Fabrics
EMBROIDERED SHAWL
Fabric 1	Red	⅝yd (60cm)

CARPET COOKIES
Fabric 2	Black	⅝yd (60cm)

DREAM
Fabric 3	Dark	⅝yd (60cm)

SHAGGY
Fabric 4	Black	⅝yd (60cm)

CACTUS FLOWER
Fabric 5	Black	¾yd (70cm)

HOKUSAI'S MUMS
Fabric 6	Dark	⅝yd (60cm)

HOUSE LEEKS
Fabric 7	Dark	⅝yd (60cm)

FLORA
Fabric 8	Blue	⅝yd (60cm)
Fabric 9	Dark	⅝yd (60cm)

ABORIGINAL DOT
Fabric 10	Orchid	3yd (2.8m)

CHECKMATE
Fabric 11	Dark	3⅛yd (2.9m)

SPOT
Fabric 12	Peacock	⅜yd (40cm)

Backing and Binding Fabrics
MILLEFIORE
Fabric 13	Dark	7¼yd (6.7m)

SPOT
Fabric 14	Black	⅞yd (85cm)

Batting
101in x 101in (257cm x 257cm)

PATCHES
The feature squares are fussy-cut 8in (20.3cm) squares, centering blooms. Each square block includes a narrow 1½in (3.8cm) finished border. These framed blocks are set on point in diagonal rows, separated by sashing strips with corner squares. The rows are completed with setting triangles: quarter-square triangles for the side-setting triangles and half-square triangles for the corners. The quilt is finished with a simple border matching the sashing.

FABRIC SWATCH DIAGRAM

Patchwork Fabrics

Fabric 1
EMBROIDERED SHAWL
Red
GP106RD

Fabric 2
CARPET COOKIES
Black
GP192BK

Fabric 3
DREAM
Dark
GP148DK

Fabric 4
SHAGGY
Black
PJ72BK

Fabric 5
CACTUS FLOWER
Black
PJ96BK

Fabric 6
HOKUSAI'S MUMS
Dark
PJ107DK

Fabric 7
HOUSE LEEKS
Dark
PJ113DK

Fabric 8
FLORA
Blue
PJ114BL

Fabric 9
FLORA
Dark
PJ114DK

Fabric 10
ABORIGINAL DOT
Orchid
GP71OD

Fabric 11
CHECKMATE
Dark
BM86DK

Fabric 12
SPOT
Peacock
GP70PC

Backing and Binding Fabrics

Fabric 13
MILLEFIORE
Dark
GP92DK

Fabric 14
SPOT
Black
GP70BK

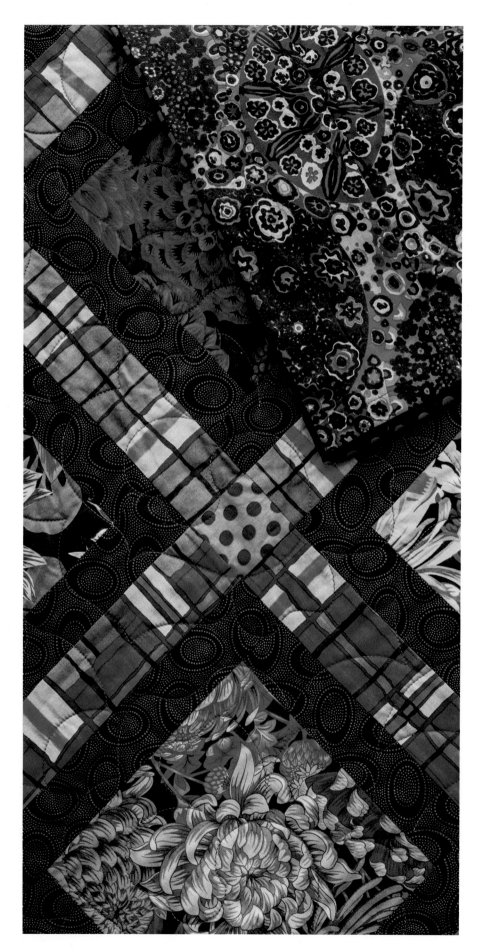

CUTTING OUT

Fabric is cut across the width unless otherwise stated.

Side-setting Triangles

From each of Fabrics 5, 6, 7 and 9, cut a square (not fussy cut) at 11⅞in (30.2cm). Cross cut each square twice diagonally to yield 4 quarter-square triangles from each, 16 side-setting triangles in total.

Feature Squares

Make a cardboard template (or use an acrylic template or ruler) to fussy cut 8in (20.3cm) squares. Cut a total of 41 feature squares from fabrics as follows:

Fabric 1 5 squares;
Fabric 2 4 squares;
Fabric 3 4 squares;
Fabric 4 4 squares;
Fabric 5 6 squares;
Fabric 6 4 squares;
Fabric 7 4 squares;
Fabric 8 5 squares;
Fabric 9 5 squares.

Corner-setting Triangles

From the remaining Fabrics 2, 4 and 8, cut a 6¼in (15.9cm) square and cross cut each once diagonally to yield 2 half-square triangles. You will need the following:

Fabric 2 1 triangle;
Fabric 4 1 triangle;
Fabric 8 2 triangles.

Framing Strips

From Fabric 10 cut 1 strip 13in (33cm) wide and cross cut 16 long framing strips measuring 13in x 2in (33cm x 5.1cm). Each strip will yield 20 framing strips.

Trim the remaining Fabric 10 strip to 11in (27.9cm) wide and cut 5 additional strips 11in (27.9cm) wide. Cross cut 102 medium framing strips measuring 11in x 2in (27.9cm x 5.1cm). Each strip will yield 20 framing strips.

Trim the remaining Fabric 10 strip to 8in (20.3cm) wide and cut 4 additional strips 8in (20.3cm) wide. Cross cut 82 short framing strips measuring 8in x 2in (20.3cm x 5.1cm). Each strip will yield 20 framing strips.

BLOCK ASSEMBLY DIAGRAM

a

b

c

Trim to fit

d

Trim to fit

e

f

Sashing and Border
From Fabric 11 cut 7 strips 11in (27.9cm) wide and cross cut a total of 100 sashing strips measuring 11in x 2½in (27.9cm x 6.4cm). Each strip will yield 16 sashing strips.

For the border, also from Fabric 11, cut 10 strips 2½in (6.4cm) wide. Join the strips end to end using ¼in (6mm) seams, and press seams open. From the length: cut 2 pieces 94in x 2½in (238.8cm x 6.4cm) for the top and bottom borders; cut 2 pieces 90in x 2½in (228.6cm x 6.4cm) for the side borders.

Sashing Squares
From Fabric 12 cut 4 strips 2½in (6.4cm) wide and cross cut a total of 60 squares at 2½in (6.4cm). Each strip will yield 16 sashing squares.

Backing
From Fabric 13 cut 2 pieces 101in (257cm) long and 1 piece 51in (130cm) long.

Binding
From Fabric 14 cut 10 strips 2½in (6.4cm) wide. Remove selvedges and sew end to end with 45° seams (see page 157).

MAKING THE QUILT
Using a design wall will help to place patches in the required layout.
Use ¼in (6mm) seams throughout.

Making the Feature Blocks
Square Blocks: Referring to the Block Assembly Diagram, sew a Fabric 10 short framing strip to opposite sides of a feature square (a) and press seams towards the framing strip. Sew a Fabric 10 medium framing strip to the remaining two sides (b) and press seams towards the framing strip. Make 41 square blocks.

Side-setting Triangle Blocks: Referring to the Block Assembly Diagram, sew a Fabric 10 medium framing strip to a short side of the triangle (c) and press

seams towards the framing strip. Sew a Fabric 10 long framing strip to the remaining short side of the triangle and press seams towards the framing strip. Trim excess as shown (d). Make 16 side-setting triangle blocks.

Corner-setting Triangle Blocks: Referring to the Block Assembly Diagram, sew a Fabric 10 medium framing strip to the long side of the triangle (e) and press seam towards the framing strip. Trim excess as shown (f). Make 4 corner-setting triangle blocks.

Centre
Lay out the blocks in diagonal rows referring to the Quilt Assembly Diagram on page 108 and the quilt photograph, adding a sashing strip between each block and then a sashing square at the junctions between each sashing strip. Sew together one diagonal row at a time, pressing seams towards the sashing strips. Pin, then sew the diagonal rows together, taking care to align crossing seams. Trim the excess sashing squares once the rows are sewn together.

Border
Pin, then sew the shorter side borders to the centre. Press seams towards the borders. Pin, then sew the longer top and bottom borders to the centre and press to complete the quilt top.

FINISHING THE QUILT
Remove selvedges from the three Fabric 13 backing pieces. Cut the shorter piece down the centre of the fabric, sew the two pieces together across the shorter edge and press seams open to make a piece 101in x 20in (257cm x 51cm). Sew the three lengths together to form a piece 101in x 101in (257cm x 257cm). Press the quilt top. Layer the quilt top, batting and backing, and baste together (see page 156).

Quilt as desired.
Trim the quilt edges and attach the binding (see page 157).

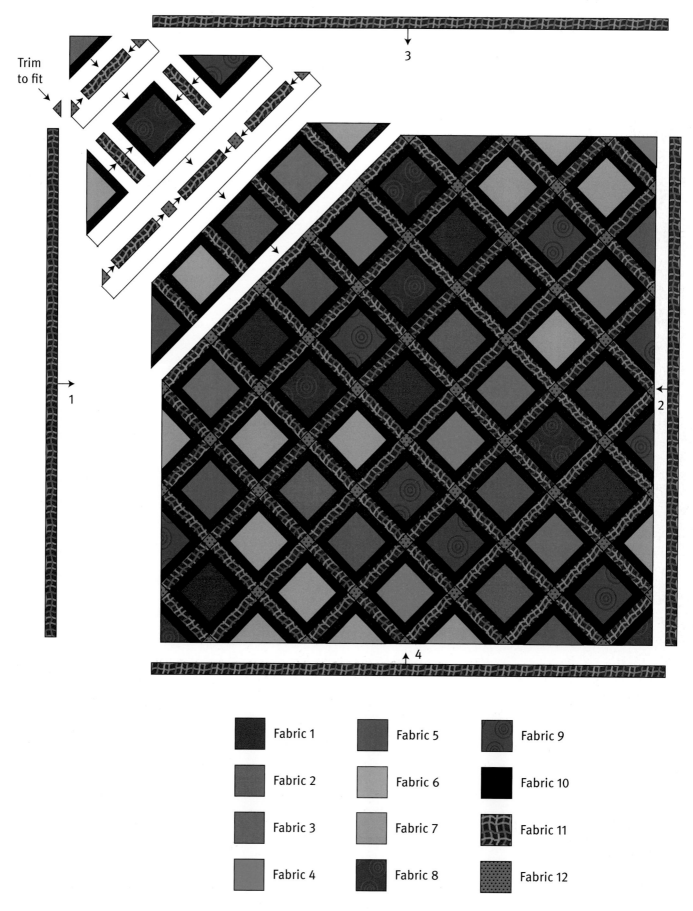

Trim to fit

1

2

3

4

Fabric 1

Fabric 5

Fabric 9

Fabric 2

Fabric 6

Fabric 10

Fabric 3

Fabric 7

Fabric 11

Fabric 4

Fabric 8

Fabric 12

colour garden *

Kaffe Fassett

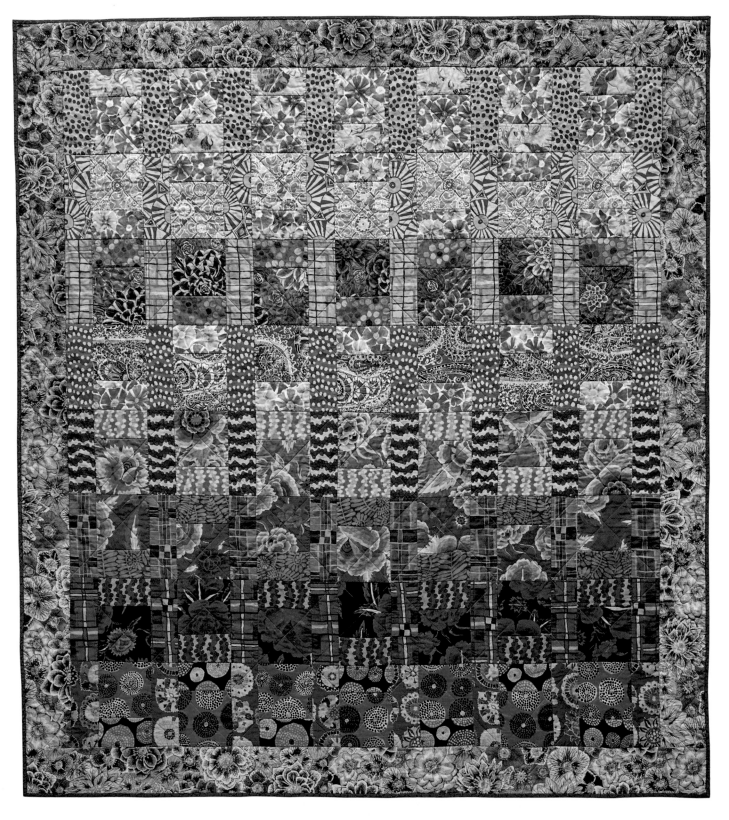

This quilt shows off a selection of Brandon's, Philip's and my designs from our current fabric collections.

SIZE OF FINISHED QUILT
82in x 76in (208cm x 193cm)

FABRICS
Fabrics have been calculated at a maximum width of 40in (102cm). Fabrics have been given a number – see Fabric Swatch Diagram for details.

Patchwork Fabrics
DISKS
Fabric 1	Black	¼yd (25cm)
Fabric 2	Blue	½yd (50cm)

FLOWER DOT
Fabric 3	Pink	¼yd (25cm)

BUBBLE STRIPE
Fabric 4	Aqua	¼yd (25cm)
Fabric 5	Blue	¼yd (25cm)
Fabric 6	Pink	¼yd (25cm)
Fabric 7	Purple	¼yd (25cm)
Fabric 8	Red	¼yd (25cm)

BROLLIES
Fabric 9	Green	¼yd (25cm)

FRONDS
Fabric 10	Orange	¼yd (25cm)

CHECKMATE
Fabric 11	Brown	¼yd (25cm)
Fabric 12	Grey	¼yd (25cm)
Fabric 13	Pink	¼yd (25cm)

CARPET COOKIES
Fabric 14	Magenta	¼yd (25cm)

PAISLEY JUNGLE
Fabric 15	Cobalt	½yd (50cm)

EMBROIDERED SHAWL
Fabric 16	Blue	½yd (50cm)
Fabric 17	Magenta	½yd (50cm)
Fabric 18	Red	½yd (50cm)

HOUSE LEEKS
Fabric 19	Red	½yd (50cm)

MEADOW
Fabric 20	Pastel	¼yd (25cm)

PINWHEELS
Fabric 21	Blue	¼yd (25cm)
Fabric 22	Spring	⅝yd (60cm)

TUDOR
Fabric 23	Pastel	½yd (50cm)

HELLEBORES
Fabric 24	Pink	1⅜yd (1.3m)

Backing and Binding Fabrics
TREE FUNGI extra wide backing
Fabric 25	Pink	2⅜yd (2.25m)

JUMBLE
Fabric 26	Lapis	¾yd (70cm)

Batting
91in x 85in (231cm x 216cm)

PATCHES
Patches are a square 6in (15.2cm) finished, a short rectangle 6in x 3in (15.2cm x 7.6cm) finished and a long rectangle 9in x 3in (22.9cm x 7.6cm) finished. All patches are cut from strips and sewn together into 8 rows. The quilt is finished with a 5in (12.7cm) border.

CUTTING OUT
Fabric is cut across the width unless otherwise stated.

Squares
From each of Fabrics 2, 15, 16, 17, 18, 19, 22 and 23, cut 2 strips 6½in (16.5cm) wide and cross cut squares at 6½in (16.5cm). Each strip will yield 6 squares. Cut 7 squares from each fabric, a total of 56 squares.

Long Rectangles
From each of Fabrics 5, 6, 7, 9, 11, 12, 13 and 14, cut 2 strips 3½in (8.9cm) wide and cross cut rectangles 9½in x 3½in (24.1cm x 8.9cm). Each strip will yield 4 rectangles. Cut 8 long rectangles from each fabric, a total of 64 long rectangles.

Short Rectangles
From each of Fabrics 1, 3, 4, 8, 10, 20, 21 and 22, cut 2 strips 3½in (8.9cm) wide and cross cut rectangles 6½in x 3½in (16.5cm x 8.9cm). Each strip will yield 6 rectangles. Cut 7 short rectangles from each fabric, a total of 54 short rectangles.

Border
From Fabric 24 cut 8 strips 5½in (14cm) wide. Join strips end to end using ¼in (6mm) seams, and press seams open. From the length cut 2 pieces 72½in x 5½in (184.2cm x 14cm) long for the side borders and 2 pieces 76½in x 5½in (194.3cm x 14cm) long for the top and bottom borders.

Backing
From Fabric 25 cut a piece 91in x 85in (231cm x 216cm).

Binding
From Fabric 26 cut 9 strips 2½in (6.4cm) wide. Remove selvedges and sew end to end with 45° seams (see page 157).

MAKING THE QUILT
Using a design wall will help to place patches in the required layout.
Use ¼in (6mm) seams throughout.

Centre
Lay out the patches referring to the Quilt Assembly Diagram on page 112 and the quilt photograph. Once you have checked the layout is correct, sew the small rectangles to the squares, and return to the layout ensuring the pieces alternate between small rectangles at the top and small rectangles at the bottom. Sew each row of patches together, pressing seams in opposite directions on alternate rows – odd rows to the left, even rows to the right – to allow the finished seams to lie flat. Sew the rows together, taking care to align crossing seams.

Borders (and Corner Squares)
Pin (to prevent stretching the borders) and sew the longer Fabric 24 border pieces to the quilt sides. Press, then pin and sew the shorter top and bottom borders to the centre to complete the quilt top.

FINISHING THE QUILT
Press the quilt top. Layer the quilt top, batting and backing, and baste together (see page 156).
Quilt as desired.
Trim the quilt edges and attach the binding (see page 157).

FABRIC SWATCH DIAGRAM

Patchwork Fabrics

Fabric 1
DISKS
Black
GP193BK

Fabric 2
DISKS
Blue
GP193BL

Fabric 3
FLOWER DOT
Pink
BM77PK

Fabric 4
BUBBLE STRIPE
Aqua
BM82AQ

Fabric 5
BUBBLE STRIPE
Blue
BM82BL

Fabric 6
BUBBLE STRIPE
Pink
BM82PK

Fabric 7
BUBBLE STRIPE
Purple
BM82PU

Fabric 8
BUBBLE STRIPE
Red
BM82RD

Fabric 9
BROLLIES
Green
BM83GN

Fabric 10
FRONDS
Orange
BM85OR

Fabric 11
CHECKMATE
Brown
BM86BR

Fabric 12
CHECKMATE
Grey
BM86GY

Fabric 13
CHECKMATE
Pink
BM86PK

Fabric 14
CARPET COOKIES
Magenta
GP192MG

Fabric 15
PAISLEY JUNGLE
Cobalt
GP60CB

Fabric 16
EMBROIDERED SHAWL
Blue
GP106BL

Fabric 17
EMBROIDERED SHAWL
Magenta
GP106MG

Fabric 18
EMBROIDERED SHAWL
Red
GP106RD

Fabric 19
HOUSE LEEKS
Red
PJ113RD

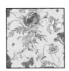
Fabric 20
MEADOW
Pastel
PJ116PT

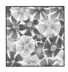
Fabric 21
PINWHEELS
Blue
PJ117BL

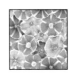
Fabric 22
PINWHEELS
Spring
PJ117SP

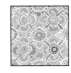
Fabric 23
TUDOR
Pastel
GP195PT

Fabric 24
HELLEBORES
Pink
PJ118PK

Backing and Binding Fabrics

Fabric 25
TREE FUNGI
Pink
QP01PK

Fabric 26
JUMBLE
Lapis
BM53LP

QUILT ASSEMBLY DIAGRAM

Fabric 1	Fabric 5	Fabric 9	Fabric 13	Fabric 17	Fabric 21
Fabric 2	Fabric 6	Fabric 10	Fabric 14	Fabric 18	Fabric 22
Fabric 3	Fabric 7	Fabric 11	Fabric 15	Fabric 19	Fabric 23
Fabric 4	Fabric 8	Fabric 12	Fabric 16	Fabric 20	Fabric 24

little jars ***

Kaffe Fassett

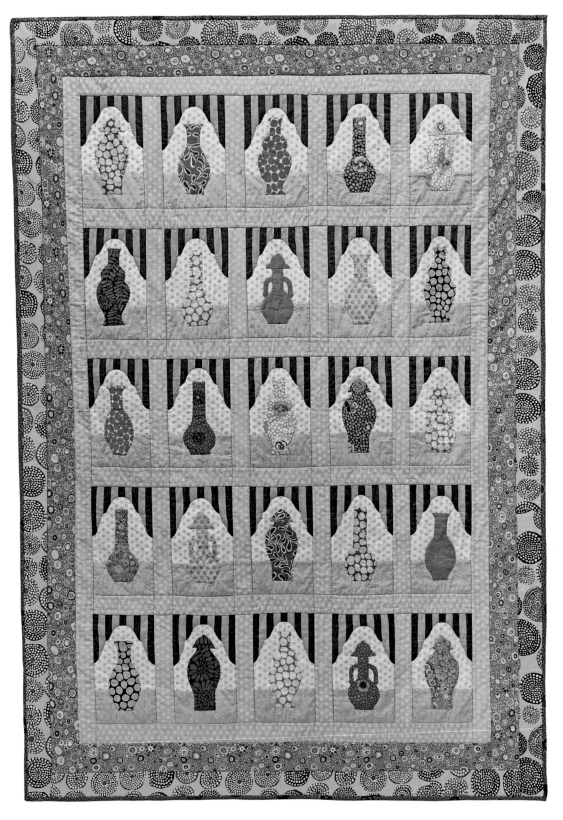

The original design for this quilt was also in soft pastels, but this new take on it, while still using pastels, is made more lively with some of our newer prints and Classics colourways.

SIZE OF FINISHED QUILT
81in x 58in (206cm x 147cm)

FABRICS
Fabrics have been calculated at a maximum width of 40in (102cm). Fabrics have been given a number – see Fabric Swatch Diagram for details.

Patchwork Fabrics
SPOT
Fabric 1	Magnolia	1¼yd (1.2m)
Fabric 2	Yellow	⅝yd (60cm)
Fabric 3	Duck Egg	1½yd (1.4m)

WIDE STRIPE
| Fabric 4 | Shell | 1yd (95cm) |

JUMBLE
Fabric 5	Cobalt	¼yd (25cm)
Fabric 6	Lime	¼yd (25cm)
Fabric 7	Rose	¼yd (25cm)
Fabric 8	Turquoise	¼yd (25cm)

FRONDS
| Fabric 9 | Orange | ¼yd (25cm) |

GUINEA FLOWER
| Fabric 10 | Apricot | ¼yd (25cm) |
| Fabric 11 | Pink | ¼yd (25cm) |

* see also Binding Fabric
| Fabric 12 | Turquoise | ¼yd (25cm) |

MILLEFIORE
| Fabric 13 | Mauve | ¼yd (25cm) |

TWIG
| Fabric 14 | Pink | ¼yd (25cm) |

SPOT
| Fabric 15 | Turquoise | ¼yd (25cm) |

ABORIGINAL DOT
| Fabric 16 | Wisteria | ¼yd (25cm) |

ROMAN GLASS
| Fabric 17 | Lavender | ¾yd (70cm) |

DISKS
| Fabric 18 | Lime | ¾yd (70cm) |

Backing and Binding Fabrics
FLOWER DOT
| Fabric 19 | Aqua | 5yd (4.65m) |

GUINEA FLOWER
| Fabric 11 | Pink | ⅝yd (60cm) |

* see also Patchwork Fabrics

Batting
89in x 67in (226cm x 170cm)

FABRIC SWATCH DIAGRAM

Patchwork Fabrics

Fabric 1
SPOT
Magnolia
GP70MN

Fabric 2
SPOT
Yellow
GP70YE

Fabric 3
SPOT
Duck Egg
GP70DE

Fabric 4
WIDE STRIPE
Shell
SS01SH

Fabric 5
JUMBLE
Cobalt
BM53CB

Fabric 6
JUMBLE
Lime
BM53LM

Fabric 7
JUMBLE
Rose
BM53RO

Fabric 8
JUMBLE
Turquoise
BM53TQ

Fabric 9
FRONDS
Orange
BM85OR

Fabric 10
GUINEA FLOWER
Apricot
GP59AP

Fabric 11
GUINEA FLOWER
Pink
GP59PK

Fabric 12
GUINEA FLOWER
Turquoise
GP59TQ

Fabric 13
MILLEFIORE
Mauve
GP92MV

Fabric 14
TWIG
Pink
GP196PK

Fabric 15
SPOT
Turquoise
GP70TQ

Fabric 16
ABORIGINAL DOT
Wisteria
GP71WS

Fabric 17
ROMAN GLASS
Lavender
GP01LV

Fabric 18
DISKS
Lime
GP193LM

Backing and Binding Fabrics

Fabric 19
FLOWER DOT
Aqua
BM77AQ

Fabric 11
GUINEA FLOWER
Pink
GP59PK

TEMPLATES

1 2 3 4 5 6

Copy all the appliqué templates onto thin card (see page 154), including the separate lids and handles.

PATCHES

The quilt gives the appearance of a wall of narrow-bordered shelves, each containing a bottle or vase. It is made up of 25 blocks set in 5 rows of 5 blocks, separated with sashing strips. Each block has a finished size of 11½in x 7in (29.2cm x 17.8cm) with a background of a large and a small rectangle. The blocks each have a canopy overlay and a bottle shape that are appliquéd in place.

CUTTING OUT

Fabric is cut across the width unless otherwise stated.

Large Rectangles

From Fabric 1 cut 5 strips 8½in (21.6cm) wide and cross cut 25 large rectangles 8½in x 7½in (21.6cm x 19.1cm). Each strip will yield 5 rectangles.

Small Rectangles

From Fabric 2 cut 5 strips 4in (10.2cm) wide and cross cut 25 small rectangles 4in x 7½in (10.2cm x 19.1cm). Each strip will yield 5 rectangles.

Sashing

From Fabric 3 cut 6 strips 2½in (6.4cm) wide. Sew the strips together end to end with straight seams and press seams open. From the length cut 20 strips 12in x 2½in (30.5cm x 6.4cm) for the vertical sashing strips in each row.
From the remaining Fabric 3 cut 11 strips 2½in (6.4cm). Sew the strips together end to end with straight seams and press seams open. From the length cut:
2 strips 70in x 2½in (177.8cm x 6.4cm) for the outer, side sashing strips;

6 strips 43½in x 2½in (110.5cm x 5.4cm) for the horizontal sashing strips.

Canopy Overlays

From Fabric 4 cut 5 strips 5½in (14cm) wide. Using the canopy overlay Template 6 on page 150, fussy cut 25 canopy overlays each with dark stripes on both sides. Each strip will yield 5 overlays.

Bottles

Cut 25 bottles, lids and handles from fabrics as follows:
Fabric 5 Bottle 2, Bottle 3;
Fabric 6 Bottle 3, Bottle 4, Bottle, lid and handles 5;
Fabric 7 Bottle 2, Bottle 3;
Fabric 8 Bottle and lid 1, Bottle 4;
Fabric 9 Bottle and lid 1, Bottle 3;
Fabric 10 Bottle and lid 1, Bottle 4;
Fabric 11 Bottle 4, Bottle, lid and handles 5;
Fabric 12 Bottle 3, Bottle, lid and handles 5;
Fabric 13 Bottle and lid 1, Bottle 4;
Fabric 14 Bottle and lid 1, Bottle 2;
Fabric 15 Bottle 2, Bottle, lid and handles 5;
Fabric 16 Bottle 2, Bottle, lid and handles 5.

Border 1

From Fabric 17 cut 7 strips 3½in (8.9cm) wide. Sew the strips together end to end with straight seams and press seams open. From the length:
cut 2 strips 76in x 3½in (193cm x 8.9cm) for the side borders;
cut 2 strips 47½in x 3½in (120.7cm x 8.9cm) for the top and bottom borders.

Border 2

From Fabric 18, cut 7 strips 3in (7.6cm) wide. Sew the strips together end to end with straight seams and press seams open. From the length:

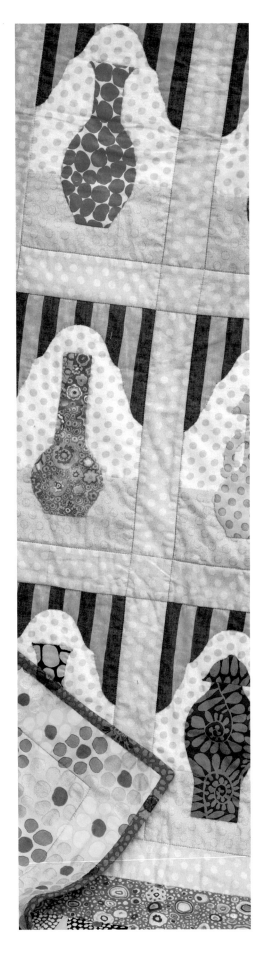

BLOCK ASSEMBLY DIAGRAM

a b c

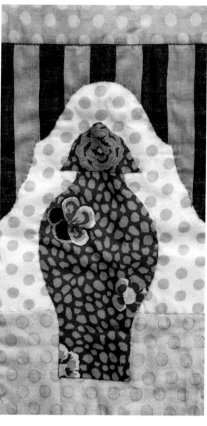

cut 2 strips 81in x 3in (205.7cm x 7.6cm)
for the side borders;
cut 2 strips 53½in x 3in (135.9cm x
7.6cm) for the top and bottom borders.

Backing
From Fabric 19 cut 2 pieces 89in (226cm)
long.

Binding
From Fabric 11 cut 8 strips 2½in (6.4cm)
wide. Remove selvedges and sew end to
end with 45° seams (see page 157).

MAKING THE QUILT
Using a design wall will help to place
patches in the required layout.
Use ¼in (6mm) seams throughout.

Making the Blocks
Referring to the Block Assembly Diagram
and the quilt photograph, make 25
bottle blocks. Sew a Fabric 1 large
rectangle and a Fabric 2 small rectangle
together and press seam towards the
small rectangle (a). This forms the shelf
back and base.
Add the striped canopy, carefully
matching the raw edges at the top. Then
hand appliqué (see page 155) the curved
lower edge to the background (b). Cut
away the excess background fabric
behind the canopy overlay to a ¼in
(6mm) seam allowance.
Hand appliqué a bottle (plus lid and
handles as required) to each block
background. The bottle should be
positioned 1½in (3.8cm) above the
bottom cut edge of the block (c). For
bottle 5, position the handles behind the
bottle and position the lid in front of it.

Centre
Referring to the Quilt Assembly Diagram
and the quilt photograph, lay out
the blocks and add the short vertical
sashing strips between each block. Sew
the blocks and sashing strips together to
form each row, pressing seams towards
the sashing strips.
Add the 6 horizontal sashing strips to
the layout. Pin (to prevent stretching),
then sew the rows and sashing strips
together. Press seams towards the
sashing strips.
Complete the centre by pinning, then
sewing the long, side sashing strips to
each side. Again, press seams towards
the sashing.

Borders 1 and 2
Pin and sew each border in turn, starting
with the shorter top and bottom borders,
followed by the longer side borders.

FINISHING THE QUILT
Remove selvedges and sew the Fabric 19
backing pieces together and trim to form
a piece 89in x 67in (226cm x 170cm).

Press the quilt top. Layer the quilt top,
batting and backing, and baste together
(see page 156).
Quilt as desired. Trim the quilt edges
and attach the binding (see page 157).

Fabric 1 Fabric 10
Fabric 2 Fabric 11
Fabric 3 Fabric 12
Fabric 4 Fabric 13
Fabric 5 Fabric 14
Fabric 6 Fabric 15
Fabric 7 Fabric 16
Fabric 8 Fabric 17
Fabric 9 Fabric 18

shadow boxes **

Kaffe Fassett

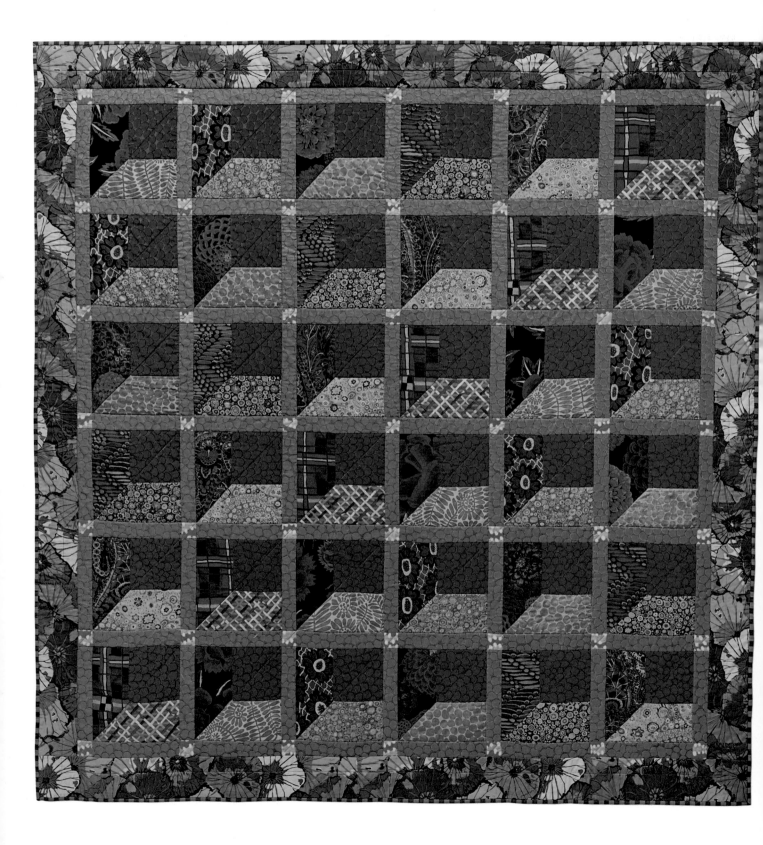

This is a cool take on a traditional 'shadow box' quilt pattern. Blocks are repeated in diagonal rows – the use of lower-contrast fabrics giving it a very different look from the original.

SIZE OF FINISHED QUILT
73in x 73in (185cm x 185cm)

FABRICS
Fabrics have been calculated at a maximum width of 40in (102cm). Fabrics have been given a number – see Fabric Swatch Diagram for details.

Patchwork Fabrics
EMBROIDERED SHAWL

Fabric 1	Red	³⁄₈yd (40cm)

FLOWER NET

Fabric 2	Crimson	³⁄₈yd (40cm)

FLORA

Fabric 3	Dark	³⁄₈yd (40cm)

BEADED CURTAIN

Fabric 4	Red	³⁄₈yd (40cm)

PAISLEY JUNGLE

Fabric 5	Rust	³⁄₈yd (40cm)

CHECKMATE

Fabric 6	Pink	³⁄₈yd (40cm)

FRONDS

Fabric 7	Green	³⁄₈yd (40cm)

PAPERWEIGHT

Fabric 8	Jewel	³⁄₈yd (40cm)
Fabric 9	Teal	³⁄₈yd (40cm)

MILLEFIORE

Fabric 10	Jade	³⁄₈yd (40cm)

MAD PLAID

Fabric 11	Cobalt	³⁄₈yd (40cm)

JUMBLE

Fabric 12	Emerald	³⁄₈yd (40cm)
Fabric 13	Lapis	1¹⁄₈yd (1.1m)
Fabric 14	Royal	1³⁄₈yd (1.3m)

BUBBLE STRIPE

Fabric 15	Aqua	¹⁄₄yd (25cm)

LOTUS LEAF

Fabric 16	Purple	1yd (95cm)

Backing and Binding Fabrics
MILLEFIORE Extra wide backing

Fabric 17	Blue	2¹⁄₄yd (2.1m)

NARROW STRIPE

Fabric 18	Mallard	⁵⁄₈yd (60cm)

Batting
81in x 81in (206cm x 206cm)

FABRIC SWATCH DIAGRAM

Patchwork Fabrics

Fabric 1
EMBROIDERED SHAWL
Red
GP106RD

Fabric 2
FLOWER NET
Crimson
BM81CR

Fabric 3
FLORA
Dark
PJ114DK

Fabric 4
BEADED CURTAIN
Red
GP191RD

Fabric 5
PAISLEY JUNGLE
Rust
GP60RU

Fabric 6
CHECKMATE
Pink
BM86PK

Fabric 7
FRONDS
Green
BM85GN

Fabric 8
PAPERWEIGHT
Jewel
GP20JE

Fabric 9
PAPERWEIGHT
Teal
GP20TE

Fabric 10
MILLEFIORE
Jade
GP92JA

Fabric 11
MAD PLAID
Cobalt
BM37CB

Fabric 12
JUMBLE
Emerald
BM53EM

Fabric 13
JUMBLE
Lapis
BM53LP

Fabric 14
JUMBLE
Royal
BM53RY

Fabric 15
BUBBLE STRIPE
Aqua
BM82AQ

Fabric 16
LOTUS LEAF
Purple
GP29PU

Backing and Binding Fabrics

Fabric 17
MILLEFIORE
Blue
QB06BL

Fabric 18
NARROW STRIPE
Mallard
SS02ML

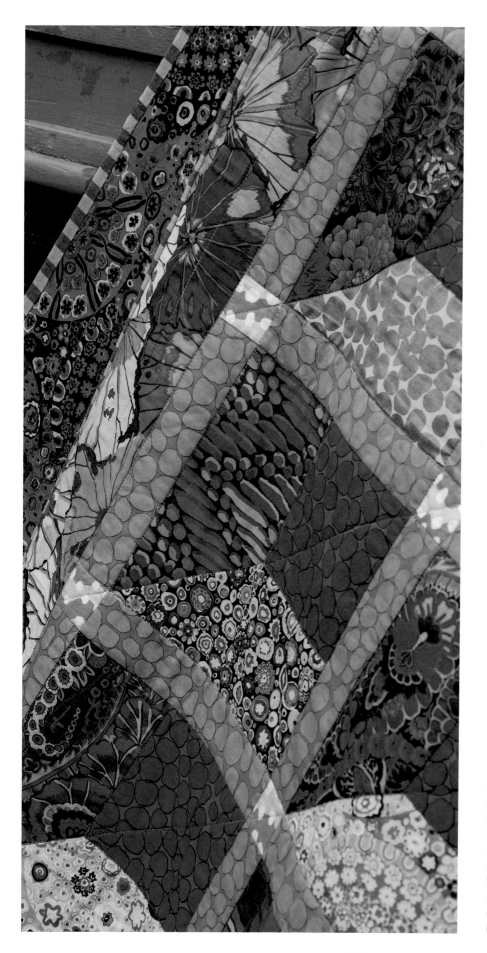

PATCHES

Blocks are made of 3 patches, all cut from strips, which are sewn in 2 diagonal halves, each made of a background half triangle and either a side trapezoid or a base trapezoid. The blocks are set in six rows of six and separated by narrow sashing strips with sashing squares at each junction. The quilt is finished with a 4in (10.2cm) border.

CUTTING OUT

Fabric is cut across the width unless otherwise stated.

Side Trapezoids

From each of Fabrics 1, 2, 3, 4, 5 and 6, cut 2 strips 4⅜in (11.1cm) wide. Referring to the Cutting Diagram, unfold the strip so you are cutting through a single layer of fabric, with right side up. To cut the first patch, square up the left-hand side and mark a point 5½in (14cm) along the top edge of the strip, then mark a point 9⅞in (25.1cm) along the bottom edge of the strip. Using the 45° line on your cutting ruler, cut at 45° diagonally across the strip from point to point (a).

To cut the second patch, mark a point 9⅞in (25.1cm) along the top edge of the strip and mark a point 5½in (14cm) along the bottom edge of the strip. Cut straight across the strip from point to point (b). Repeat and cut 4 more side trapezoids. Each strip will yield 4 trapezoids. Cut 6 from each fabric.

Base Trapezoids

Note: The 45° angle of the block base trapezoids faces the opposite direction. From each of Fabrics 7, 8, 9 ,10, 11 and 12, cut 2 strips 4⅜in (11.1cm) wide. Referring to the Cutting Diagram, unfold the strip so you are cutting through a single layer of fabric, right side up. To cut the first patch, square up the left-hand side and mark a point 9⅞in (25.1cm) along the top edge of the strip, then mark a point 5½in (14cm) along the bottom edge of the strip. Using the 45° line on your cutting ruler, cut at 45° diagonally across the strip from point to point (c). To cut the second patch, mark a point 5½in (14cm) along the top edge of the strip and mark a point 9⅞in (25.1cm) along the bottom edge of the

TRAPEZOID CUTTING DIAGRAM

Side Trapezoids

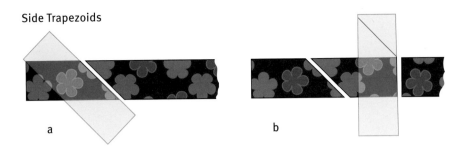

a

b

Base Trapezoids

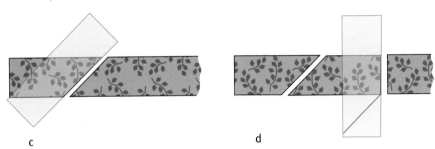

c

d

BLOCK ASSEMBLY DIAGRAM

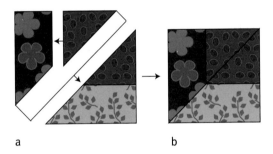

a

b

strip. Cut straight across the strip from point to point (d). Repeat and cut 4 more base trapezoids. Each strip will yield 4 trapezoids. Cut 6 from each fabric.

Background Triangles
From Fabric 13 cut 6 strips 6in (15.2cm) wide and cross cut 36 squares at 6in (15.2cm). Cut each square in half diagonally to create 72 half-square background triangles.

Sashing Strips
From Fabric 14 cut 5 strips 9½in (24.1cm) wide and cross cut 84 sashing strips 2in x 9½in (5.1cm x 24.1cm). Each strip will yield 20 sashing strips.

Sashing Squares
From Fabric 15 cut 3 strips 2in (5.1cm) wide and cross cut 49 squares at 2in (5.1cm). Each strip will yield 20 sashing squares.

Border
From Fabric 16 cut 7 strips 4½in (11.4cm) wide. Join strips end to end using ¼in (6mm) seams, and press seams open.
From the length:
cut 2 pieces 73in (185.4cm) long for the top and borders;
cut 2 pieces 65in (165.1cm) long for the side borders.

Backing
Trim Fabric 17 to 81in x 81in (206cm x 206cm).

Binding
From Fabric 18 cut 8 strips 2½in (6.4cm) wide. Remove selvedges and sew end to end with 45° seams (see page 157).

MAKING THE QUILT
Using a design wall will help to place patches in the required layout.
Use ¼in (6mm) seams throughout.

Making the Blocks
There are 6 blocks of each variation of fabrics. Referring to the Block Assembly Diagram, piece 36 blocks, sewing background triangles to all the side and base trapezoids (a) and press seams towards the trapezoids. Referring to the Block Assembly Diagram and the photograph, sew the corresponding side and base units together along the long diagonal edge, carefully matching crossing seams (b).

Centre
Lay out the blocks, sashing strips and sashing squares referring to the Quilt Assembly Diagram on page 122 and the quilt photograph (the blocks in the same fabrics run in diagonal lines). After checking the layout is correct, start sewing blocks and sashing strips into rows, starting and finishing with a sashing strip, and sew horizontal sashing strips and sashing squares together, starting and ending with a sashing square. Press all seams towards sashing strips.
Sew the rows of sashing strips and blocks together and press, taking care to align crossing seams.

Borders
Pin (to prevent stretching borders) and sew the shorter Fabric 16 borders to the sides. Press, then pin and sew the longer top and bottom borders to the centre to complete the quilt top.

FINISHING THE QUILT
Press the quilt top. Layer the quilt top, batting and backing, and baste together (see page 156).
Quilt as desired.
Trim the quilt edges and attach the binding (see page 157).

QUILT ASSEMBLY DIAGRAM

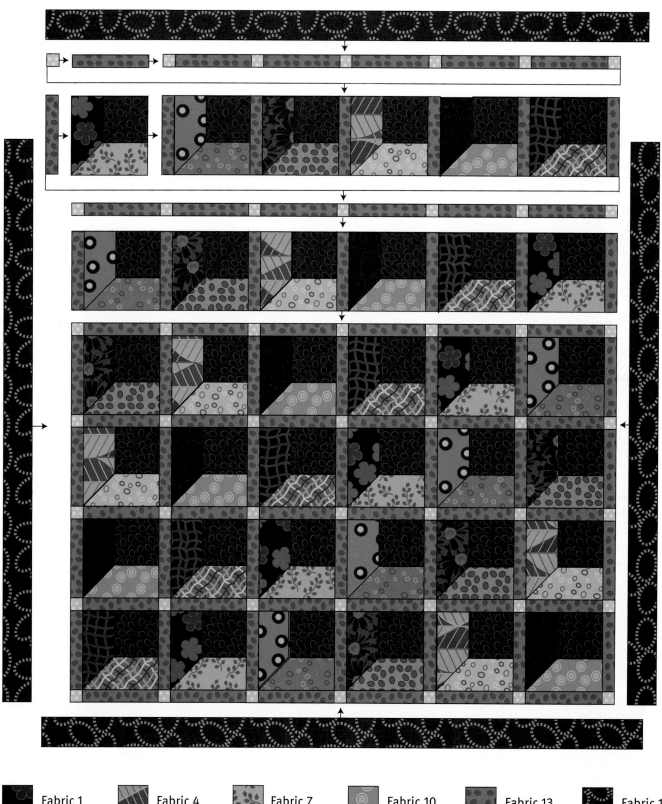

Fabric 1 Fabric 4 Fabric 7 Fabric 10 Fabric 13 Fabric 16

Fabric 2 Fabric 5 Fabric 8 Fabric 11 Fabric 14

Fabric 3 Fabric 6 Fabric 9 Fabric 12 Fabric 15

vintage stars **

Kaffe Fassett

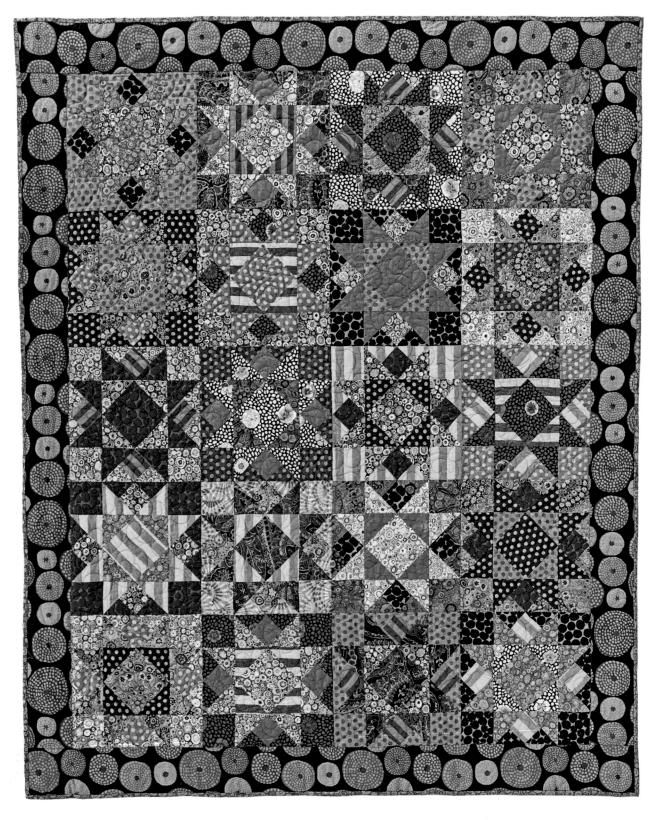

This version of Liza's double-star quilt shows off some of the vintage, or more 'Victorian', shades of our Classic fabric collection as well as some of my current Shot Stripes.

SIZE OF FINISHED QUILT
69in x 57in (175cm x 145cm)

FABRICS
Fabrics have been calculated at a maximum width of 40in (102cm). Fabrics have been given a number – see Fabric Swatch Diagram for details.

Patchwork Fabrics
JUMBLE
Fabric 1	Prune	⅜yd (40cm)
Fabric 2	Royal	¼yd (25cm)
Fabric 3	Salmon	¼yd (25cm)

PAPERWEIGHT
Fabric 4	Algae	⅜yd (40cm)
Fabric 5	Grey	⅜yd (40cm)
Fabric 6	Pumpkin	⅜yd (40cm)
Fabric 7	Sludge	⅜yd (40cm)
Fabric 8	Teal	⅜yd (40cm)

* see also Binding Fabric

GUINEA FLOWER
Fabric 9	Green	⅜yd (40cm)
Fabric 10	Purple	⅜yd (40cm)

SPOT
Fabric 11	Autumn	¼yd (25cm)
Fabric 12	Bottle	⅛yd (15cm)
Fabric 13	Pacific	⅜yd (40cm)
Fabric 14	Violet	⅜yd (40cm)

MILLEFIORE
Fabric 15	Antique	⅜yd (40cm)
Fabric 16	Dusty	¼yd (25cm)

PAPER FANS
Fabric 17	Green	⅛yd (15cm)

WIDE STRIPE
Fabric 18	Shell	⅛yd (15cm)
Fabric 19	Apple	⅜yd (40cm)

NARROW STRIPE
Fabric 20	Mallard	⅛yd (15cm)

PAISLEY JUNGLE
Fabric 21	Moss	⅜yd (40cm)

** see also Backing Fabric

DISKS
Fabric 22	Black	1¾yd (1.7m)

or ⅞yd (85cm) if cutting across and joining strips

Backing and Binding Fabrics
PAISLEY JUNGLE
Fabric 21	Moss	3¾yd (3.5m)

** see also Patchwork Fabrics

PAPERWEIGHT
Fabric 8	Teal	⅝yd (60cm)

* see also Patchwork Fabrics

Batting
78in x 66in (198cm x 168cm)

PATCHES
These double-star blocks are made using three sizes of square patches (centre, corner and inset squares) and two sizes of triangle patches (inset quarter-square triangle ('QST') and setting half-square triangle ('HST'); all are cut from strips. The finished blocks are 17in (43.2cm) square, set in 5 rows of 4 with a contrasting wide border.

CUTTING OUT
Fabric is cut across the width unless otherwise stated.

Cut patches from each of Fabrics 1 to 21 in the following order, from largest to smallest, referring to the Cutting Table for the number of patches. If no patches are required, move on to the next.

Centre Squares
Cut a strip 4¾in (12.1cm) wide and cross cut squares at 4¾in (12.1cm).

Inset QSTs
Trim any remaining strip (from above) and cut additional strips (if required) 4¼in (10.8cm) wide and cross cut squares at 4¼in (10.8cm). Cross cut each square twice diagonally to yield 4 inset QSTs from each square.

Setting HSTs
Trim any remaining strip (from above) and cut additional strips (if required) 3⅞in (9.8cm) wide and cross cut squares at 3⅞in (9.8cm). Cross cut each square once diagonally to yield 2 centre setting HSTs from each square.

Corner Squares
Trim any remaining strips (from above) and cut additional strips (if required) 3½in (8.9cm) wide and cross cut squares at 3½in (8.9cm).

Inset Squares
Trim any remaining strips (from above) and cut additional strips (if required) 2⅝in (6.7cm) wide and cross cut squares at 2⅝in (6.7cm).

Border
From Fabric 22 cut down the length of the fabric 4 strips 5in (12.7cm) wide and cross cut 2 pieces 60½in x 5in (153.7cm x 12.7cm) for the side borders and 2 pieces 57½in x 5in (146.1cm x 12.7cm) for the top and bottom borders.

Backing
From Fabric 21 cut 2 pieces 66in x 40in (168cm x 102cm).

Binding
From Fabric 8 cut 7 strips 2½in (6.4cm) wide. Remove selvedges and sew end to end with 45° seams (see page 157).

CUTTING TABLE

	Centre Squares	Inset QSTs	Setting HSTs	Corner Squares	Inset Squares
Fabric 1	1	8	8	4	8
Fabric 2	1		16		12
Fabric 3		16		8	8
Fabric 4	1	8	8	4	4
Fabric 5	1	8	8	4	
Fabric 6	2		28	4	4
Fabric 7	1	8	8	4	
Fabric 8	2		20		
Fabric 9	1	8	12	4	
Fabric 10	2	8	16	4	4
Fabric 11		16	12	8	4
Fabric 12		8	4	4	
Fabric 13	1	8	8	4	8
Fabric 14	1		16	4	4
Fabric 15	3	8	28	4	4
Fabric 16		16	4	8	
Fabric 17		8		4	
Fabric 18			12		
Fabric 19	1	8	12	4	8
Fabric 20			4		12
Fabric 21	2	8	16	4	
TOTALS	20	160	240	80	80

FABRIC SWATCH DIAGRAM

Patchwork Fabrics

Fabric 1
JUMBLE
Prune
BM53PV

Fabric 2
JUMBLE
Royal
BM53RY

Fabric 3
JUMBLE
Salmon
BM53SL

Fabric 4
PAPERWEIGHT
Algae
GP20AE

Fabric 5
PAPERWEIGHT
Grey
GP20GY

Fabric 6
PAPERWEIGHT
Pumpkin
GP20PN

Fabric 7
PAPERWEIGHT
Sludge
GP20SL

Fabric 8
PAPERWEIGHT
Teal
GP20TE

Fabric 9
GUINEA FLOWER
Green
GP59GN

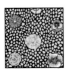

Fabric 10
GUINEA FLOWER
Purple
GP59PU

Fabric 11
SPOT
Autumn
GP70AU

Fabric 12
SPOT
Bottle
GP70BT

Fabric 13
SPOT
Pacific
GP70PF

Fabric 14
SPOT
Violet
GP70VI

Fabric 15
MILLEFIORE
Antique
GP92AN

Fabric 16
MILLEFIORE
Dusty
GP92DY

Fabric 17
PAPER FANS
Green
GP143GN

Fabric 18
WIDE STRIPE
Shell
SS01SH

Fabric 19
WIDE STRIPE
Apple
SS01AL

Fabric 20
NARROW STRIPE
Mallard
SS02ML

Fabric 21
PAISLEY JUNGLE
Moss
GP60MS

Fabric 22
DISKS
Black
GP193BK

Backing and Binding Fabrics

Fabric 21
PAISLEY JUNGLE
Moss
GP60MS

Fabric 8
PAPERWEIGHT
Teal
GP20TE

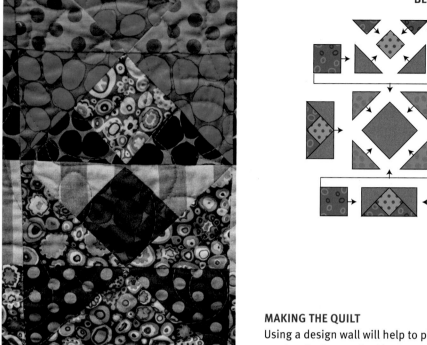

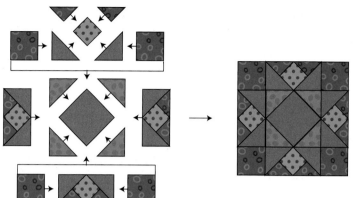

MAKING THE QUILT
Using a design wall will help to place patches in the required layout.
Use ¼in (6mm) seams throughout.

Making the Blocks
Referring to the Block Assembly Diagram and the quilt photograph, sew a setting HST to each side of a centre square. Make 4 side sections, first sewing an inset QST to adjoining sides of an inset square, then sewing a setting HST to the remaining 2 sides to create a rectangle. Lay out the centre and sides and add corner squares in fabric matching the inset QSTs. Check the layout is correct, then sew a side section to each side of the centre, sew a corner square to each end of the remaining 2 side sections, and sew these to the top and bottom to complete the block.

Repeat for the remaining 19 blocks, referring to the Quilt Assembly Diagram and the quilt photograph for placement.

Centre
Lay out the blocks in 5 rows of 4, referring to the Quilt Assembly Diagram and quilt photograph. Sew the blocks together one row at a time, pressing seams in opposite directions on alternate rows – odd rows to the left, even rows to the right – to allow the finished seams to lie flat. Sew the rows together, taking care to align crossing seams.

Fabric 1 Fabric 12

Fabric 2 Fabric 13

Fabric 3 Fabric 14

Fabric 4 Fabric 15

Fabric 5 Fabric 16

Fabric 6 Fabric 17

Fabric 7 Fabric 18

Fabric 8 Fabric 19

Fabric 9 Fabric 20

Fabric 10 Fabric 21

Fabric 11 Fabric 22

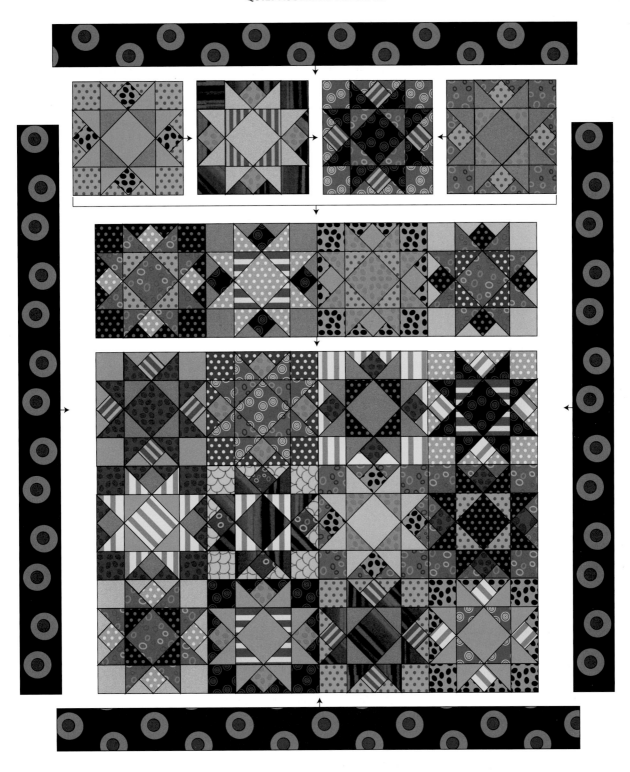

Borders
Pin (to prevent stretching borders), then sew the longer side borders to the centre. Press seams towards the border then pin and sew the shorter top and bottom borders to complete the quilt top.

FINISHING THE QUILT
Remove selvedges and sew the Fabric 21 backing pieces together and trim to form a piece 78in x 66in (198cm x 168cm).

Press the quilt top. Layer the quilt top, batting and backing, and baste together (see page 156).
Quilt as desired.
Trim the quilt edges and attach the binding (see page 157).

shady parterre **

Kaffe Fassett

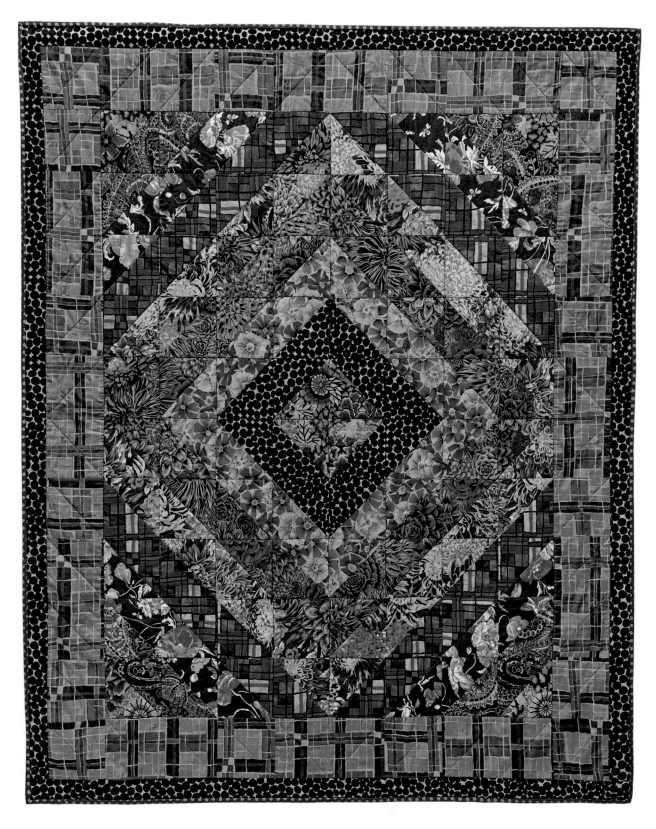

This version of a quilt of mine reminds me of a formal garden parterre with grassy paths between flower beds full of colour, as seen in country gardens and seaside towns around England.

SIZE OF FINISHED QUILT
81½in x 68½in (207cm x 174cm)

FABRICS
Fabrics have been calculated at a maximum width of 40in (102cm). Fabrics have been given a number – see Fabric Swatch Diagram for details.

Patchwork Fabrics
DREAM
Fabric 1 Dark ¼yd (25cm)
JUMBLE
Fabric 2 Rose 1⅛yd (1.1m)
PINWHEELS
Fabric 3 Autumn ½yd (50cm)
HOUSE LEEKS
Fabric 4 Dark ¾yd (70cm)
JAPANESE CHRYSANTHEMUM
Fabric 5 Autumn ⅞yd (85cm)
CHECKMATE
Fabric 6 Dark ¾yd (70cm)
MEADOW
Fabric 7 Red ½yd (50cm)
PAISLEY JUNGLE
Fabric 8 Moss ½yd (50cm)
CHECKMATE
Fabric 9 Brown 1⅜yd (1.3m)

Backing and Binding Fabrics
LOTUS LEAF
Fabric 10 Dark 5yd (4.65m)
SPOT
Fabric 11 Royal ¾yd (70cm)

Batting
90in x 77in (229cm x 196cm)

PATCHES
These are half-square triangles, cut from squares from strips cut across the width of the fabric. Triangles are arranged to form a large on-point square pattern, sewn together in pairs to form squares and set in 10 rows of 8 squares to form the centre of the quilt.

FABRIC SWATCH DIAGRAM

Patchwork Fabrics

Fabric 1
DREAM
Dark
GP148DK

Fabric 2
JUMBLE
Rose
BM53RO

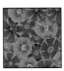
Fabric 3
PINWHEELS
Autumn
PJ117AU

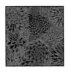
Fabric 4
HOUSE LEEKS
Dark
PJ113DK

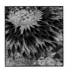
Fabric 5
JAPANESE CHRYSANTHEMUM
Autumn
PJ41AU

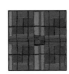
Fabric 6
CHECKMATE
Dark
BM86DK

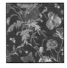
Fabric 7
MEADOW
Red
PJ116RD

Fabric 8
PAISLEY JUNGLE
Moss
GP60MS

Fabric 9
CHECKMATE
Brown
BM86BR

Backing and Binding Fabrics

Fabric 10
LOTUS LEAF
Dark
GP29DK

Fabric 11
SPOT
Royal
GP70RY

CUTTING OUT
Fabric is cut across the width of the fabric unless otherwise stated.

Centre
Cut strips 7⅜in (18.7cm) wide and cross cut squares at 7⅜in (18.7cm). Cut each square once diagonally to make 2 triangles. Each strip will yield 5 squares, giving 10 triangles per strip. Cut a total of 80 squares to yield 160 triangles from fabrics as follows:
Fabric 1 (1 strip) 8 triangles;
Fabric 2 (2 strips) 12 triangles;
Fabric 3 (2 strips) 20 triangles;
Fabric 4 (3 strips) 28 triangles;
Fabric 5 (4 strips) 32 triangles;
Fabric 6 (3 strips) 28 triangles;
Fabric 7 (2 strips) 20 triangles;
Fabric 8 (2 strips) 12 triangles.

Border 1
From Fabric 9 cut 7 strips 6½in (16.5cm) wide and cross cut 14 large rectangles 6½in x 13½in (16.5cm x 34.3cm) and 16 small rectangles 6½in x 7in (16.5cm x 17.8cm).

Border 2
From the remaining Fabric 2 cut 8 strips 2½in (6.4cm) wide. Remove selvedges and sew together end to end. Cut 2 lengths 77½in x 2½in (196.9cm x 6.4cm) for the side borders and cut 2 strips 68½in x 2½in (174cm x 6.4cm) for the top and bottom borders.

Backing
From Fabric 10 cut 2 pieces 90in x 40in (228.6cm x 102cm).

Binding
From Fabric 11 cut 8 strips 2½in (6.4cm) wide. Remove selvedges and sew together end to end.

MAKING THE QUILT
Using a design wall will help to place patches in the required layout. Use ¼in (6mm) seams throughout.

Lay out the triangles referring to the Quilt Assembly Diagram and the quilt photograph. Sew each pair of triangles together along the long diagonal edge to form the square blocks. As you are sewing the triangles together along the bias edges, take care not to stretch these when sewing. Gently press seams flat without stretching them and return each square to the design wall.

Check the layout is correctly formed of 80 square blocks (10 rows of 8) before sewing the blocks together in rows, pressing seams in opposite directions on alternate rows – odd rows to the left, even rows to the right – to allow the finished seams to sit flat.

Sew the 10 rows together, carefully matching crossing seams, and press the quilt centre.

Border 1
For each of the 4 border sections, sew together 4 small rectangles and 3 large rectangles, alternating between small and large, to measure 65½in x 6½in (166.4cm x 16.5cm). Use rectangles from different strips (ie from different sections of the Fabric 9 check pattern), to add

variety along the strips. Pin and sew a Fabric 9 border section to each side of the quilt top and press seams. Trim ½in (1.3cm) from each end of the 2 remaining border sections so they measure 64½in x 6½in (163.8cm x 16.5cm). Pin and sew a trimmed Fabric 9 border section to the top and bottom and press seams. Trim ½in (1.3cm) from each end of the 2 remaining border pieces so they measure 64½in x 6½in (163.8cm x 16.5cm). Pin and sew a shorter Fabric 9 border strip to the top and bottom and press seams.

Border 2
Pin and sew a longer Fabric 2 border strip to each side of the quilt top and press seams. Pin and sew a shorter Fabric 2 border strip to the quilt top and bottom to complete the quilt top.

FINISHING THE QUILT
Remove selvedges and sew the Fabric 10 backing pieces together along the long edge and trim to form a piece 90in x 77in (229cm x 196cm).

Press the quilt top. Layer the quilt top, batting and backing, and baste together (see page 156)
Quilt as desired.
Trim the quilt edges and attach the binding (see page 157).

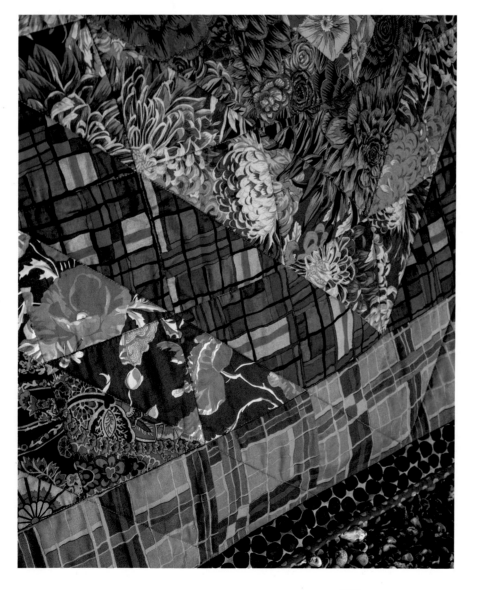

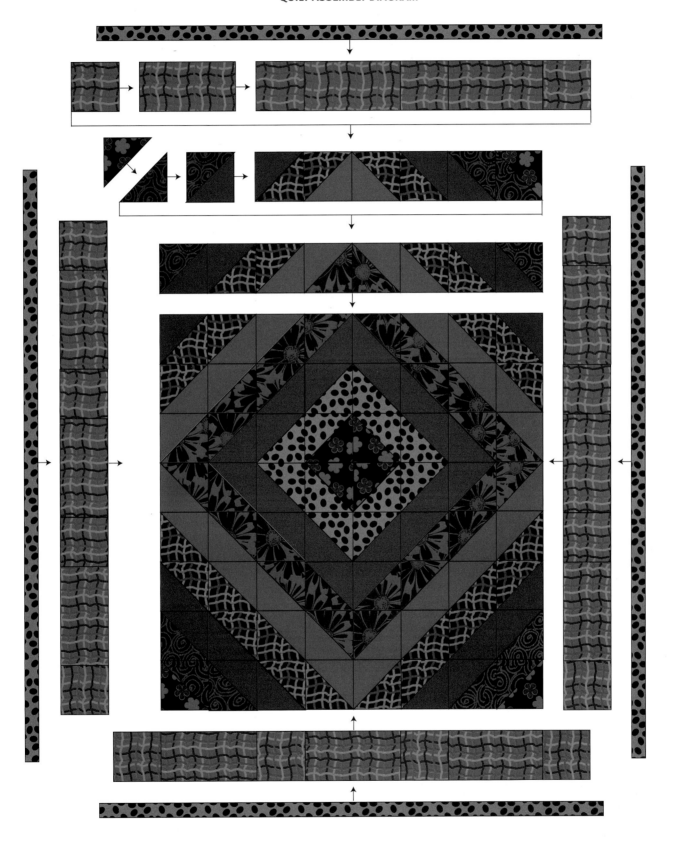

succulent hexagons ***

Kaffe Fassett

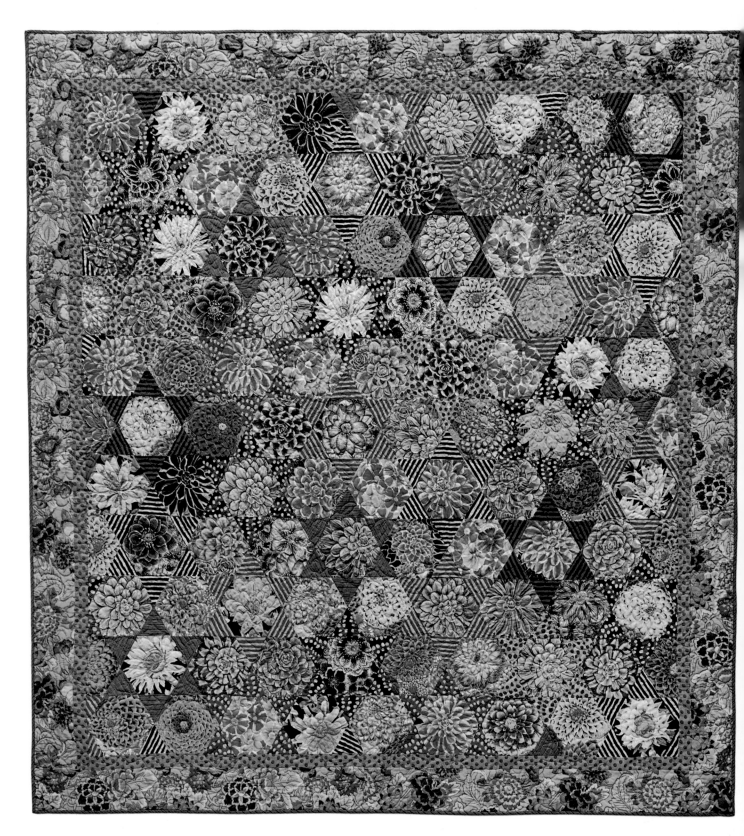

This is one of the most popular quilts in our workshops. Here I have put Philip's latest selection of floral designs to good use, fussy cutting the blooms and setting them off with several of Brandon's current stripes.

SIZE OF FINISHED QUILT
84½in x 80½in (214.6cm x 204.5cm)

FABRICS
Fabrics have been calculated at a maximum width of 40in (102cm). Fabrics have been given a number – see Fabric Swatch Diagram for details.

Patchwork Fabrics
CACTUS FLOWER
Fabric 1	Contrast	⅞yd (85cm)

HOUSE LEEKS
Fabric 2	Contrast	1⅛yd (1.1m)
Fabric 3	Grey	1yd (95cm)
Fabric 4	Natural	¾yd (70cm)

FLORA
Fabric 5	Green	½yd (50cm)
Fabric 6	Mauve	1¼yd (1.2m)

PINWHEELS
Fabric 7	Spring	¼yd (25cm)
Fabric 8	Blue	¼yd (25cm)

HELLEBORES
Fabric 9	Natural	¾yd (70cm)

BUBBLE STRIPE
Fabric 10	Black	⅜yd (40cm)
Fabric 11	Pink	¼yd (25cm)
Fabric 12	Purple	¼yd (25cm)

COMB STRIPE
Fabric 13	Blue	⅜yd (40cm)
Fabric 14	Orange	¼yd (25cm)
* see Binding Fabric		
Fabric 15	Pink	¼yd (25cm)
Fabric 16	Yellow	¼yd (25cm)

SPOT
Fabric 17	Aqua	⅝yd (60cm)

CLOISONNE
Fabric 18	Aqua	1⅜yd (1.3m)

Backing and Binding Fabrics
LOTUS LEAF extra wide backing
Fabric 19	Purple	2½yd (2.3m)

COMB STRIPE
Fabric 14	Orange	¾yd (70cm)
* see also Patchwork Fabrics		

Batting
93in x 89in (236cm x 226cm)

FABRIC SWATCH DIAGRAM

Patchwork Fabrics

Fabric 1
CACTUS FLOWER
Contrast
PJ96CN

Fabric 2
HOUSE LEEKS
Contrast
PJ113CN

Fabric 3
HOUSE LEEKS
Grey
PJ113GY

Fabric 4
HOUSE LEEKS
Natural
PJ113NL

Fabric 5
FLORA
Green
PJ114GN

Fabric 6
FLORA
Mauve
PJ114MV

Fabric 7
PINWHEELS
Spring
PJ116SP

Fabric 8
PINWHEELS
Blue
PJ116BL

Fabric 9
HELLEBORES
Natural
PJ118NL

Fabric 10
BUBBLE STRIPE
Black
BM82BK

Fabric 11
BUBBLE STRIPE
Pink
BM82PK

Fabric 12
BUBBLE STRIPE
Purple
BM82PU

Fabric 13
COMB STRIPE
Blue
BM84BL

Fabric 14
COMB STRIPE
Orange
BM84OR

Fabric 15
COMB STRIPE
Pink
BM84PK

Fabric 16
COMB STRIPE
Yellow
BM84YE

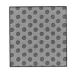
Fabric 17
SPOT
Aqua
GP70AQ

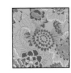
Fabric 18
CLOISONNE
Aqua
GP46AQ

Backing and Binding Fabrics

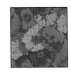
Fabric 19
LOTUS LEAF
Purple
QB07PU

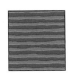
Fabric 14
COMB STRIPE
Orange
BM84OR

TEMPLATES

A B C D/D Rev

PATCHES

Patches are 3¾in (9.5cm) hexagons (A) as well as half-hexagons (B), 60° triangles (C) and half-triangles for setting in the edges (D and D Reverse). There are 11 rows of hexagons, some surrounded with 6 matching triangles, while alternate hexagons share 2 triangles each from neighbouring hexagons. Odd rows have 9 hexagons; even rows have 8 hexagons with halves at each end. Acrylic templates are commercially available for this quilt.

CUTTING OUT

Fabric is cut across the width unless otherwise stated.

Hexagon A and Half-hexagon B

Using templates A and B, cut hexagons and half-hexagons from fabrics as follows, fussy cutting to centre a flower bloom in each hexagon:

Fabric 1 A x 11;
Fabric 2 A x 17;
Fabric 3 A x 14, B x 1;
Fabric 4 A x 9;
Fabric 5 A x 6, B x 2;
Fabric 6 A x 20, B x 3;
Fabric 7 A x 4, B x 2;
Fabric 8 A x 4;
Fabric 9 A x 9, B x 2.

Triangle C and Half-triangle D/D Reverse

Cut strips 4in (10.2cm) wide. Cut alternately, rotating the template 180° after each cut, as shown in the Cutting Diagram. Each strip will yield 15 of Triangle C with enough fabric remaining at each end of the strip to cut a half-

triangle D or D Reverse, if required. Using templates C, D and D Reverse, cut triangles and half-triangles from fabrics as follows:

Fabric 10 (3 strips) C x 34, D x 2, DRev x 2;
Fabric 11 (2 strips) C x 22, D x 1;
Fabric 12 (2 strips) C x 23, D x 2, DRev x 1;
Fabric 13 (3 strips) C x 33, D x 2, DRev x 2;
Fabric 14 (2 strips) C x 24, D x 1, DRev x 2;
Fabric 15 (2 strips) C x 22, D x 1, DRev x 1;
Fabric 16 (2 strips) C x 28, D x 3, DRev x 4.

Border 1

From Fabric 17 cut 8 strips 2in (5.1cm) wide, join strips end to end and cut pieces as follows:
2 pieces 72in x 2in (182.9cm x 5.1cm) for the side borders;
2 pieces 71in x 2in (180.3cm x 5.1cm) for the top and bottom borders.

Border 2

From Fabric 18 cut 8 strips 5½in (14cm) wide, join strips end to end and cut pieces as follows:
2 pieces 75in x 2in (190.5cm x 5.1cm) for the side borders;
2 pieces 81in x 2in (205.7cm x 5.1cm) for the top and bottom borders.

Backing

Trim Fabric 19 backing to 93in x 89in (236cm x 226cm).

Binding

From Fabric 14 cut 9 strips 2½in (6.4cm) wide. Remove selvedges and sew end to end with 45° seams (see page 157).

MAKING THE QUILT

Using a design wall will help to place patches in the required layout.
Use ¼in (6mm) seams throughout.

Centre

Lay out the hexagons and triangles referring to the Quilt Assembly Diagram and the quilt photograph, taking care to arrange sets of 6 matching Triangle C patches around hexagons as shown. Check the layout, particularly to ensure stripes run in the same direction either around or radiating from the hexagon centres, depending on the Triangle C patch fabric.

Sew the patches together, one row at a time, as shown in the Quilt Assembly Diagram. Sew a triangle to diagonally opposite sides of each hexagon, then sew each section together. Complete each odd row with half-triangles and complete each even row with a half-hexagon. Pin, then sew the rows together, taking care to align crossing seams.

Border 1

Pin, then sew, the two longer Fabric 17 borders to the sides; press then pin and sew the two shorter top and bottom borders.

Border 2

Pin, then sew the two shorter Fabric 18 borders to the sides; press then pin and sew the two longer top and bottom borders to complete the quilt top.

FINISHING THE QUILT

Remove selvedges and trim Fabric 19 backing to form a piece 93in x 89in (236cm x 226cm)

Press the quilt top. Layer the quilt top, batting and backing, and baste together (see page 156).
Quilt as desired.
Trim the quilt edges and attach the binding (see page 157).

CUTTING DIAGRAM

D C D Rev

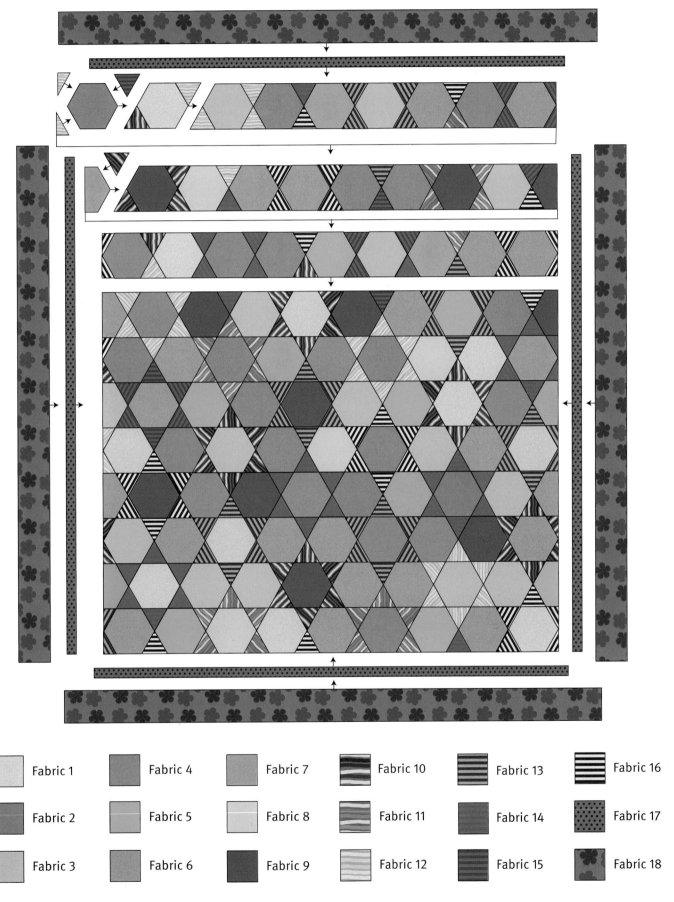

Fabric 1

Fabric 2

Fabric 3

Fabric 4

Fabric 5

Fabric 6

Fabric 7

Fabric 8

Fabric 9

Fabric 10

Fabric 11

Fabric 12

Fabric 13

Fabric 14

Fabric 15

Fabric 16

Fabric 17

Fabric 18

love in the mist **

Kaffe Fassett

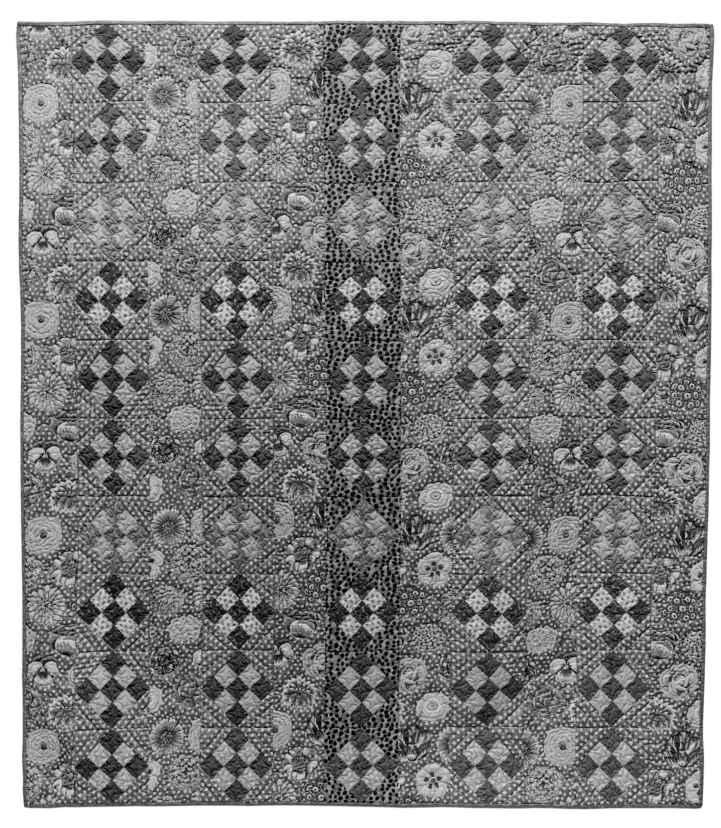

This pastel colourway of my original design sets off the pastel 9-patches in this soft and misty quilt, featuring Spots and Aboriginal Dots from our Classics collection.

SIZE OF FINISHED QUILT
85in x 78½in (216cm x 200cm)

FABRICS
Fabrics have been calculated at a maximum width of 40in (102cm). Fabrics have been given a number – see Fabric Swatch Diagram for details.

Patchwork Fabrics
BIG BLOOMS
Fabric 1	Pastel	2½yd (2.3m)

SPOT
Fabric 2	Steel	1⅞yd (1.8m)
Fabric 3	Apple	⅝yd (60cm)
Fabric 4	Hydrangea	⅜yd (40cm)
Fabric 5	Sky	⅜yd (40cm)

JUMBLE
Fabric 6	Yellow	⅜yd (40cm)

ABORIGINAL DOT
Fabric 7	Wisteria	½yd (50cm)
Fabric 8	Cantaloupe	½yd (50cm)
Fabric 9	Turquoise	⅜yd (40cm)

* see also Binding Fabric

BUBBLE STRIPE
Fabric 10	Purple	½yd (50cm)

Backing and Binding Fabrics
MAD PLAID extra wide backing
Fabric 11	Grey	2½yd (2.3m)

ABORIGINAL DOT
Fabric 9	Turquoise	¾yd (70cm)

* see also Patchwork Fabrics

Batting
93in x 87in (236cm x 221cm)

PATCHES
Patches are squares cut at 2½in (6.4cm) and made into 9-patch units, which are set on point to form square blocks using half-square setting triangles. Blocks are sewn together in columns, but the same-coloured blocks are set in the same position in each column, forming horizontal bands of matching blocks. Unpieced feature-fabric columns, cut from 6½in (16.5cm) strips, separate the pieced 9-patch columns.

FABRIC SWATCH DIAGRAM

Patchwork Fabrics

Fabric 1
BIG BLOOMS
Pastel
GP91PT

Fabric 2
SPOT
Steel
GP70ST

Fabric 3
SPOT
Apple
GP70AL

Fabric 4
SPOT
Hydrangea
GP70HY

Fabric 5
SPOT
Sky
GP70SK

Fabric 6
JUMBLE
Yellow
BM53YE

Fabric 7
ABORIGINAL DOT
Wisteria
GP71WS

Fabric 8
ABORIGINAL DOT
Cantaloupe
GP71CA

Fabric 9
ABORIGINAL DOT
Turquoise
GP71TQ

Fabric 10
BUBBLE STRIPE
Purple
BM82PU

Backing and Binding Fabrics

Fabric 11
MAD PLAID
Grey
QM02GY

Fabric 9
ABORIGINAL DOT
Turquoise
GP71TQ

CUTTING OUT
Fabric is cut across the width of the fabric, except for Fabric 1, which is cut **down** the length. When cutting squares for the 9-patch blocks and the triangle patches, for best results use spray starch before cutting.

Feature Strips
Remove selvedges from Fabric 1 before cutting. Cut 6 strips 6½in x 85½in (16.5cm x 217.2cm) **down** the length.

Setting Triangles
Cut strips 5⅛in (12.9cm) wide and cross cut squares at 5⅛in (12.9cm). Each strip will yield 7 squares. Cut each square once diagonally to make 2 setting triangles from each square. Cut a total of 100 squares (yielding 200 setting triangles) from fabrics as follows:
Fabric 2 (12 strips) 80 squares – 160 triangles;
Fabric 10 (3 strips) 20 squares – 40 triangles.
Note: As Fabric 10 has stripes that need to run vertically through the blocks, cut 10 of the squares diagonally from the bottom left corner to the top right corner, and cut the remaining 10 squares diagonally from the top left corner to the bottom right corner.

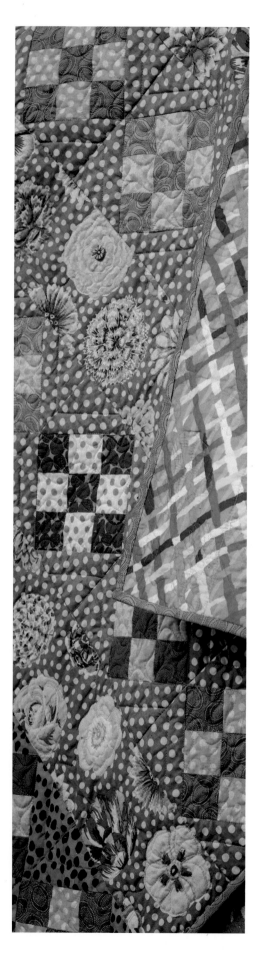

9-SQUARE UNIT DIAGRAM

BLOCK ASSEMBLY DIAGRAM

Nine-Patch Squares

Cut strips 2½in (6.4cm) wide and cross cut squares at 2½in (6.4cm). Each strip will yield 16 squares. Cut a total of 450 squares from fabrics as follows:
Fabric 3 (7 strips) 100 squares;
Fabric 4 (4 strips) 60 squares;
Fabric 5 (3 strips) 40 squares;
Fabric 6 (4 strips) 50 squares;
Fabric 7 (5 strips) 75 squares;
Fabric 8 (5 strips) 75 squares;
Fabric 9 (4 strips) 50 squares.

Backing

Trim Fabric 11 backing to 93in x 87in (236cm x 221cm).

Binding

From Fabric 9 cut 9 strips 2½in (6.4cm) wide. Remove selvedges and sew end to end with 45° seams (see page 157).

MAKING THE QUILT

Using a design wall will help to place patches in the required layout.
Use ¼in (6mm) seams throughout.

Referring to the 9-Square Unit Diagram and the quilt photograph for fabric placement, sew the squares into 9-patch units. Make a total of 50 9-square units in the following fabric combinations:
Fabrics 3 and 7 15 units;
Fabrics 4 and 8 15 units;
Fabrics 3 and 9 10 units;
Fabrics 5 and 6 10 units.

Set out the columns of 9-square units on point in between the feature-strip columns on a design wall, then add the setting triangles to the layout.
Note: The central 9-patch unit column has Fabric 10 setting triangles, and the other 9-patch unit columns have Fabric 2 setting triangles. Referring to the Block Assembly Diagram and the quilt

photograph, sew a setting triangle to each side of each 9-patch unit to form 40 blocks with Fabric 2 corners and 10 blocks with Fabric 10 corners, taking care to ensure the stripes of the Fabric 10 triangles all run in the same direction. Return the blocks to the layout and position the centre column blocks with the corner stripes running down the length of the column.

MAKING THE QUILT

Referring to the Quilt Assembly Diagram and the the quilt photograph, sew the pieced blocks together into 5 columns of 10 blocks each, making sure every column has the same sequence of blocks from top to bottom. Add a feature strip to each side of the quilt layout and between each pieced column to make 11 quilt columns in total. Pin, then sew the columns together, pressing seams towards the feature strips.

FINISHING THE QUILT

Press the quilt top. Layer the quilt top, batting and backing, and baste together (see page 156).
Quilt as desired.
Trim the quilt edges and attach the binding (see page 157).

Fabric 1

Fabric 2

Fabric 3

Fabric 4

Fabric 5

Fabric 6

Fabric 7

Fabric 8

Fabric 9

Fabric 10

green squares **

Kaffe Fassett

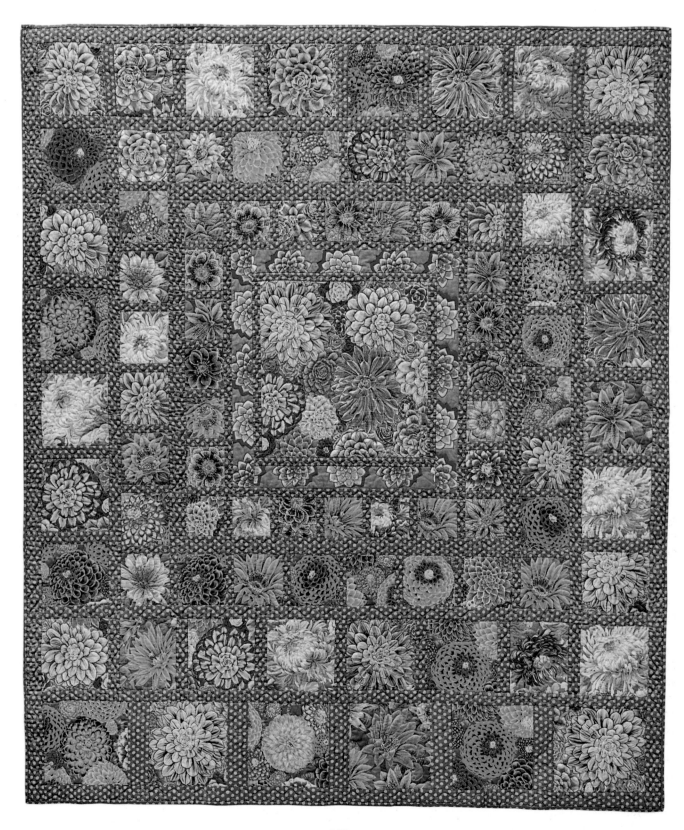

This simple layout is perfect for showcasing a selection of spring-like green blooms from the current fabric collections. It has eight alternating pieced and unpieced borders surrounding a central panel with an extra row of blocks across the bottom of the quilt.

SIZE OF FINISHED QUILT
87in x 76in (221cm x 193cm)

FABRICS
Fabrics have been calculated at a maximum width of 40in (102cm). Fabrics have been given a number – see Fabric Swatch Diagram for details.

Patchwork Fabrics
HOUSE LEEKS
| Fabric 1 | Grey | 1½yd (1.4m) |
| Fabric 2 | Natural | 1yd (95cm) |

CACTUS FLOWER
| Fabric 3 | Green | 1yd (95cm) |

FLORA
| Fabric 4 | Green | 1¾yd (1.7m) |

SHAGGY
| Fabric 5 | Aqua | 1yd (95cm) |

HELLEBORES
| Fabric 6 | Pink | ⅝yd (60cm) |

SHADOW FLOWER
| Fabric 7 | Teal | ⅝yd (60cm) |

SPOT
| Fabric 8 | Pacific | 2¾yd (2.6m) |

* see also Binding Fabric

Backing and Binding Fabrics
ENCHANTED extra wide backing
| Fabric 9 | Green | 2⅜yd (2.25m) |

SPOT
| Fabric 8 | Pacific | ¾yd (70cm) |

* see also Patchwork Fabrics

Batting
95in x 84in (241cm x 213cm)

PATCHES
Patches are squares and rectangles in various sizes, referred to by a capital letter in both the instructions and the diagrams. Squares and rectangles are sewn into borders, connected with sashing strips. There are 8 borders surrounding the centre square, then a sashing strip and a pieced bottom row are added, making the quilt rectangular. The quilt is then finished with an outer border.

FABRIC SWATCH DIAGRAM

Patchwork Fabrics

Fabric 1
HOUSE LEEKS
Grey
PJ113GY

Fabric 2
HOUSE LEEKS
Natural
PJ113NL

Fabric 3
CACTUS FLOWER
Green
PJ96GN

Fabric 4
FLORA
Green
PJ114GN

Fabric 5
SHAGGY
Aqua
PJ72AQ

Fabric 6
HELLEBORES
Pink
PJ118PK

Fabric 7
SHADOW FLOWER
Teal
GP187TE

Fabric 8
SPOT
Pacific
GP70PF

Backing and Binding Fabrics

Fabric 9
ENCHANTED
Green
QB08GN

Fabric 8
SPOT
Pacific
GP70PF

CUTTING OUT
Fabric is cut across the width unless otherwise stated. When required strips are longer than 40in (102cm) – the usable width of the fabric – remove selvedges and join strips end to end to obtain the required length; use ¼in (6mm) seams and press seams open. All squares and rectangles in Fabrics 1–6 are fussy cut to show off a blossom, which is either centred or slightly off-centre. This is a scrappy quilt and the flowers do not need to match those in our quilt exactly so select the blooms in the fabrics that you like best. Pay attention to the patch sizes and arrange them as you prefer, except for Fabric 6, which is only used in alternate squares in Border 4.

Centre Panel
From Fabric 1 cut a panel 20in (50.8cm) square for the quilt centre.

Floral Squares and Rectangles
Fussy cut squares and rectangles in the following sizes:
Square A for Border 4 – 5in (12.7cm);
Square B for Border 6 – 6¼in (15.9cm);
Square C for Border 8 – 8½in (21.6cm);
Rectangle D for Border 8 – 8½in x 7¼in (21.6cm x 18.4cm);
Square E for Bottom Row – 10in (25.4cm);
Rectangle F for Bottom Row – 11¼in x 10in (28.6cm x 25.4cm).

Cut squares and rectangles from fabrics as follows:
Fabric 1 F x 1, E x 1, D x 3, C x 6;
Fabric 2 C x 4, B x 5, A x 4;
Fabric 3 E x 1, D x 1, C x 1, B x 7, A x 7;
Fabric 4 F x 1, E x 2, D x 2, C x 3, B x 14, A x 1;
Fabric 5 D x 2, C x 6, B x 2, A x 2;
Fabric 6 A x 10.

Borders and Sashing

Border 2 From Fabric 7 cut 3 strips 3in (7.6cm) wide across the width, remove selvedges and sew end to end. From the length cut 2 pieces 22in x 3in (55.9cm x 7.6cm) for the top and bottom borders and cut 2 pieces 27in x 3in (68.6cm x 7.6cm) for the side borders.

All sashing and unpieced borders, except Border 2, are cut from Fabric 8. To avoid seams in the borders, cut strips 99in (251.5cm) long, down the length of the fabric as follows, cutting the wider and longer pieces first, then fitting the shorter pieces into the remaining ends of the strips. Label all border pieces.

Bottom Row Sashing Strips Cut a strip 3in (7.6cm) wide and cross cut 5 sashing strips 10in x 3in (25.4cm x 7.6cm). Cut 6 strips 2½in (6.4cm) wide and cut border pieces as follows:

Outer Border Cut 2 pieces 72½in x 2½in (184.2cm x 6.4cm) for the top and bottom borders and cut 2 pieces 87½in x 2½in (222.3cm x 6.4cm) for the side borders.

Border 5 Cut 2 pieces 38in x 2½in (96.5cm x 6.4cm) for the top and bottom borders and cut 2 pieces 42in x 2½in (106.7cm x 6.4cm) for the side borders. Cut 6 strips 2in (5.1cm) wide and cut the border and sashing pieces as follows:

Bottom Sashing Strip Cut a piece 72½in x 2in (184.2cm x 5.1cm).

Border 7 Cut 2 pieces 53½in x 2in (135.9cm x 5.1cm) for the top and bottom borders and cut 2 pieces 56½in x 2in (143.5cm x 5.1cm) for the side borders.

Border 8 Sashing Strips Cut 28 sashing strips 8½in x 2in (21.6cm x 5.1cm), using one of the strips and trimming the remaining ends of the strips. Cut 4 strips 1½in (3.8cm) wide and cut border and sashing pieces as follows:

Border 3 Cut 2 pieces 27in x 1½in (68.6cm x 3.8cm) for the top and bottom borders and cut 2 pieces 29in x 1½in (73.7cm x 3.8cm) for the side borders.

Border 1 Cut 2 pieces 20in x 1½in (50.8cm x 3.8cm) for the top and bottom borders and cut 2 pieces 22in x 1½in (55.9cm x 3.8cm) for the side borders.

Border 6 Sashing Strips Cut 28 sashing strips 6¼in x 1½in (15.9cm x 3.8cm) using one of the strips and trimming the remaining ends of the strips.

Border 4 Sashing Strips Cut 24 sashing strips 5in x 1½in (12.7cm x 3.8cm) using one of the strips and trimming the remaining ends of the strips.

Backing
Trim Fabric 9 backing to 95in x 84in (241cm x 213cm).

Binding
From Fabric 8 cut 9 strips 2½in (6.4cm) wide. Remove selvedges and sew end to end with 45° seams (see page 157).

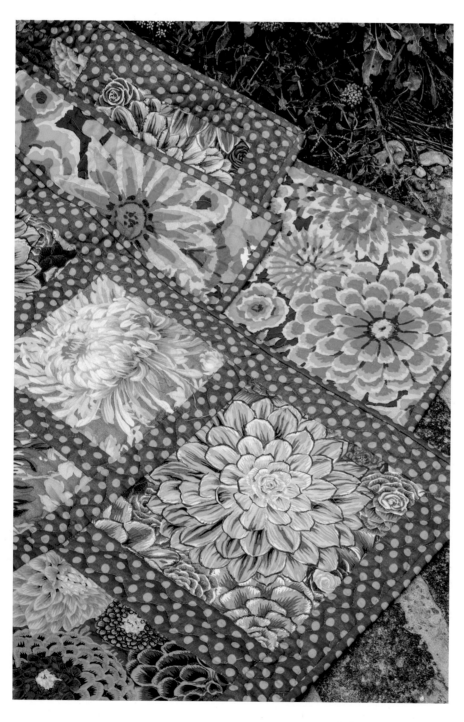

142

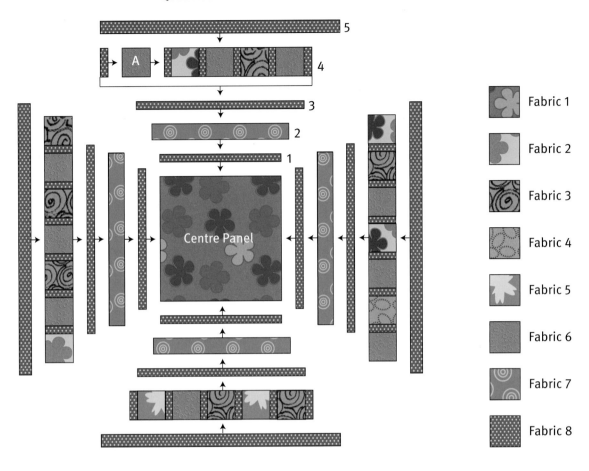

Fabric 1

Fabric 2

Fabric 3

Fabric 4

Fabric 5

Fabric 6

Fabric 7

Fabric 8

MAKING THE QUILT
Using a design wall will help to place patches in the required layout.
Use ¼in (6mm) seams throughout.

Centre
Lay out the centre panel, blocks, borders and sashing strips, referring to Quilt Assembly Diagrams 1 and 2 and the quilt photograph for fabric placement. Take care to add the borders in the numbered order shown in the diagrams.

Borders 1–3 To the centre panel add the Border 1 strips, with top and bottom first, and then the sides. Add the Border 2 strips and then the Border 3 strips in the same sequence, as in Diagram 1.

Border 4 Border 4 is pieced using 24 Square A patches interspersed with sashing strips. Piece the top and bottom borders, each with 5 square A patches and 6 sashing strips. Sew to the quilt. Piece the side borders, each

with 7 square A patches and 6 sashing strips. Sew to the quilt sides.

Border 5 Add the Border 5 strips, shorter top and bottom strips first, and then the longer sides.

Borders 6–8 Border 6 is pieced using 28 Square B patches interspersed with sashing strips. Piece the top and bottom border, each with 6 Square B patches and 7 sashing strips. Sew to the quilt. Piece the side borders, each with 8 Square B patches and 7 sashing strips. Sew to the quilt as shown in Diagram 2.

Border 7 Add the Border 7 strips, the shorter top and bottom ones first, and then the longer sides.

Border 8 Border 8 is pieced using 20 Square C patches and 8 Rectangle D patches, the patches interspersed with sashing strips. Refer to Quilt Assembly Diagram 2 on page 144 for the layout and note the Rectangle D patches are

positioned 1 patch in from the corners on all 4 sides. Piece the top and bottom borders as shown and sew to the quilt. Piece the sides and sew to the quilt.

Bottom Sashing Strip Sew the bottom sashing strip to the quilt.

Bottom Row This row is pieced using 4 Square E patches and 2 Rectangle F patches, 1 at each end, interspersed with the 5 bottom row sashing strips. Sew to the bottom of the quilt.

Outer Border Add the top and bottom outer borders to the quilt, then the side outer borders, to complete the quilt top.

FINISHING THE QUILT
Press the quilt top. Layer the quilt top, batting and backing, and baste together (see page 156).
Quilt as desired.
Trim the quilt edges and attach the binding (see page 157).

QUILT ASSEMBLY DIAGRAM 2

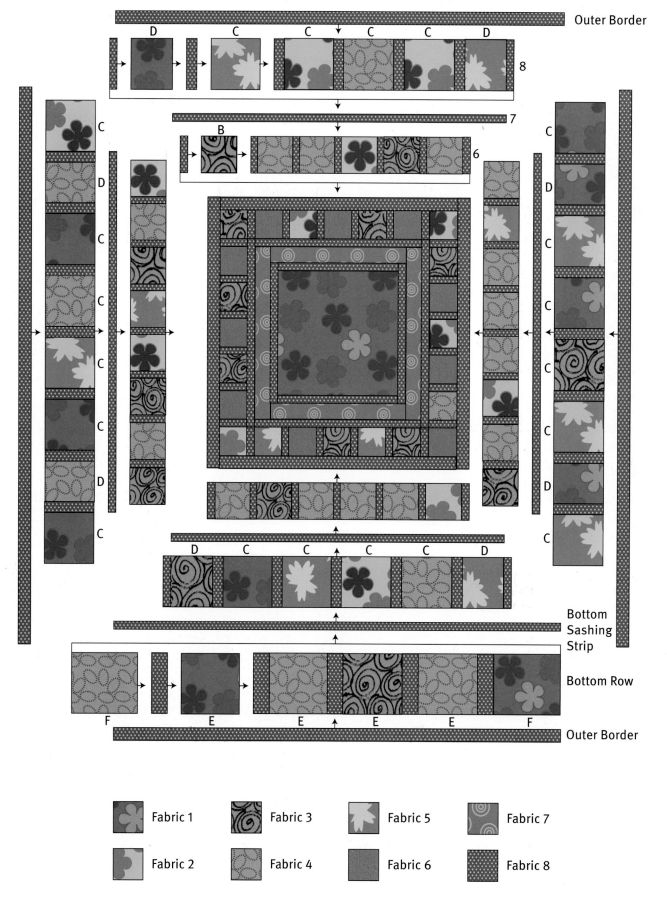

Outer Border

D C C C C D

8

7

B

6

C

D

C

C

C

C

C

D

C

C

D

C

Outer Border

D C C C C D

Bottom Sashing Strip

Bottom Row

F E E E E F

Outer Border

| Fabric 1 | Fabric 3 | Fabric 5 | Fabric 7 |
| Fabric 2 | Fabric 4 | Fabric 6 | Fabric 8 |

144

autumn postcard ****

Liza Prior Lucy

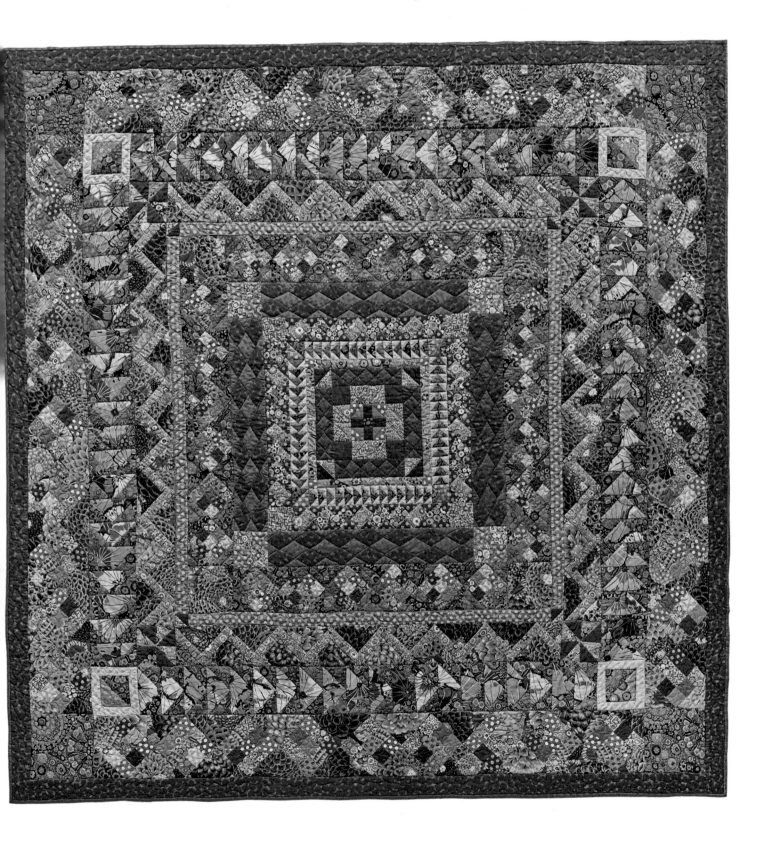

Not for the faint-hearted, *Autumn Postcard* is Liza's new take on her original quilt design, based on an antique quilt spotted on a postcard at the Victoria and Albert Museum in London. This beauty of a quilt is a real feat of geometry and piecing.

Owing to its intricacy, we are reproducing only its fabric requirements and the templates for it in this book.

For those patchwork and quilting enthusiasts who might wish to make it, FreeSpirit is offering a free downloadable pdf of the complete instructions, including the fabric requirements, the diagrams and the accompanying flat shot. Please go to the following link to obtain it: https://freespiritfabrics.com/be-inspired/quilts-by-the-sea/.

SIZE OF FINISHED QUILT
84in x 84in (213cm x 213cm)

FABRICS
Fabrics have been calculated at a maximum width of 40in (102cm). Fabrics have been given a number – see Fabric Swatch Diagram for details.

Patchwork Fabrics
MILLEFIORE

Fabric 1	Dusty	2yd (1.9m)
Fabric 2	Orange	⅜yd (40cm)

FLORA

Fabric 3	Antique	2¼yd (2.1m)

LOTUS LEAF

Fabric 4	Red	1yd (95cm)

JUMBLE

Fabric 5	Teal	1¼yd (1.2m)

ROMAN GLASS

Fabric 6	Gold	¾yd (70cm)

PAPERWEIGHT

Fabric 7	Pumpkin	⅜yd (40cm)
Fabric 8	Grey	¼yd (25cm)
Fabric 9	Blue	¼yd (25cm)

AMAZE

Fabric 10	Grey	¼yd (25cm)

ABORIGINAL DOT

Fabric 11	Maroon	¼yd (25cm)
Fabric 12	Wisteria	¼yd (25cm)
Fabric 13	Pumpkin	¼yd (25cm)

SPOT

Fabric 14	Tobacco	⅝yd (60cm)

* see also Binding Fabric

Fabric 15	Pacific	½yd (50cm)
Fabric 16	Sage	⅜yd (40cm)
Fabric 17	Charcoal	¼yd (25cm)
Fabric 18	Pond	¼yd (25cm)
Fabric 19	Plum	⅜yd (40cm)
Fabric 20	Autumn	¼yd (25cm)
Fabric 21	Storm	¼yd (25cm)

SHARKS TEETH

Fabric 22	Carnival	¼yd (25cm)

Backing and Binding Fabrics
LOTUS LEAF extra wide backing

Fabric 23	Purple	2¾yd (2.6m)

SPOT

Fabric 14	Tobacco	¾yd (70cm)

* see also Patchwork Fabrics

Batting
93in x 93in (236cm x 236cm)

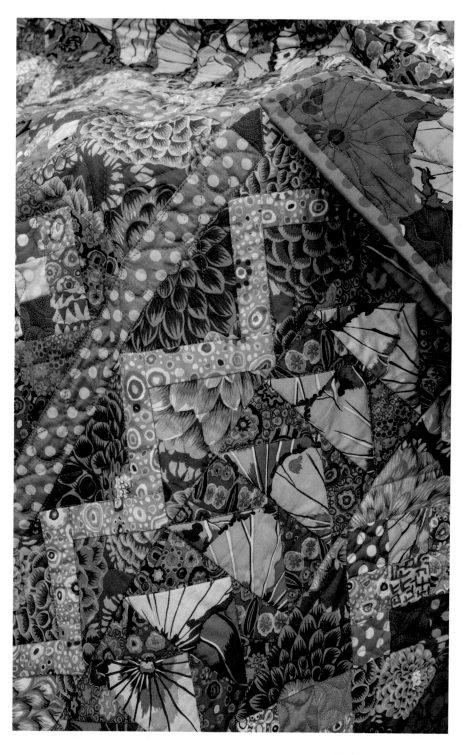

FABRIC SWATCH DIAGRAM

Patchwork Fabrics

Fabric 1
MILLEFIORE
Dusty
GP92DY

Fabric 2
MILLEFIORE
Orange
GP92OR

Fabric 3
FLORA
Antique
PJ114AN

Fabric 4
LOTUS LEAF
Red
GP29RD

Fabric 5
JUMBLE
Teal
BM53TE

Fabric 6
ROMAN GLASS
Gold
GP01GD

Fabric 7
PAPERWEIGHT
Pumpkin
GP20PN

Fabric 8
PAPERWEIGHT
Grey
GP20GY

Fabric 9
PAPERWEIGHT
Blue
GP20BL

Fabric 10
AMAZE
Grey
BM78GY

Fabric 11
ABORIGINAL DOT
Maroon
GP71MM

Fabric 12
ABORIGINAL DOT
Wisteria
GP71WS

Fabric 13
ABORIGINAL DOT
Pumpkin
GP71PN

Fabric 14
SPOT
Tobacco
GP70TO

Fabric 15
SPOT
Pacific
GP70PF

Fabric 16
SPOT
Sage
GP70SJ

Fabric 17
SPOT
Charcoal
GP70CC

Fabric 18
SPOT
Pond
GP70PO

Fabric 19
SPOT
Plum
GP70PL

Fabric 20
SPOT
Autumn
GP70AU

Fabric 21
SPOT
Storm
GP70SR

Fabric 22
SHARKS TEETH
Carnival
BM60CV

Backing and Binding Fabrics

Fabric 23
LOTUS LEAF
Purple
QG07PU

Fabric 14
SPOT
Tobacco
GP70TO

templates

Refer to the individual quilt instructions for the templates needed. Look for the quilt name on the templates to make sure you are using the correct shapes for the project. Arrows on templates should be lined up with the straight grain of the fabric, which runs either along the selvedge or at 90 degrees to the selvedge. Following marked grain lines is important to avoid bias edges, which can cause distortion.

An acrylic version of this template (entitled *Folded Ribbons* quilt) is available from Paper Pieces (www.paperpieces.com)

A/A REVERSE
DUSKY RIBBONS

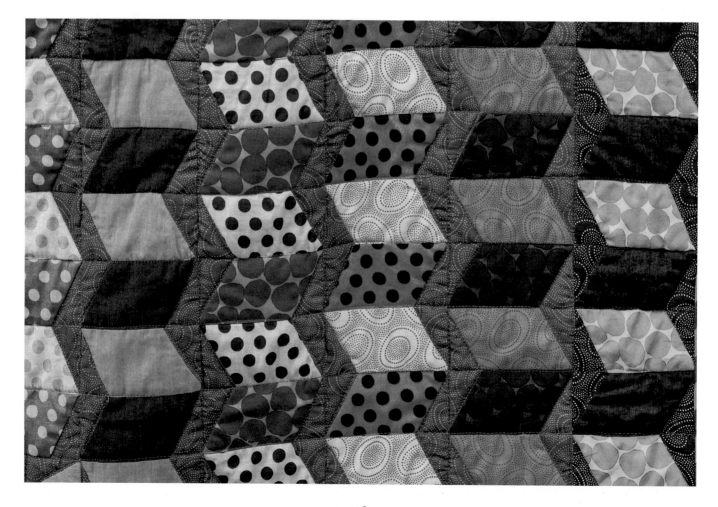

Little Jars Templates
All the templates for the *Little Jars* do not include a seam allowance. Cut templates as printed from cardboard/template plastic; then draw a ¼in (6mm) seam allowance around each template onto the fabric before cutting it out. For hand appliqué, the seam allowance can be folded around the template edge and pressed, to give a smooth finish.

1

LITTLE JARS

2

LITTLE JARS

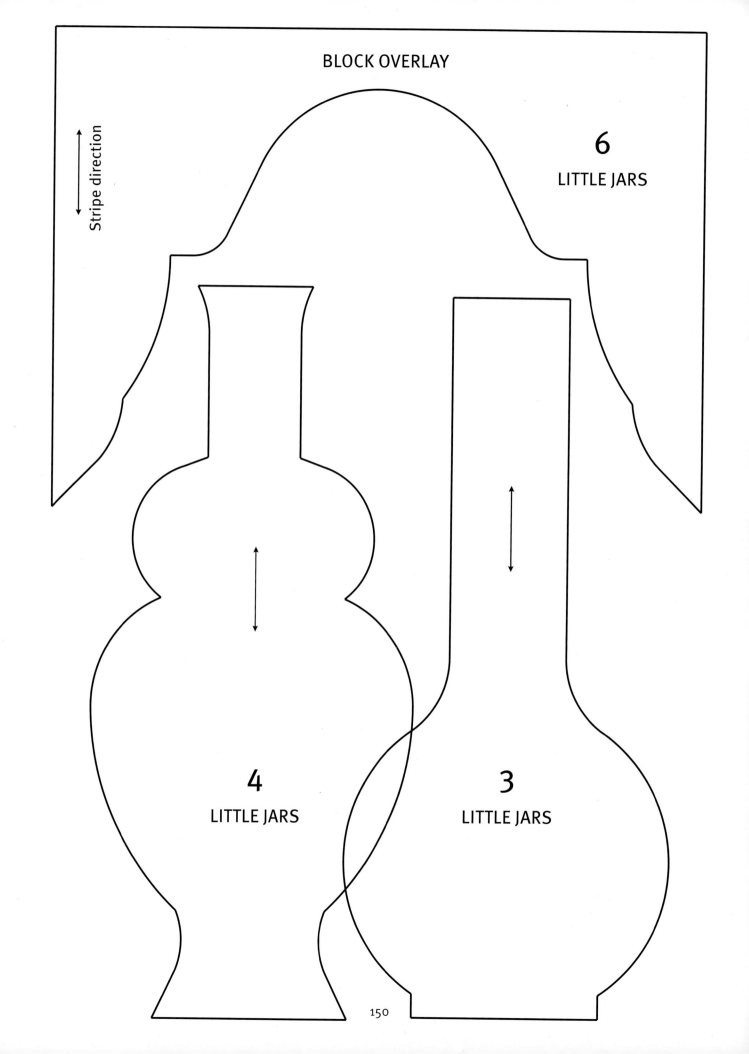

BLOCK OVERLAY

Stripe direction

6
LITTLE JARS

4
LITTLE JARS

3
LITTLE JARS

150

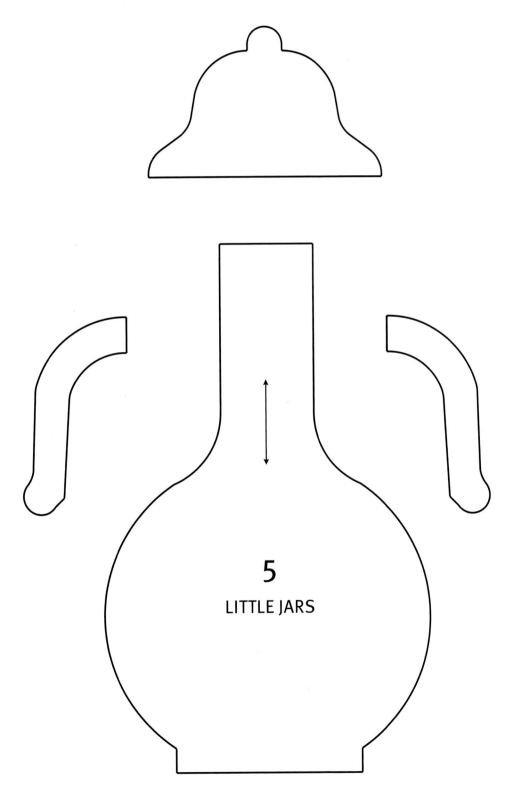

5

LITTLE JARS

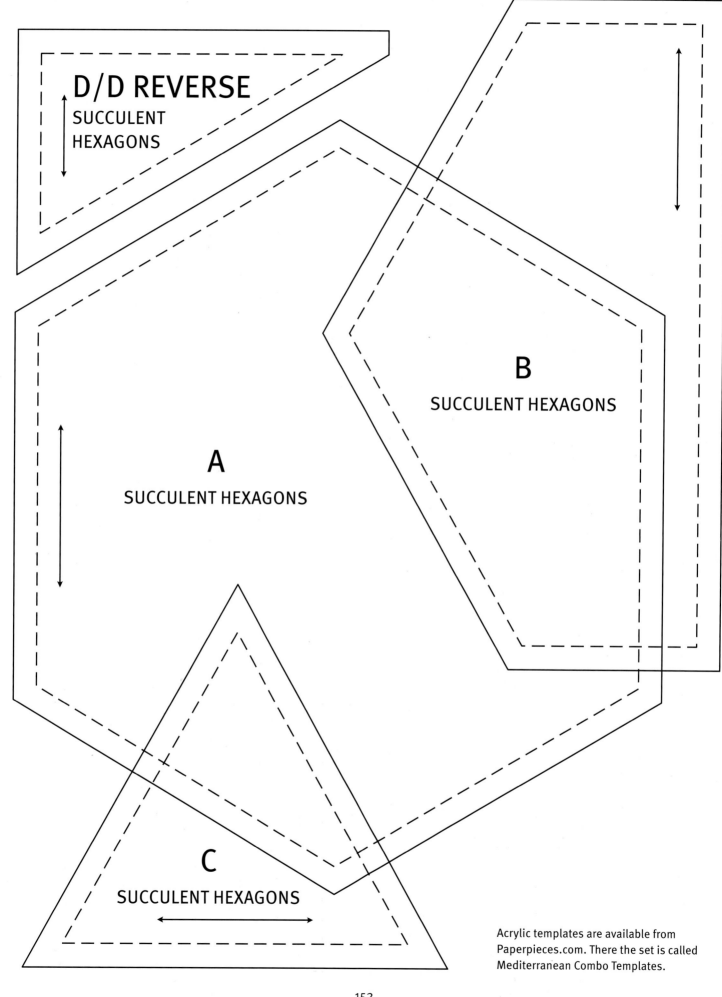

D/D REVERSE
SUCCULENT
HEXAGONS

A
SUCCULENT HEXAGONS

B
SUCCULENT HEXAGONS

C
SUCCULENT HEXAGONS

Acrylic templates are available from
Paperpieces.com. There the set is called
Mediterranean Combo Templates.

152

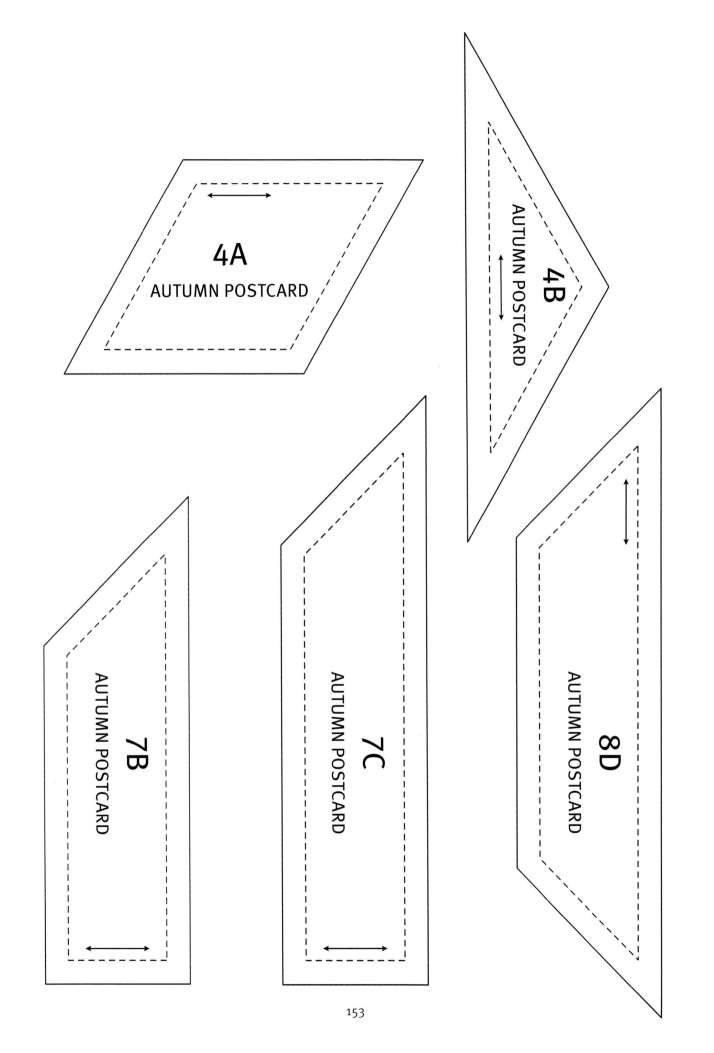

4A
AUTUMN POSTCARD

4B
AUTUMN POSTCARD

7B
AUTUMN POSTCARD

7C
AUTUMN POSTCARD

8D
AUTUMN POSTCARD

patchwork and quilting know-how

These instructions are intended for the novice quilt maker, providing the basic information needed to make the projects in this book, along with some useful tips.

EXPERIENCE RATINGS
* Easy, straightforward, suitable for a beginner.
** Suitable for the average patchworker and quilter.
*** For the more experienced patchworker and quilter.

ABOUT THE FABRICS
The fabrics used for the quilts in this book are mainly from Kaffe Fassett Collective:
GP is the code for Kaffe Fassett's designs, PJ for Philip Jacobs' and BM for Brandon Mably's.
The other fabrics used are Shot Cottons and Stripes with SC or SS prefixes as well as wide backing fabrics with QB prefixes.

PREPARING THE FABRIC
Prewash all new fabrics before you begin, to ensure that there will be no uneven shrinkage and no bleeding of colours when the finished quilt is laundered. Press the fabric whilst it is still damp to return crispness to it. All fabric requirements in this book are calculated on a 40in (102cm) usable fabric width, to allow for shrinkage and selvedge removal.

MAKING TEMPLATES
Transparent template plastic is the best material to use: it is durable and allows you to see the fabric and select certain motifs. You can also use tracing paper and thin stiff cardboard.

Templates for machine piecing
1 Trace off the actual-sized template provided either directly on to template plastic, or on to tracing paper and then on to thin cardboard. Use a ruler to help you trace off the straight cutting line, dotted seam line and grain lines.
 Sometimes templates are too large to print complete. Transfer the template on to the fold of a large sheet of paper, cut out and open out for the full template. Some templates are printed at a reduced size and need to be scaled up on a photocopier.
2 Cut out the traced off template using a craft knife, a ruler and a self-healing cutting mat.
3 Punch holes in the corners of the template, at each point on the seam line, using a hole punch.

Templates for hand piecing
• Make a template as for machine piecing, but do not trace off the cutting line. Use the dotted seam line as the outer edge of the template.

• This template allows you to draw the seam lines directly on to the fabric. The seam allowances can then be cut by eye around the patch.

CUTTING THE FABRIC
On the individual instructions for each project, you will find a summary of all the patch shapes used.
 Always mark and cut out any border and binding strips first, followed by the largest patch shapes and finally the smallest ones, to make the most efficient use of your fabric. The border and binding strips are best cut using a rotary cutter.

Rotary cutting
Rotary cut strips are usually cut across the fabric from selvedge to selvedge, but some projects may vary, so please read through all the instructions before you start cutting the fabrics.

1 Before beginning to cut, press out any folds or creases in the fabric. If you are cutting a large piece of fabric, you will need to fold it several times to fit the cutting mat. When there is only a single fold, place the fold facing you. If the fabric is too wide to be folded only once, fold it concertina-style until it fits your mat. A small rotary cutter with a sharp blade will cut up to six layers of fabric; a large cutter up to eight layers.

2 To ensure that your cut strips are straight and even, the folds must be placed exactly parallel to the straight edges of the fabric and along a line on the cutting mat.

3 Place a rotary ruler over the raw edge of the fabric, overlapping it about ½in (1.25cm). Make sure that the ruler is at right angles to both the straight edges and the fold to ensure that you cut along the straight grain. Press down on the ruler and wheel the cutter away from you along the edge of the ruler.

4 Open out the fabric to check the edge. Don't worry if it's not perfectly straight – a little wiggle will not show when the quilt is stitched together. Re-fold the fabric, then place the ruler over the trimmed edge, aligning the edge with the markings on the ruler that match the correct strip width. Cut strip along the edge of the ruler.

USING TEMPLATES
The most efficient way to cut out templates is by first rotary cutting a strip of fabric to the width stated for your template, and then marking off your templates along the strip, edge to edge at the required angle. This method leaves hardly any waste and gives a random effect to your patches.
 A less efficient method is to fussy cut them, where the templates are cut individually by placing them on particular motifs or stripes, to create special effects. Although this method is more wasteful, it yields very interesting results.

1 Place the template face down, on the wrong side of the fabric, with the grain-line arrow following the straight grain of the fabric, if indicated. Be careful though – check with your individual instructions, as some instructions may ask you to cut patches on varying grains.

2 Hold the template firmly in place and draw around it with a sharp pencil or crayon, marking in the corner dots or seam lines. To save fabric, position patches close together or even touching. Don't worry if outlines positioned on the straight grain when drawn on striped fabrics do not always match the stripes when cut – this will add a degree of visual excitement to the patchwork!

3 Once you've drawn all the pieces needed, you are ready to cut the fabric, with either a rotary cutter and ruler or a pair of sharp sewing scissors.

Basic hand and machine piecing
Patches can be stitched together by hand or machine. Machine stitching is quicker, but hand assembly allows you to carry your patches around with you and work on them in every spare moment. The choice is yours. For techniques that are new to you, practise on scrap pieces of fabric until you feel confident.

Hand piecing

1 Pin two patches with right sides together, so that the marked seam lines are facing outwards.

2 Using a single strand of strong thread, secure the corner of a seam line with a couple of back stitches.

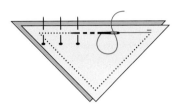

3 Sew running stitches along the marked line, working 8–10 stitches per inch (2.5cm) and ending at the opposite seam line corner with a few back stitches. When hand piecing never stitch over the seam allowances.

4 Press the seams to one side, as shown in machine piecing (Step 2).

Machine piecing

Follow the quilt instructions for the order in which to piece the individual patchwork blocks and then assemble the blocks together in rows.

1 Seam lines are not marked on the fabric for simple shapes, so stitch ¼in (6mm) seams using the machine needle plate, a ¼in (6mm) wide machine foot, or tape stuck to the machine as a guide. Pin two patches with right sides together, matching edges.

For some shapes, particularly diamonds, you need to match the sewing lines, not the fabric edges. Place 2 diamonds right sides together but offset so that the sewing lines intersect at the correct position. Use pins to secure for sewing.

Set your machine at 10–12 stitches per inch (2.5cm) and stitch seams from edge to edge, removing pins as you feed the fabric through the machine.

2 Press the seams of each patchwork block to one side before attempting to join it to another block. When joining diamond shaped blocks you will need to offset the blocks in the same way as diamond shaped patches, matching the sewing lines, not the fabric edges.

3 When joining rows of blocks, make sure that adjacent seam allowances are pressed in opposite directions to reduce bulk and make matching easier. Pin pieces together directly through the stitch line and to the right and left of the seam. Remove pins as you sew. Continue pressing seams to one side as you work.

Inset (Y) seams

When 3 or more patches have seams that come together without making a rectangle (i.e. in a Y-shape), an inset seam is needed. As shown in the diagram, with RS together, first sew the A–B seam. Then, starting from an inner point to an outer point, sew the A–C seam, and finally the A–D seam. Make sure you start and finish each ¼in (6mm) seam exactly at the beginning and end (as marked by dots on the diagram) and do not stitch into the seam allowance.

MACHINE APPLIQUÉ WITH ADHESIVE WEB

To make appliqué very easy you can use adhesive web (which comes attached to a paper backing sheet) to bond the motifs to the background fabric. There are two types of web available: the first keeps the pieces in place while they are stitched, the second permanently attaches the pieces so that no sewing is required. Follow steps 1 and 2 for the non-sew type and steps 1–3 for the type that requires sewing.

1 Trace the reversed appliqué design onto the paper side of the adhesive web, leaving a ¼in (6mm) gap between all the shapes. Roughly cut out the motifs ⅛in (3mm) outside your drawn line.

2 Bond the motifs to the reverse of your chosen fabrics. Cut out on the drawn line with very sharp scissors. Remove the backing paper by scoring the centre of the motif carefully with a scissor point and peeling the paper away from the centre out (to prevent damage to the edges). Place the motifs onto the background, noting any which may be layered. Cover with a clean cloth and bond with a hot iron (check instructions for temperature setting as adhesive web can vary depending on the manufacturer).

3 Using a contrasting or toning coloured thread in your machine, work small close zig zag stitches (or a blanket stitch if your machine has one) around the edge of the motifs; the majority of the stitching should sit on the appliqué shape. When stitching up to points, stop with the machine needle in the down position, lift the foot of your machine, pivot the work, lower the foot and continue to stitch. Make sure all the raw edges are stitched.

HAND APPLIQUÉ

Good preparation is essential for speedy and accurate hand appliqué. The finger-pressing method is suitable for needle-turning application, used for simple shapes like leaves and flowers. Using a card template is the best method for bold simple motifs such as circles.

Finger–pressing method

1 To make your template, transfer the appliqué design using carbon paper on to stiff card, and cut out the template. Trace around the outline of your appliquéd shape on to the right side of your fabric using a well sharpened pencil. Cut out shapes, adding by eye a ¼in (6mm) seam allowance all around.

2 Hold the shape right side up and fold under the seam, turning along your drawn line, pinch to form a crease. Dampening the fabric makes this very easy. When using shapes with points such as leaves, turn in the seam allowance at the point first, as shown in the diagram. Then continue all round the shape. If your shapes have sharp curves, you can snip the seam allowance to ease the curve. Take care not to stretch the appliqué shapes as you work.

Straight stems

Place fabric face down and simply press over the ¼in (6mm) seam allowance along each edge. You don't need to finish the ends of stems that are layered under other appliqué shapes. Where the end of the stem is visible, simply tuck under the end and finish neatly.

Needle-turning application

Take the appliqué shape and pin in position. Stroke the seam allowance under with the tip of the needle as far as the creased pencil line, and hold securely in place with your thumb. Using a matching thread, bring the needle up from the back of the block into the edge of the shape and proceed to blind-hem in place. (This stitch allows the motifs to appear to be held on invisibly.) To do this, bring the thread out from below through the folded edge of the motif, never on the top. The stitches must be small, even and close together to prevent the seam allowance from unfolding and from frayed edges appearing. Try to avoid pulling the stitches too tight, as this will cause the motifs to pucker up. Work around the whole shape, stroking under each small section before sewing.

QUILTING

When you have finished piecing your patchwork and added any borders, press it carefully. It is now ready for quilting.

Marking quilting designs and motifs

Many tools are available for marking quilting patterns, check the manufacturer's instructions for use and test on scraps of fabric from your project. Use an acrylic ruler for marking straight lines.

Stencils

Some designs require stencils; these can be made at home, by transferring the designs on to template plastic, or stiff cardboard. The design is then cut away in the form of long dashes, to act as guides for both internal and external lines. These stencils are a quick method for producing an identical set of repeated designs.

BACKING FABRIC

The quilts in this book use two different widths of backing fabric – the standard width of 44in (112cm) and a wider one of 108in (274cm). If you can't find (or don't want to use) the wider fabric then select a standard-width fabric instead and adjust the amount accordingly. For most of the quilts in the book, using a standard-width fabric will probably mean joins in the fabric. The material list for each quilt assumes that an extra 4in of backing fabric is needed all round (8in in total) when making up the quilt sandwich, to allow for long-arm quilting if needed. We have assumed a usable width of 40in (102cm), to allow for selvedge removal and possible shrinkage after washing.

Preparing the backing and batting

• Remove the selvedges and piece together the backing fabric to form a backing at least 4in (10cm) larger all around than the patchwork top.

• Choose a fairly thin batting, preferably pure cotton, to give your quilt a flat appearance. If your batting has been rolled up, unroll it and let it rest before cutting it to the same size as the backing.

• For a large quilt it may be necessary to join two pieces of batting to fit. Lay the pieces of batting on a flat surface so that they overlap by around 8in (20cm). Cut a curved line through both layers.

overlap wadding

• Carefully peel away the two narrow pieces and discard. Butt the curved cut edges back together. Stitch the two pieces together using a large herringbone stitch.

1 On the floor or on a large work surface, lay out the backing with wrong side uppermost. Use weights along the edges to keep it taut.

2 Lay the batting on the backing and smooth it out gently. Next lay the patchwork top, right side up, on top of the batting and smooth gently until there are no wrinkles. Pin at the corners and at the midpoints of each side, close to the edges.

3 Beginning at the centre, baste diagonal lines outwards to the corners, making your stitches about 3in (7.5cm) long. Then, again starting at the centre, baste horizontal and vertical lines out to the edges. Continue basting until you have basted a grid of lines about 4in (10cm) apart over the entire quilt.

4 For speed, when machine quilting, some quilters prefer to baste their quilt sandwich layers together using rust-proof safety pins, spaced at 4in (10cm) intervals over the entire quilt.

HAND QUILTING

This is best done with the quilt mounted on a quilting frame or hoop, but as long as you have basted the quilt well, a frame is not essential. With the quilt top facing upwards, begin at the centre of the quilt and make even running stitches following the design. It is more important to make even stitches on both sides of the quilt than to make small ones. Start and finish your stitching with back stitches and bury the ends of your threads in the batting.

TIED QUILTING

If you prefer you could use tied quilting rather than machine quilting. For tied quilting, use a strong thread that will withstand being pulled through the quilt layers and tied in a knot. You can tie with the knot on the front of the quilt or the back, as preferred. Leaving tufts of thread gives an attractive, rustic look.

Thread a needle with a suitable thread, using the number of strands noted in the project. Put the needle and thread through from the front of the work, leaving a long tail. Go through to the back of the quilt, make a small stitch and then come back through to the front. Tie the threads together using a reef knot and trim the thread ends to the desired

length. For extra security, you could tie a double knot or add a spot of fabric glue on the knot.

MACHINE QUILTING

• For a flat looking quilt, always use a walking foot on your machine for stitching straight lines, and a darning foot for free-motion quilting.

• It is best to start your quilting at the centre of the quilt and work out towards the borders, doing the straight quilting lines first (stitch-in-the-ditch) followed by the free-motion quilting.

• When free-motion quilting, stitch in a loose meandering style as shown in the diagrams. Do not stitch too closely as this will make the quilt feel stiff when finished. If you wish you can include floral themes or follow shapes on the printed fabrics for added interest.

• Make it easier for yourself by handling the quilt properly. Roll up the excess quilt neatly to fit under your sewing machine arm, and use a table or chair to help support the weight of the quilt that hangs down the other side.

FINISHING
Preparing to bind the edges

Once you have quilted or tied your quilt sandwich together, remove all the basting stitches. Then, baste around the outer edge of the quilt ¼in (6mm) from the edge of the top patchwork layer. Trim the back and batting to the edge of the patchwork and straighten the edge of the patchwork if necessary.

Binding and 45-degree seams

1 Cut bias or straight grain strips the width required for your binding, making sure the grain-line is running the correct way on your straight grain strips. Cut enough strips until you have the required length to go around the edge of your quilt.

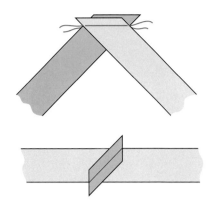

2 To join strips together, the two ends that are to be joined must be cut at a 45-degree angle, as above. Stitch right sides together, trim turnings and press seam open.

Binding the edges

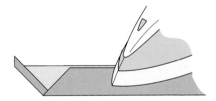

1 Cut the starting end of binding strip at a 45-degree angle, fold a ¼in (6mm) turning to wrong side along cut edge and press in place. With wrong sides together, fold strip in half lengthways, keeping raw edges level, and press.

2 Starting at the centre of one of the long edges, place the doubled binding on to the right side of the quilt keeping raw edges level. Stitch the binding in place. starting ¼in (6mm) in from the diagonal folded edge. Reverse stitch to secure, and work ¼in (6mm) in from edge of the quilt towards first corner of quilt. Stop ¼in (6mm) in from corner and work a few reverse stitches.

3 Fold the loose end of the binding up, making a 45-degree angle (see A). Keeping the diagonal fold in place, fold the binding back down, aligning the raw edges with the next side of the quilt. Starting at the point where the last stitch ended, stitch down the next side (see B).

4 Continue to stitch the binding in place around all the quilt edges in this way, tucking the finishing end of the binding inside the diagonal starting section.

5 Turn the folded edge of the binding on to the back of the quilt. Hand stitch the folded edge in place just covering binding machine stitches, and folding a mitre at each corner.

glossary of terms

Adhesive or fusible web This comes attached to a paper-backed sheet and is used to bond appliqué motifs to a background fabric. There are 2 types of web available, the first keeps the pieces in place whilst they are stitched, the second permanently attaches the pieces so that no sewing is required.

Appliqué The technique of stitching fabric shapes on to a background to create a design. It can be applied either by hand or machine with a decorative embroidery stitch, such as buttonhole, or satin stitch.

Backing The bottom layer of a quilt sandwich. It is made of fabric pieced to the size of the quilt top with the addition of about 4in (10cm) all around to allow for quilting take-up.

Basting or tacking This is a means of holding two fabric layers or the layers of a quilt sandwich together temporarily with large hand stitches or pins.

Batting or wadding This is the middle layer, or padding in a quilt. It can be made of cotton, wool, silk or synthetic fibres.

Bias The diagonal grain of a fabric. This is the direction which has the most give or stretch, making it ideal for bindings, especially on curved edges.

Binding A narrow strip of fabric used to finish off the edges of quilts or projects; it can be cut on the straight grain of a fabric or on the bias.

Block A single design unit that when stitched together with other blocks create the quilt top. It is most often a square, hexagon, or rectangle, but it can be any shape. It can be pieced or plain.

Border A frame of fabric stitched to the outer edges of the quilt top. Borders can be narrow or wide, pieced or plain. As well as making the quilt larger, they unify the overall design and draw attention to the central area.

Chalk pencils Available in various colours, they are used for marking lines or spots on fabric.

Cutting mat Designed for use with a rotary cutter, it is made from a special self-healing material that keeps your cutting blade sharp. Cutting mats come in various sizes and are usually marked with a grid to help you line up the edges of fabric and cut out larger pieces.

Design wall Used for laying out fabric patches before sewing. A large wall or folding board covered with flannel fabric or cotton batting in a neutral shade (dull beige or grey work well) will hold fabric in place so that an overall view can be taken of the placement.

Free-motion quilting Curved wavy quilting lines stitched in a random manner. Stitching diagrams are often given for you to follow as a loose guide.

Fussy cutting This is when a template is placed on a particular motif, or stripe, to obtain interesting effects. This method is not as efficient as strip cutting, but yields very interesting results.

Grain The direction in which the threads run in a woven fabric. In a vertical direction it is called the lengthwise grain, which has very little stretch. The horizontal direction, or crosswise grain is slightly stretchy, but diagonally the fabric has a lot of stretch. This grain is called the bias. Wherever possible the grain of a fabric should run in the same direction on a quilt block and borders.

Grain lines These are arrows printed on templates which should be aligned with the fabric grain.

Inset seams or setting-in A patchwork technique whereby one patch (or block) is stitched into a Y shape formed by the joining of two other patches (or blocks).

Patch A small shaped piece of fabric used in the making of a patchwork pattern.

Patchwork The technique of stitching small pieces of fabric (patches) together to create a larger piece of fabric, usually forming a design.

Pieced quilt A quilt composed of patches.

Quilting Traditionally done by hand with running stitches, but for speed modern quilts are often stitched by machine. The stitches are sewn through the top, wadding and backing to hold the three layers together. Quilting stitches are usually worked in some form of design, but they can be random.

Quilting hoop Consists of two wooden circular or oval rings with a screw adjuster on the outer ring. It stabilises the quilt layers, helping to create an even tension.

Reducing glass Used for viewing the complete composition of a quilt at a glance. It works like a magnifier in reverse. A useful tool for checking fabric placement before piecing a quilt.

Rotary cutter A sharp circular blade attached to a handle for quick, accurate cutting. It is a device that can be used to cut several layers of fabric at one time. It must be used in conjunction with a self-healing cutting mat and a thick plastic ruler.

Rotary ruler A thick, clear plastic ruler marked with lines in imperial or metric measurements. Sometimes they also have diagonal lines indicating 45 and 60 degree angles. A rotary ruler is used as a guide when cutting out fabric pieces using a rotary cutter.

Sashing A piece or pieced sections of fabric interspaced between blocks.

Sashing posts When blocks have sashing between them the corner squares are known as sashing posts.

Selvedges Also known as selvages, these are the firmly woven edges down each side of a fabric length. Selvedges should be trimmed off before cutting out your fabric, as they are more liable to shrink when the fabric is washed.

Stitch-in-the-ditch or Ditch quilting Also known as quilting-in-the-ditch. The quilting stitches are worked along the actual seam lines to give a pieced quilt texture.

Template A pattern piece used as a guide for marking and cutting out fabric patches, or marking a quilting, or appliqué design. Usually made from plastic or strong card that can be reused many times. Templates for cutting fabric usually have marked grain lines which should be aligned with the fabric grain.

Threads One hundred percent cotton or cotton-covered polyester is best for hand and machine piecing. Choose a colour that matches your fabric. When sewing different colours and patterns together, choose a medium to light neutral colour, such as grey or ecru. Specialist quilting threads are available for hand and machine quilting.

Walking foot or Quilting foot This is a sewing machine foot with dual feed control. It is very helpful when quilting, as the fabric layers are fed evenly from the top and below, reducing the risk of slippage and puckering.

Yo-Yos A circle of fabric double the size of the finished puff is gathered up into a rosette shape.

Y seams See Inset seams.

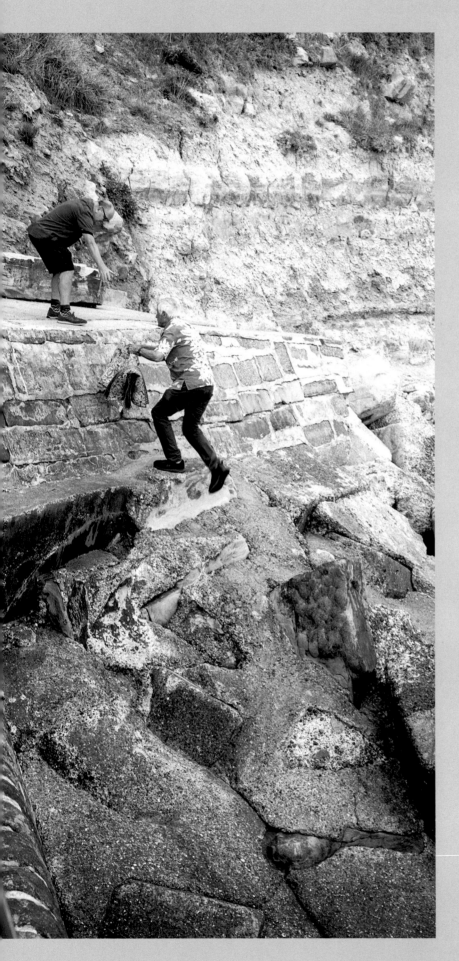

Quilts by the Sea is dedicated to Judy Baldwin, Sally Davies and Roberta Horton, all sadly missed. Three wonderful quilters who contributed to many of our patchwork and quilting books over the years.

ACKNOWLEDGMENTS

I would like to thank the splendid town of Hastings and St Leonards for supplying us with our lovely settings. Thanks to Belinda and Yvonne Mably for giving us a base to operate from and a delicious Kirsch during our photoshoot. Many thanks to our neighbours Christoph and Martin for sharing their gorgeous garden.

Always the deepest gratitude for a creative and joyful contribution from our quilt makers Janet Haigh, Ilaria Padovani and Julie Harvey in the UK and Mira Mayer, Bobbi Penniman and Emilija Mayer Gross in the US. We are always grateful to Judy Irish and Mary-Jane Hutchinson for their quilting.

Grateful acknowledgement of Bundle Backhouse's detailed organising and careful checking of patterns in this book. Thanks also to our art designer Anne Wilson for her beautiful layouts. This book would never exist without the immensely talented eye of our photographer Debbie Patterson and the coordination of our master overseer on all these books, Susan Berry.

The quilts were made and quilted as follows
(the quilter's name is in *italics*):
Hourglass Stripes Julie Harvey, *Mary-Jane Hutchinson*
Spot Swatches Ilaria Padovani, *Mary-Jane Hutchinson*
Cool Stars Ilaria Padovani, *Mary-Jane Hutchinson*
Maroon Frames Ilaria Padovani, *Mary-Jane Hutchinson*
Blooming Snowballs Julie Harvey, *Mary-Jane Hutchinson*
Water Garden Mira Mayer, *Judy Irish*
Pastel Fiesta Bobbi Penniman, *Judy Irish*
Jiggery Pokery Cushions Bundle Backhouse
Lorna Doone Liza Prior Lucy, *Judy Irish*
Cabanas Liza Prior Lucy, *Judy Irish*
Dusky Ribbons Liza Prior Lucy, *Judy Irish*
Fruit Sorbet Cushion Bundle Backhouse
Marble Tile Cushion Bundle Backhouse
Little Jars Janet Haigh, *Janet Haigh & Mary-Jane Hutchinson*
Colour Garden Ilaria Padovani, *Mary-Jane Hutchinson*
Flower Boxes Julie Harvey, *Mary-Jane Hutchinson*
Shadow Boxes Julie Harvey, *Mary-Jane Hutchinson*
Shady Parterre Ilaria Padovani, *Mary-Jane Hutchinson*
Autumn Postcard Liza Prior Lucy, *Judy Irish*
Vintage Stars Emilija Mayer Gross, *Judy Irish*
Succulent Hexagons Judy Baldwin, *Judy Irish*
Green Squares Liza Prior Lucy, *Judy Irish*
Love in the Mist Emilija Mayer Gross, *Judy Irish*